The
Isenheim
Altarpiece

ANDRÉE HAYUM

The
Isenheim
Altarpiece

GOD'S MEDICINE
AND THE PAINTER'S
VISION

PRINCETON UNIVERSITY PRESS
Princeton, New Jersey

Copyright © 1989 by Princeton University Press
Published by Princeton University Press,
41 William Street, Princeton, New Jersey 08540
In the United Kingdom:
Princeton University Press, Oxford

All Rights Reserved

Library of Congress Cataloging-in-Publication Data
Hayum, Andrée. The Isenheim altarpiece
God's medicine and the painter's
vision / Andrée Hayum. p. cm.
Includes index. ISBN 0-691-04070-2 (alk. paper)
1. Grünewald, Matthias, 16th cent. Isenheim Altar.
2. Grünewald, Matthias, 16th cent.
—Criticism and interpretation.
3. Christian art and symbolism
—Renaissance, 1450–1600—Germany.
4. Musée d'Unterlinden (Colmar, France)
I. Title. N6888.G75A65 1990 759.3—dc19
89-30107

This book has been composed in Linotron Galliard

Clothbound editions of Princeton University Press books
are printed on acid-free paper, and binding materials
are chosen for strength and durability. Paperbacks,
although satisfactory for personal collections,
are not usually suitable for library rebinding
Printed in the United States of America
by Princeton University Press,
Princeton, New Jersey

Published with the assistance of the Getty Grant Program

19,056

For my father

and

to the memory of my mother

Princeton Essays on the Arts

for a complete list of books in this series, see page 200

Contents

ILLUSTRATIONS

Preface

The fascination and demands of this project have kept the author in its orbit for more years than she is willing to admit. The many debts incurred in the process can easily be acknowledged, however. On the institutional level, I must thank my own university, Fordham, for twice granting me faculty fellowships along with several faculty research grants and for extending leaves of absence while I took advantage of financial assistance from outside foundations: two fellowships from the National Endowment for the Humanities and one from the Fulbright Program of the Council for International Exchange of Scholars. I am most grateful to these institutions as I am to the American Council of Learned Societies, the Ingram Merrill Foundation, and the Samuel H. Kress Foundation for their support.

My research has taken me to many libraries and archives both here and abroad. The New York Public Library, already a haven for me during my college years, became the home base for all my research as a scholar. The staff—in particular, of the Division of Art and Architecture, Prints and Photographs, and Rare Books and Manuscripts—has invariably put itself at my disposal. I have benefited from the collections of the library of the Institute of Fine Arts, the Metropolitan Museum of Art—whose Department of Prints and Photographs has also been important—the Frick Collection, and Columbia University's Avery Library. Special thanks are due to the staff of the Rare Books Room at the New York Academy of Medicine library, a setting that became indispensable for this work.

The Isenheim Altarpiece has received voluminous modern critical treatment, but it also quickly compelled me to step outside the realm of the literature on art and consequently had me moving in Europe between a specialized treasury like the Zentralinstitut für Kunstgeschichte in Munich and the vast resources of the Bibliothèque Nationale in Paris. Furthermore, as Alsace is a region traditionally committed to charting its own habits and history, studying one of its monuments meant being audience to a literature that was best absorbed on its native terrain. Thus memorable days were spent at Strasbourg's Bibliothèque Nationale et Universitaire and at Colmar's Bibliothèque de la Ville, whose director,

Francis Gueth, deserves my thanks. The Archives du Haut-Rhin in Colmar are rich in their holdings and meticulous in their arrangement, a reflection of the virtues of their director, Christian Wilsdorf, who was unfailingly helpful to me. And then there is the Musée d'Unterlinden itself. In the early days of my visits, its former curator, Pierre Schmitt, patiently indulged my questions; the late Charles Fellmann facilitated my access to Grünewald's great altarpiece and generously provided me with many of his own photographs of the monument. More recently, I have been fortunate in the colleagueship and camaraderie of the museum's energetic director, Christian Heck.

For their attentiveness to and encouragement of this work at its earliest stages, I am particularly grateful to Rosalind Krauss, as well as to Marilyn Lavin, Nan Rosenthal, and the late H. W. Janson. My colleague at Fordham, Elizabeth C. Parker, ably held the fort while I was off doing research and always lent an informed and sympathetic ear to its progress. James Ackerman and Sydney Freedberg, splendid teachers of Italian Renaissance art and culture, have been the most gracious advocates of the geographic and temporal changes of direction my work has taken, all the time holding the doors open for my reentries into the Italian fold. In the same breath, I must thank three excellent scholars of German art for welcoming me to new territories; they have proffered advice on specific points and displayed generous interest: Christiane Andersson, Alan Shestack, and Charles Talbot. These thanks I also extend to my fellow sojourner north and south of the Alps, Colin Eisler.

Over time, the opportunity to air different sections of this research in public, thanks to the kind invitation of colleagues, was extremely useful in advancing and sharpening my ideas. This included lectures at New York University's Institute of Fine Arts, Swarthmore College, Vassar College, University of British Columbia, University of California at Berkeley and Santa Cruz, Yale University, Columbia University, University of Chicago, the Detroit Institute of Arts, and the National Gallery of Art, Washington, D.C. In such a context, a well-timed query, perhaps long forgotten by the questioner, left me readier to pursue a particular detail or issue that I had theretofore treated only perfunctorily. I think especially of Natalie Zemon Davis, Amy Johnson, H. Marshall Leicester, Jr., J. Patrice Marandel, Nan Rosenthal, and Richard Saez.

In turn, a suggestion by Svetlana Alpers caused me to focus on reactions to Grünewald's altarpiece in modern times. A short segment of

Chapter IV, in which I began to evaluate this subject, was published as "Grünewald, The Isenheim Altarpiece, and the Politics of Culture," an offering in *Tribute to Lotte Brand Philip*, New York, 1985. Barbara Lane, as an editor of that volume, and for other constructive professional assistance and advice, has my appreciation. My friend Dr. Qais Al-Awqati, with his grasp of intellectual history and his place at the crossroads of the scientific and clinical enterprises, became an ideal sounding board and informant for my thoughts about the original medical aspects of the altarpiece in the first chapter, a previous version of which appeared in the *Art Bulletin* in December 1977.

Once the manuscript took shape, it was to benefit from critical readings by Constance Jordan and Linda Seidel. Amy Edith Johnson gave it the polish that only her editorial skills can effect. At the end, Doris Bergman assisted in correcting the proofs with her able scrutiny. In the interim, Mark Anderson gamely consented to survey the German citations and quotations, as did my colleagues Eva Stadler, for the French, and George Shea, for the Latin, thereby saving me from embarrassing errors of transcription. At the publisher's suggestion, I have presented foreign-language material in English, using existing translations when possible. Where not otherwise indicated, translations into English are mine. Comments by Paul Hirsch occasionally sharpened my German comprehension; Eva Stadler and George Shea provided fine points of French and Latin. The latter advised me especially in my translation of the passage from a Latin sermon of the period in the third chapter, for which expert guidance I also thank Fred J. Nichols; Frederick Goldin sagely improved upon my rendering of comparable sections of German sermons. For her advice in the case of Greek etymology, along with relevant references to thematic sources and bibliography concerning the ancient world, I want to thank Laura Slatkin. Beyond acknowledging such products of a vast storehouse of erudition, I owe to her the necessary encouragement to proceed with the final phases of completing this manuscript. Her responsiveness to the ideas, her infallible judgment in matters of structure, style, and sequence of expository language, her understanding and affection, alone made that possible.

The last tribute is reserved for Grünewald's altarpiece. As artists and writers before me have attested, this monument, once noticed, becomes an active presence in one's life. The attraction began for me as an act of liberation—after dutiful completion of a suitable dissertation. A new and formidable companion, the Isenheim Altarpiece has seen me

through professional maturation, always instigating, challenging, and responding to my evolving intellectual, aesthetic, and historical interests. It was also a touchstone in times of dramatic social and political change. But more sharply etched reminders of my journey are the personal markers of changing and sustained relations: friendships, loves, inevitable losses. All of these are encoded here.

THE
ISENHEIM
ALTARPIECE

INTRODUCTION

"As for the altarpiece, it seems necessary to put it back as an ensemble, for this alone conveys its full beauty; otherwise one would be transmitting to posterity mere fragments which, taken and considered in isolation, serve no purpose and lend themselves to nothing other than the history of a mutilated work."[1]

In 1794, having escaped destruction and removal during the iconoclastic controversy of the Reformation, the Isenheim Altarpiece was put in storage in the Colmar library to save it from the ravages of vandalism that were a by-product of the French Revolution. At that time the official commissaries, whose task was to report on works of art in the region of Alsace, appealed for continued access to this altarpiece, emphasizing their admiration of it and especially urging eventual restoration to its original framework and placement. Their words still resonate for us and illuminate the course of the present study. Since the middle of the nineteenth century, when it was first installed in the Musée d'Unterlinden in Colmar, the Isenheim Altarpiece has been exhibited in a dismantled state.[2] To be sure, the modern mode of installation, together with the gradual perfecting of techniques of photographic reproduction, has allowed us to study the panels with unprecedented ease and intensity, but these very tools of our research have militated against a perception of the work as a functioning totality within a living context. The organic existence of the altarpiece, as the commissaries suggested, has been forever ruptured.

Recovering the altarpiece, reconstructing it imaginatively, returning it to its original context, has necessarily meant integrating a number of ways of seeing. One of these explores the possibility of hierarchies of significance inscribed onto the layout of the single pictorial field. At the same time, guided by an awareness of the original arrangement of the Isenheim panels, which we know from a firsthand description of the altarpiece while it was still in situ, I have proposed in earlier studies that any coherent interpretation must go beyond the subject matter of the separate sections of the altarpiece (Figs. 1–4), that is, must consider it

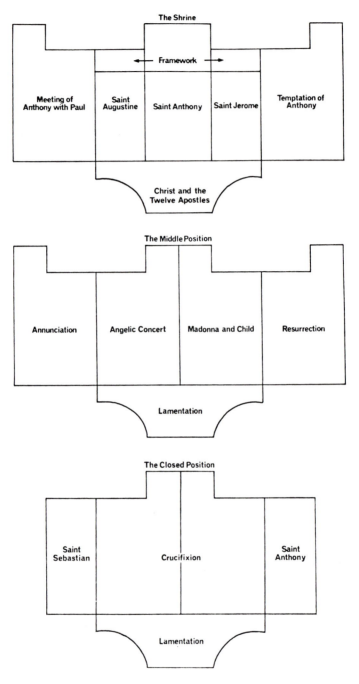

FIGURE I. Diagram of the three levels of the altarpiece.

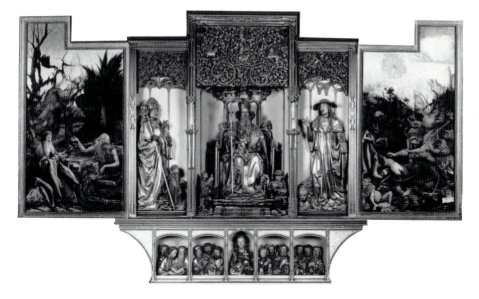

FIGURE 2. Grünewald, Isenheim Altarpiece, open state.

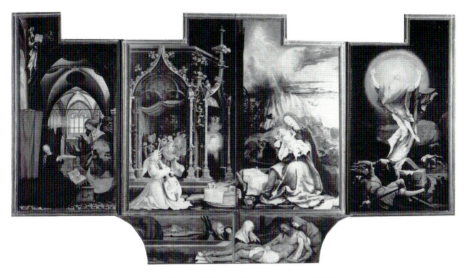

FIGURE 3. Grünewald, Isenheim Altarpiece, middle state.

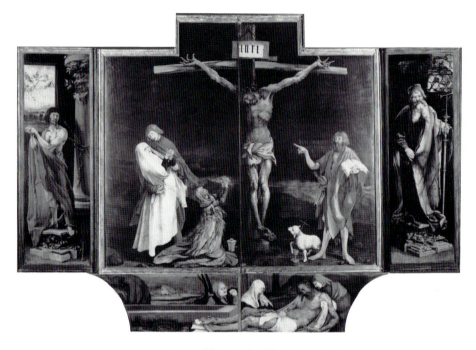

FIGURE 4. Grünewald, Isenheim Altarpiece, closed state.

as a structural unity.[3] In this case, it is crucial to determine a composite viewing of its successive openings. As an analogy, we may use the fusing of sequential images and their unfolding during and through the passage of time distinctive to the medium of film to evoke characteristics not ordinarily associated with our experience of painting; but the capacity for gradual revelation through time is surely appropriate to such a monument of alternating faces, as well as to its place in the temporal context of church ceremony and the liturgical calendar.

To look at the Isenheim Altarpiece as a separate and distinct phenomenon, in terms of the particular needs and circumstances that gave rise to its creation, rather than from the privileged modern viewpoint of the evolution of the artist's work, has seemed to me the most direct and fruitful way of approaching this complex polyptych.[4] The first chapter of the present work, therefore, examines the monastic context of the altarpiece.

Such studies, however, may easily reach an impasse in their tendency

toward causal explanation: toward the consideration of the work of art as the end point in a one-way vector of explication from context and patronage to object. Beyond questions of patronage, context, or function, the altarpiece as a type of monument became, for me, a revelatory model for the study of art as a culturally integrated system of communication, requiring, along with direct visual analysis, interdependent investigations of such issues as architectural setting, patronage, role within a prescribed ritual practice, and reception by a specific audience.

Certain changes of orientation within art history, as well as in neighboring fields, have provided needed openings for more supple and dynamic constellations of concern. As research for the present work was taking shape, for example, Michael Baxandall's *Painting and Experience in Fifteenth Century Italy* was published—a book that treats the early Renaissance picture as part of a process of exchange between artist and patron.[5] More closely related to anthropology than to traditional history of art, and often challenging conventions about what constitutes evidence relevant to art, this study envisages artistic form as a repository of perceptual customs and experiences shared by artist and viewer.

Baxandall's book appeared in the early 1970s, at the same time that Michel Foucault's writings were reaching a wider audience in America. Foucault's cultural histories of illness in general and madness in particular present the institutions devised for treating the sick and the insane—the hospital or asylum—not as static, tangible structures but as projections of shifting perceptions about what it means to be human or to deviate from health.[6]

These essays share the present study's concern with aspects of culture inherent in mental attitudes, involving in this case an inquiry into the fact that the monastic complex at Isenheim was a hospital order. If the extraordinary quality and content of the imagery in the Isenheim Altarpiece prompt one beyond a set of academic considerations about patronage and function, it is a tragic irony that, as this book is being readied for publication, an international epidemic of the fatal syndrome known as AIDS serves to heighten our identification with the needs that determined the role of the altarpiece, according to my portrayal, in the hospital context.

The Western world takes for granted its Judeo-Christian heritage. Even as some facet of religious dogma or ceremony may still become a rallying point for debate within a small segment of believers, established religion has lost its place as a dynamic and broadly based tradition, and

liturgical practice has been tamed and even trivialized. The acquisition and exhibition of religious art by museums and private collectors serve as an index of the altered potency of these objects in the contemporary world, analogous to the change in status that the zoo as an institution imposes on natural creatures. To be sure, studies over the last generation that have emphasized the liturgical context of Western religious art were certainly stimulated, in part, by an impulse to recapture those times and places where such artifacts were functionally integrated into the fabric of society as viable manifestations of a system of belief.[7] Not surprisingly, however, thoroughgoing attempts to characterize the phenomenology of worship and the space of sacred ritual have more often addressed "primitive," ancient, or non-Western cultures.[8]

Thus, in Chapters II and III, where I explore the altarpiece's message within the sacramental economy, it is the anthropologist's perspective that I have tried to reestablish, so that the mingling of dogma and ritual at the nexus of the altarpiece may again claim the mythic dimension that was its original portion. When we turn to social practice, however, it is fruitful, as social historians have shown us, to chart movement and behavior within the formal spaces determined by rituals—processions, festivals, and even games—in order to propose an open, loosely woven structure of reciprocity between representation and context—an active field, in other words, in which to place a devotional object like an altarpiece.[9]

Given the historical position of the Isenheim Altarpiece at the threshold of the Reformation, the mounting threat to the status of the sacraments was a reality that had to be countered. We shall see how these issues could have guided Grünewald in his very articulation of form with paint and in the way his altarpiece appealed to the sensorium of the original audience. Importantly, moreover, his period witnessed a shift to the printed transmission of knowledge. I have attempted to deal with the goals of painting, as I see them in the Isenheim Altarpiece, from the point of view of this crucial cultural change. Here art-historical scholarship by and large remains silent.[10] The evolving conditions of written in relation to oral communication, set forth in the work of Walter J. Ong, S.J., have provided an instructive analogue for my consideration of the modes of address deployed by a work like the Isenheim Altarpiece.[11]

The altarpiece as a medium of communication, the levels of address to its audience, the nature of its reception: these are *leitmotivs* of my

investigation. They are brought to bear in a later phase of the history of the Isenheim Altarpiece in Chapter IV, where I deal with the afterlife of this monument in modern times. The current critical tendency, especially in literary studies, to view the texture and shape of a work of art as structured by its readers or perceivers would seem to coincide with this emphasis on the modern response to the altarpiece.[12] But here methodology is a special function of the work's own identity, as well as of a changing awareness in the present-day historian. The latter increasingly expresses suspicion of the narrator gazing at the past across a seemingly transparent field, an unimpeded vista through time, the fantasy provided by the archaeologist's handling of an ancient shard. As for Grünewald's altarpiece, modern reception is a concern dictated by its particular history, for Grünewald and the Isenheim Altarpiece were effectively lost to us until the mid-nineteenth century.

As early as 1675, Joachim von Sandrart, in his *German Academy of the Arts of Architecture, Sculpture, and Painting*, addressed himself to this predicament:

> It is regrettable that the works of this outstanding man have fallen into oblivion to such a degree that I do not know a single living person who could offer any information whatever, be it written or oral, about the activities of the master. I shall, therefore, compile with special care everything that I know about him, in order that his worth may be brought to light. Otherwise, I believe his memory might be lost completely a few years hence.[13]

For all his good intentions, von Sandrart compounded the problem by misnaming the artist Grünewald—a misnomer so favored that I will perpetuate it here for convenience' sake. Knowledge of Grünewald's life and career, compared with that of his compatriot and contemporary Albrecht Dürer, and in contrast to that of his many Italian counterparts, remains notoriously imprecise. Only at the beginning of our own century did archival evidence bring to light his real name: Mathis Gothart Nithart.[14] Nithart, we learn, was most likely born in Würzburg, probably about 1475 or 1480, and died in Halle in 1528, which makes him roughly contemporary with Raphael; Nithart's death occurred in the same year as that of Albrecht Dürer.[15] Further documents relating to his life and career are few and far between.[16] He worked for the Archbishop Uriel von Gemmingen and for Cardinal Albrecht von Brandenburg. He shared a patron with Dürer in Jacob Heller. We are acquainted with this

artist primarily as a painter, but he functioned as supervising designer and engineer for the rebuilding of the Aschaffenburg Palace. Other documents mention his being consulted as a waterworks expert. He was apparently involved in the manufacture of paints, later of soap—a career thus bearing some comparison to Leonardo's in its diversity, its combination of art and engineering or technology; in a relatively small painterly output; and even in the ill-fated history of some of the works.[17]

The fame of this Mathis Gothart Nithart, or rather of a creative spirit "Grünewald," in fact depends almost exclusively on modern response to the most important work associated with his career: the tremendous polyptych from the Antonite monastery at Isenheim in Alsace. Once this monument was put on public view, just after the middle of the nineteenth century, scholarly interest slowly began to focus on it. The nascent discipline of art history would play its role in the general celebration of Renaissance artists and, for Grünewald, in giving coherence to our minimal information about him and his works. It was less the achievements of scholarship, however, than the exceptional preoccupation with this monument on the part of painters, writers, and composers of the modern period that was to guarantee it an afterlife of mythic grandeur. As we shall see in Chapter IV, artists and thinkers such as Joris-Karl Huysmans, Max Beckmann, Walter Benjamin, Pablo Picasso, and Paul Hindemith, to name just a few, provided testimony—sometimes over the course of an entire lifetime, and even, frequently, through artistic re-creation—to its inspiring effect on them.

This phase of the history of the altarpiece, graced as it was by an emerging cultural sensibility increasingly prepared to respond to its extraordinary imagery and embellished by the attention of the growing academic discipline of art history, also reinforced certain barriers to our understanding. Grünewald was rescued from oblivion, and a place was created for him in the aesthetic canon; but the fantasy of a monolithic "Grünewald" has often overshadowed any comprehensive consideration of his individual works. The critical tendency to view sixteenth-century painting as a history of its individual artists and to envision a painter's career by molding a developmental trajectory to structure his artistic output has sometimes obscured the dramatic sense in which works like the Isenheim Altarpiece stand apart in terms of sheer quality and complexity. Without it, Grünewald would be considered an interesting but secondary master, but this was a fact that the living artists who played such an important part in creating his fame in modern times were com-

pelled to overlook. Their responsiveness to so obvious a masterpiece as the Isenheim Altarpiece was necessarily bound up with the search for an author with whom they could identify their own creative problems and pursuits.

In my own examination of the Isenheim Altarpiece, Grünewald is admittedly somewhat submerged. I give simultaneous attention to the tradition of this type of monument and to the various cultural and religious conditions of its genesis. Furthermore, this orientation toward authorship, which may be seen to dovetail with elements of contemporary critical practice that give priority to the inherited discourse within an artistic genre or the successive interpretations of a given text, is, in the case of the Isenheim Altarpiece, historically motivated.[18]

For one thing, while von Sandrart did succeed in forging a link between the artist he named "Grünewald" and the Isenheim Altarpiece, that association remained fragile throughout most of its history. For example, after seeing the altarpiece in situ, Rudolf II was so taken with the monument that he attempted to purchase it for his collection. In his letter of inquiry of 1597, however, not once does an artist's name appear.[19] The character of not quite belonging to, or even transcending, an individual artist's oeuvre, combined with the status of masterpiece early achieved by the Isenheim Altarpiece, paradoxically makes the seventeenth-century misattribution to Dürer understandable.[20] Its manifestly superb quality prevented attribution to any but the most renowned master.

Moreover, the process of explicating a work like the Isenheim Altarpiece, whose stature is certain but concerning which there are tremendous gaps in our information, teaches a salutary lesson in historical clarification. Who actually was Grünewald? Or, rather, Mathis Gothart Nithart? Where did he learn his craft? How did he work? Where did he travel? Why did he receive the commission from the monks at Isenheim? How do we reconcile the level of achievement in the Isenheim Altarpiece with Grünewald's other works? These basic questions inform my research in the face of the other continuing reality, which prevails despite its fragmentary state, namely, the altarpiece's unforgettable appeal and the intense reaction it has managed to arouse in the most diverse viewers.[21] To assess that reaction is also my aim.

If the film medium can yield insights into the process of viewing the Isenheim Altarpiece, it can also lend support to current attitudes and goals of the historian. I refer to the way in which the naive confidence

in film's capacity for realistic portrayal has been called into question by certain contemporary filmmakers in the service of revealing both the opacities and ambiguities of history and historical data and the frequent discontinuities between knowledge and experience. One thinks, for example, of Jean-Marie Straub's *Chronicle of Anna Magdalena Bach*, wherein a narrator, assuming the role of Bach's second wife, relates events from the composer's life and career.[22] Shots of period costumes and sets are interspersed with documents in the form of music sheets, scores, announcements, and letters presented in close-up, full-screen view. At the same time, Bach's music, buoyant through the effect of amplification on the sound track, achieves independent life as it transcends the calculatedly spare and static images. Where one might, in print, have taken for granted the power of biographic document to explain artistic output, the simultaneous channels of address possible in film leave the viewer struggling to find some organic connection between the scrupulously conveyed documentary evidence and the experience of the music itself.

With the visual arts there is an analogous double course. The objects that come down through time confront us with compelling force, then follow academic procedures of research, and sometimes tired habits of inquiry and conventions of proof. The Isenheim Altarpiece especially resists the scholar's tendency to peg knowledge to experience or to amass factual detail that overwhelms experience altogether. This book is dedicated to what I see as the invaluable proposition of meticulously tracking our responses to this extraordinary altarpiece—a work that speaks frankly from and of its historical place as it continues to touch our present condition. It will be not only the object but also the guide in these scholarly investigations. Then we will travel like the helmsman who, while holding in sight a destination, responds and yields at every turn to nature's changing cues.

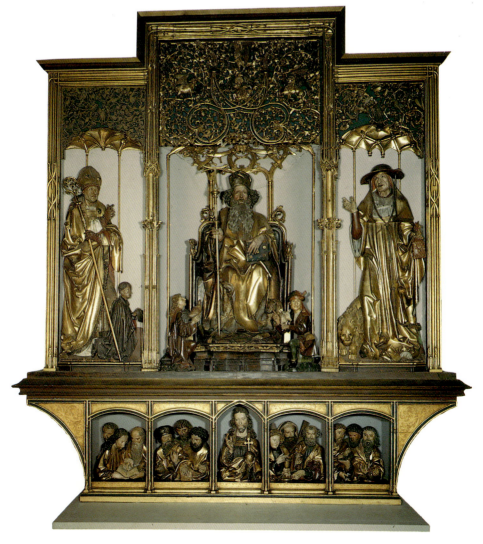

PLATE I.
Nikolaus Hagenauer, Isenheim Altarpiece, Carved Shrine.

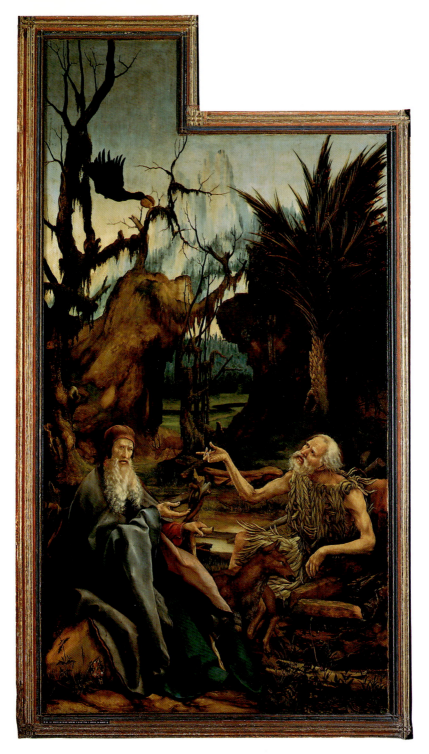

PLATE 2.
Matthias Grünewald, Isenheim Altarpiece, *Meeting of Saints Anthony and Paul*.

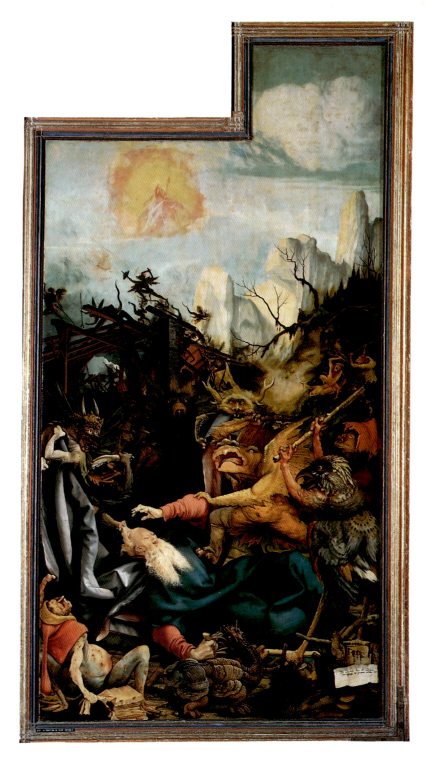

PLATE 3.
Grünewald, Isenheim Altarpiece, *Temptation of Saint Anthony.*

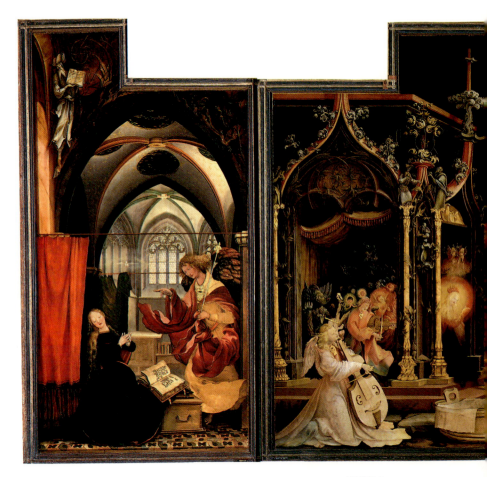

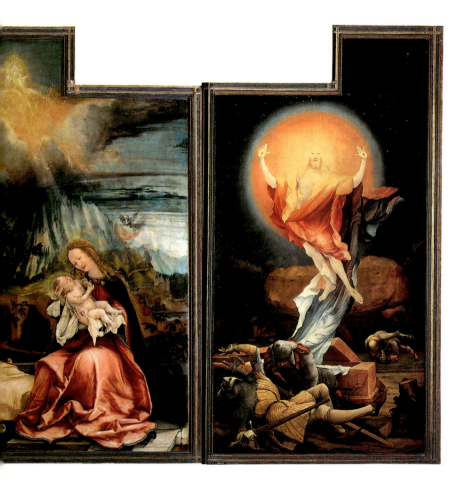

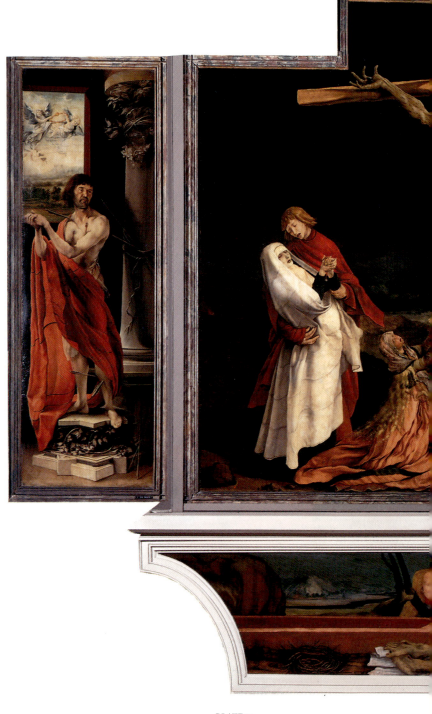

PLATE 7.
Grünewald, Isenheim Altarpiece, closed state, *Crucifixion, Lamentation, Saints Sebastian and Anthony.*

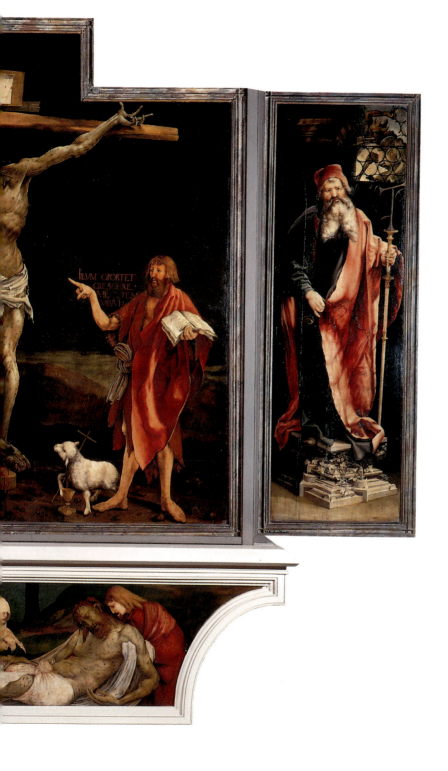

ILLVM OPORTET
CRESCERE
ME AVTEM
MINVI

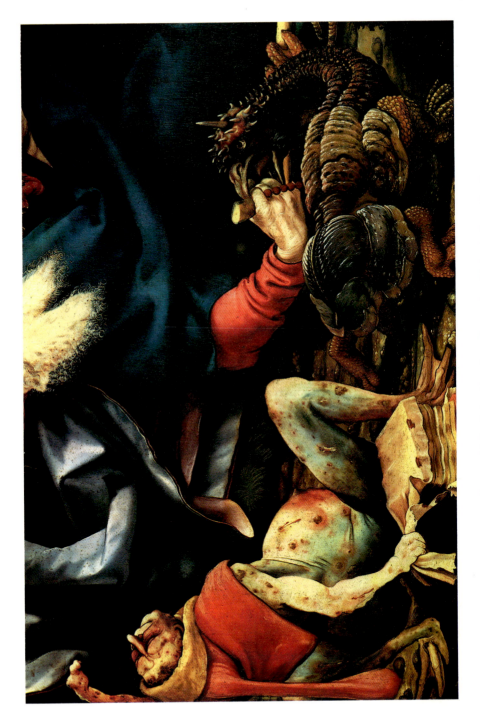

I

MEANING AND FUNCTION:
THE HOSPITAL CONTEXT

The contemporary viewer of art is in many ways a sophisticated crea-
ture. Museum exhibition, textbook presentation, and modern
means of communication have brought the art of far-ranging times and
places into the orbit of the familiar. These same phenomena, as well as
the proliferating of reproductions of works of art, have transmitted the
patterns, distinctions, and evolution of artistic styles—lessons that, in
the not so distant past, were the privileged lifetime's experience of few.
Even a hierarchy of values, formerly the subject of rarefied philosophical
debate, is implied by exhibition and publication practices, and concre-
tized for the public in the well-advertised transactions of that network
of collectors, galleries, and auction houses that structure the burgeoning
market for art.

Still, as though in resistance to such artificial, if intensive, exposure,
mystery and mystique surround many of the monuments of art history,
with the result that this same public may frequently be shocked by the
vicissitudes in the world of art or by the working methods of artists in
the premodern period. How to comprehend a Vasari, for instance, who
secured the renown of Masaccio's fresco of *The Trinity* in Santa Maria
Novella, Florence, by celebrating it in his *Lives of the Artists*, only to hide
it from future generations when, as a painter, he fulfilled a commission
for an altarpiece that stood in front of this very fresco?

Less shocking but equally unexpected is the realization that some of
the acknowledged masterpieces of Renaissance art—Michelangelo's Sis-
tine Ceiling among them—were not self-sufficient works but were de-
signed to complement or merely complete a preexisting decorative proj-
ect. Thus, at Isenheim, Grünewald's panels were made both to cover and
reveal an already existing sculptured shrine. Its tripartite framing struc-
ture encloses a majestic, enthroned, central figure of Saint Anthony Ab-
bot, patron of the monastery, flanked by Saints Augustine and Jerome
(Pl. 1). These large gilded and polychromed statues were elevated from

FIGURE 5(a). Official seal of order (photo from *Société scientifique du Dauphiné*, 9, 1879).

the altar by a supporting base, or predella, that contains half-length figures of Christ surrounded by his disciples. Thus we must, first of all, pause and contemplate the significance of the shrine.

This carved wooden complex takes us back to the early era of the shaping of Christianity as an official system of belief, with its apostolic origins in the *disputà*-like predella, its theological elaboration in the standing church fathers, Augustine and Jerome, and its central place of honor devoted to Saint Anthony—that much sought-after reflection of the divine spirit on earth and exemplary holy man of late antiquity. It is he who exemplifies the charisma and Christ-like powers, first recorded by the Greek bishop Athanasius in his account of the life of this saint, with its emphasis on discipline and renunciation, struggles against evil and temptation, and miraculous acts of curing and revivification.[1] Anthony's choice of a life of contemplation and prayer in the desert wilderness and his influence on growing communities of hermits are also pertinent to our subject; these had long established him as founder of the institution of monasticism.

In 1095 an order was dedicated especially to his patronage at Saint-Antoine-en-Viennois, near Lyons, and devotion to this saint had inten-

sified when his remains were transferred from Constantinople to Saint-Didier-la-Mothe in the Dauphiné by about 1070.[2] The monastery at Isenheim was founded shortly after the order adopted the law of Saint Augustine in the late thirteenth century, thus accounting for the statue of this church father in episcopal garb.[3] Official seals of the order set out the juridical format for the enthroned Anthony at Isenheim with staff and book in hand (Fig. 5a).[4] Together with the small statues that have recently come to light from the sculptured shrine at Isenheim—kneeling pilgrims, a peasant and a burgher offering livestock, who were originally placed on either side of the saint (Fig. 5b)—this configuration confirms the feudal hierarchy at the summit of which the holy Anthony found himself by the late Middle Ages after his order had spread throughout Western Europe and had benefited from privileges bestowed by successive popes (Pl. 1).[5]

The altarpiece had been commissioned by Johan d'Orliaco, preceptor

FIGURE 5(b). Detail of statuettes, carved shrine, Isenheim Altarpiece.

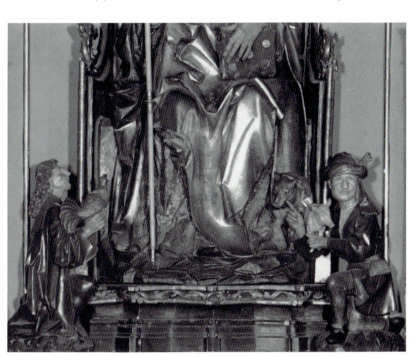

at Isenheim from 1460 to 1490, who appears as the small kneeling figure at the feet of Saint Augustine. Part of a more general project of renovation in the church, the altarpiece was left unfinished for reasons we do not know, and the subsequent preceptor of the monastery, Guido Guersi, arranged for Grünewald to complete this work.[6] An eighteenth-century description of the altarpiece informs us of its original appearance.[7]

To the wooden shrine Grünewald added painted panels of the *Meeting of Saints Anthony and Paul* at the left and a *Temptation of Saint Anthony* at the right (Fig. 2, Pls. 2 and 3). Saint Jerome, who appears next to Anthony in the wooden shrine, is the source for the story represented in the wing at the left: Anthony's journey to visit the one man who was reportedly even older and holier than he, the Hermit Paul.[8] In the wing at the right, Anthony is beset by demonic forces in his struggle against temptation. These wings closed directly over the shrine, revealing painted panels of the *Madonna and Child and Incarnation Tabernacle* in the central section and a new set of wings showing an *Annunciation* at the left, a *Resurrection* at the right, with a *Lamentation* by Grünewald now covering the sculptured predella (Fig. 3, Pls. 4, 5, and 6). The outer wings of the *Annunciation* and the *Resurrection* folded on top of the central section once again, this time resulting in the closed state of the altarpiece, with its famous *Crucifixion* in the center (Fig. 4, Pl. 7). The *Lamentation* remains as the base panel, and two narrow wings, originally permanently secured, of Saints Sebastian and Anthony flank the *Crucifixion*.

With the painted panels commissioned by Guersi between 1508 and 1516, the altarpiece originally stood on the main altar of the monastery church, and we might first of all locate its function within the general liturgy. Indeed, the procedure for disclosing the panels was undoubtedly based on such a deeply ingrained sense of the recurring rhythms of the liturgical seasons and their punctuation by the feast days in a calendar year that the absence of precise documentation in this regard is not surprising. On the other hand, though a vast literature now exists on Grünewald and the Isenheim Altarpiece, the few known features about this masterpiece have not received the kind of attention that could yield both a plausible and a synthetic history. Thus I will persist in the reexamination of what is known by taking full account of the fact that the Antonite community that commissioned this work was part of a hospital order devoted to the care of the sick.

This role for the Antonite Order has frequently been mentioned in the literature, but its bearing on the meaning and purpose of the Isenheim Altarpiece has tended to be viewed and analyzed mainly in terms of isolatable details. I should like to propose instead that by the time Grünewald's panels were added, the hospital context had become a powerful motivating force in the commission, that it provided a principal component in the iconographic fabric of the work, and that it shaped a crucial aspect of the altarpiece's overall function.[9]

To pursue this line of interpretation, it is necessary to make the most of the internal evidence offered by the work itself, where the full implications of certain motifs and figures and their handling by Grünewald need to be explored. Secondly, my approach has been guided by circumstances surrounding similar commissions, by information on the Antonite Order, and by research into contemporary attitudes toward illness and its treatment. Here, Roger van der Weyden's altarpiece at Beaune, the *Last Judgment*, is important (Fig. 8a). Extensive documents exist for this commission, its original context is clear, and the Hôtel-Dieu at Beaune was also originally dedicated to Saint Anthony.[10] Although we know little about the monastery at Isenheim, there is a considerable amount of information on the mother house of the Antonites at Saint-Antoine-en-Viennois.[11] In addition, I have made use of two sources well known to historians of the Antonite Order but not usually tapped by art historians—statutes of reform of the order dating to 1478, little more than a generation earlier than the Isenheim Altarpiece, and a history of the Antonites by Aymar Falco, written in 1534, less than a generation after the Isenheim commission.[12] Finally, we must recall that at this very period the impulse to describe known diseases and their treatments was finding a wider outlet through the advent of printing, making these and related texts accessible to us.

Three specific details have been observed in the Isenheim Altarpiece that link it to the hospital context. One concerns the closed state (Pl. 7), whose wings represent Saints Sebastian and Anthony. Sebastian had long been invested with the power to protect against the plague (Fig. 6).[13] Outbreaks of this scourge within living memory had turned him into a popular cult figure in the region of Alsace.[14] A prayer to Saint Sebastian formulated in 1516—"Let us be released from this epidemic's pestilence and from every tribulation of the flesh and the spirit!"—further reveals that this saint came to be associated with the repelling and warding off of general bodily harm and of sudden, devastating, and ep-

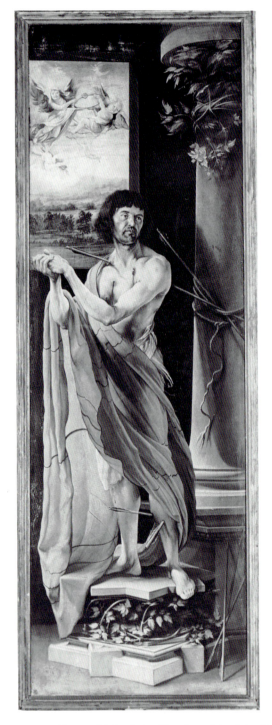

FIGURE 6. Grünewald, Isenheim Altarpiece, Saint Sebastian.

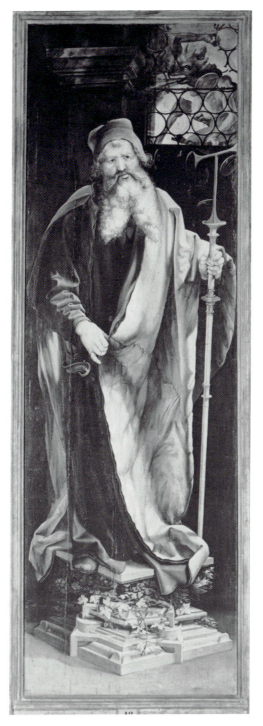

FIGURE 7. Grünewald, Isenheim Altarpiece, Saint Anthony.

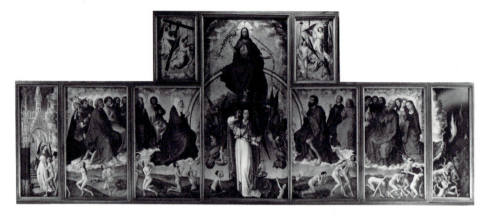

FIGURE 8(a). Roger van der Weyden, *Last Judgment* Altarpiece, interior, 1445–1448.

idemic disease in the broad sense.[15] As for Anthony Abbot (Fig. 7), Aymar Falco declared the primary goal of the monastery to be the care of those afflicted with a disease perceived to be like a plague—*ignis plaga, pestilentia ignis*—which often went under the name of this patron: Saint Anthony's Fire, *Feu d'Antoine, Antonius Feuer.*[16] Moreover, inspired by the saint's acts of healing recorded in Athanasius's biography, and specific to the circumstances of the founding of the Antonite order, curative powers came to be identified with Anthony.[17] Sebastian and Anthony are paired in other key examples, such as Roger van der Weyden's Beaune altarpiece, on whose exterior they appear in grisaille (Fig. 8b).[18] Together they establish the themes of dire illness and miraculous healing as central to the meaning of the altarpiece at Isenheim.

In its open state (Fig. 2), two features of the altarpiece have been the focus of scrutiny. One is the haunting figure in the foreground of the *Temptation of Saint Anthony* (Pl. 8). His distended stomach, inflamed boils, and withered arm all seem based on direct observation—so much so that the figure's webbed feet, which suggest the fantastic, did not stop a lively written controversy at the turn of our century over what disease Grünewald meant to depict. Diagnoses formulated by several physicians, including Freud's teacher, the neurologist J. M. Charcot, ranged from leprosy to syphilis.[19] The Antonite reforms of 1478 in fact contain their own diagnostic stipulation: "The next day they [the patients] must be led before the chapel of said hospital and they must be examined to

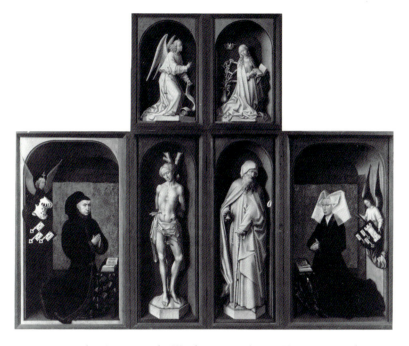

FIGURE 8(b). Roger van der Weyden, *Last Judgment* Altarpiece, exterior.

find out if the disease is the *infernal fire*."²⁰ Only in 1597 was this disease discovered to be alimentary in origin and its cause isolated as ergot, or poisoned rye.²¹ During Grünewald's time the cause was unknown, but its terrible effects could not escape notice, and its various symptoms elicited frequent depiction and description. Popular representations around the time of the Isenheim Altarpiece often show its victims with a crutch under one arm, the other arm actually in flames (Fig. 9). Centuries earlier Sigebert de Gembloux had reported on these victims: "The intestines eaten up by the force of Saint Anthony's Fire, with ravaged limbs, blackened like charcoal; either they die miserably, or they live more miserably seeing their feet and hands develop gangrene and separate from the rest of the body; and they suffer muscular spasms that deform them."²² Given the professed goals of the monastery, we can assume that the artist meant to suggest the symptoms of Saint Anthony's Fire.²³ Still, one diagnosing physician in the early twentieth century, less driven than his colleagues by the impulse toward precise classification, and recog-

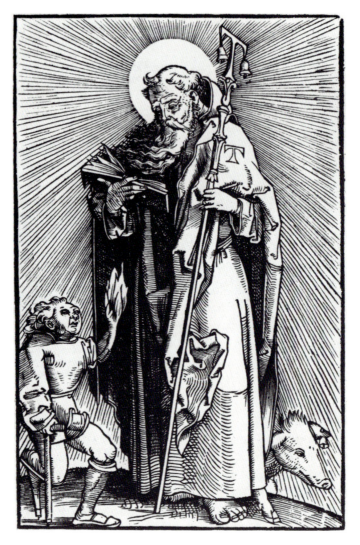

FIGURE 9. *Saint Anthony*, woodcut from Hans Von Gersdorff, *Feldtbuch der Wundtartzney*, Strassburg, 1517.

nizing need as a monastery hospital's overall criterion for admission, wisely assesses the compelling condition Grünewald created in his diseased demon as a "synthèse pathologique."[24]

On the other side of the wooden shrine, in the foreground of the *Meeting of Saints Anthony and Paul*, small bunches of plants and herbs appear, whose exactitude of representation also elicited identification

FIGURE 10. Grünewald, *Meeting of Saints Anthony and Paul* (detail).

(Figs. 10 and 11). Wolfgang Kühn and Lottlisa Behling have published studies that identify these plants by comparing them to the illustrations in fifteenth- and sixteenth-century herbals, such as Hieronymus Bock's *Kräuterbuch* or the *Herbarum Vivae Eicones* by Otto Brunfels.[25] These handbooks, matching illustration with written explanation and especially suited to the transformation from manuscript to printed transmission of knowledge, codified the age-old, empirical tradition of utilizing plants, herbs, and flowers—administered both internally and externally—for medicinal purposes.[26] In the case of Saint Anthony's Fire, certain plants, flowers, and herbs thought to be cold and dry (verbena, sage, plantain, and poppy, among others) were recommended: an allopathic treatment to counter the burning heat that characterized the disease.[27] Grünewald also demonstrates his facility for such precise description of healing plants in the panels for the Heller Altarpiece, now in Karlsruhe, where he renders them in delicate grisaille (Fig. 12). In the Isenheim Altarpiece, they are compositional counterparts of the diseased figure in the *Temptation* panel at the right. Several grow in the vicinity of the small plaque bearing Guido Guersi's coat of arms, below

the seated Anthony (Fig. 11). Guersi, who as preceptor of the monastery at Isenheim commissioned this work, identifies himself with Anthony, patron and healer.

The middle stage of the altarpiece, consisting of a *Madonna and Child and Incarnation Tabernacle*, had, apart from my prior investigation, suggested no systematic association with the hospital context (Fig. 3). But given the healing saints in the closed state and the diseased figure and medicinal plants in the open position, we are led to a hypothesis that appears occasionally in the literature, which sometimes seems to be taken for granted but for which there is no strict documentary basis, namely, that the Isenheim Altarpiece functioned as part of the healing program at the monastery hospital.[28] It is helpful to consider some cultural factors of the time that make such a hypothesis viable.

Anyone who stands in awe before the technology of life-support systems in a major hospital has been witness to the way in which, even in the face of impending death, present-day medical attitudes and treatments are primarily geared toward the preservation of life. The development, in the latter half of the nineteenth century, of the germ theory of disease transmission, and, from it, the discovery of means for halting

FIGURE 11. Grünewald, *Meeting of Saints Anthony and Paul* (detail).

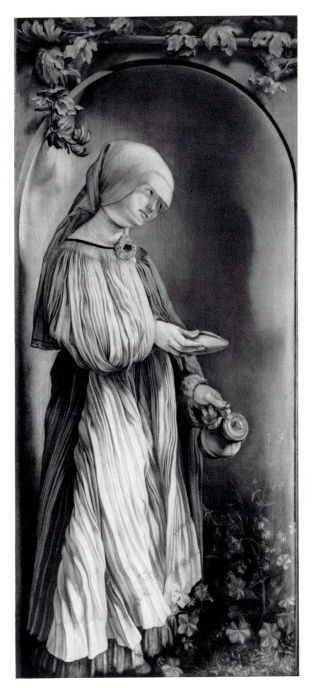

FIGURE 12. Grünewald, *Saint Elizabeth*.

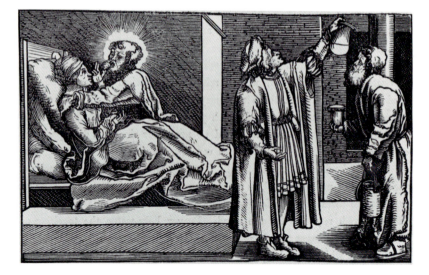

FIGURE 13. Woodcut from Boethius, *De Consolatione Philosophiae*, Augsburg, 1537.

lethal infection through antisepsis and the use of antibiotics, played the leading role in severing what had been an inevitable link between disease and death. So greatly did this change affect our perception of disease that the continuing and still considerable lack of success in the struggle with a disease like cancer has not inhibited our aggressive approach to the possibility of cure.

Only lately has the retrovirus HIV come to the fore, which brings us closer to the world encompassed by the Isenheim Altarpiece, a world that as little as a decade ago I had still characterized in terms of the sharpest contrast to modern times, when I wrote that diseases then could quickly take on epidemic proportions, their etiologies be largely unknown, and acute illness be accompanied by inevitable deterioration, along with imminent threat of death.[29] Hence the practice of medicine was basically defensive. For instance, in his *Feldtbuch der Wundtartzney*, a text published in nearby Strasbourg in 1517, Hans von Gersdorff prescribes ways of alleviating illness rather than restoring health. His methods include a gamut of soothing efforts, compresses, poultices, potions, and the like and procedures for eliminating symptoms, ranging from bloodletting to amputation. Accounts of miraculous cure and hortatory themes of revelation and transcendence are found alongside evidence of

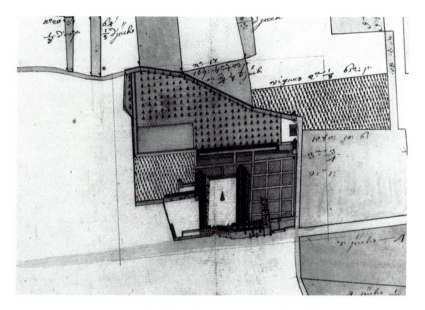

FIGURE 14. Plan, Isenheim monastery complex, Colmar.

tangible medical skills. A print illustrating a German edition of Boethius illustrates these two healing methods in one frame (Fig. 13). On the right, the physician examines a urine specimen, then as now a standard means of diagnosis. At the other side of the room, a healing saint exercises his powers over the bedridden woman. In the monastery hospital, whose purpose was to provide shelter for the poor and the infirm, the connecting church also introduced important prescriptions and avenues of relief.

A schematic view of Isenheim (Fig. 14) reveals the large scale and strategic placement of the church, with its left nave wall skirting the main road, which cuts through the town on its way to the somber Vosges Mountains immediately west of the monastery. Precisely such a binding relationship between the monastery hospital and the church is formulated at the outset in the founding prescriptions of Beaune's Hôtel-Dieu, where Nicolas Rolin proclaimed, "I herewith found and irrevocably endow, in the city of Beaune, a hospital, for poor sick people, with a chapel in the Lord's honor."[30] For both the patients and physicians in such a hospital the structure of each day would have been provided by the church, by the sound of its bells, and by the organized sequence of

27

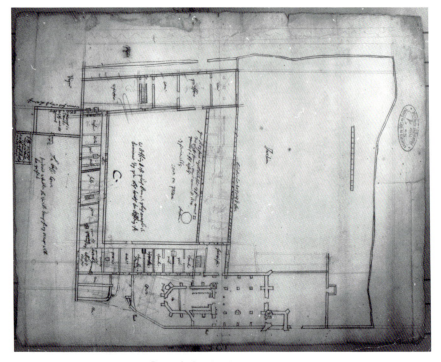

FIGURE 15. Ground plan, Isenheim monastery complex.

prayers and devotion. The reforms of the Antonite order of 1478 advocate prayer and entry into the church as a steady routine for patients: "May each patient be required for every canonical hour to say twelve Our Fathers and as many Ave Marias, and in the church if it is possible."[31] The actual assembling of patients before the holy objects of a monastery is called for in these reforms, demanding that new patients eventually be led "before the brothers for the holy wine and before the relics as is the custom."[32] In the Beaune documents Rolin calls for thirty beds to be erected in a hall continuous with the chapel, so that Roger van der Weyden's triptych could be viewed even by those too infirm to approach the altar.[33] At Isenheim the altarpiece was housed in the choir of the church (Fig. 15), but we should keep in mind that the tremendous scale of the altarpiece would have made it visible from points outside the choir.[34] Furthermore, the patients were very special laymen. This is confirmed by the reforms of 1478 that stipulate their duties and rights. They probably entered the choir at specified times during the year. One

such occasion might have been when they took communion—a require-
ment on six feast days throughout the year, according to the reforms.[35]
An examination of the imagery in the altarpiece further helps us to un-
derstand it as an active primer on the possible goals of life under the
pressure of death.

Pain is essentially a private experience that isolates its victim from his
surroundings. In the open state of the Isenheim Altarpiece (Fig. 2),
Grünewald urges the viewer's confrontation with this immediate reality,
and he presents a circumscribed possibility for its alleviation. It should
be noticed, for example, that the graphic representation of the diseased
state in the form of a demon (Pl. 8) appears along the bottom frame,
which would have been at the viewer's eye level as he approached the
altar (Fig. 16). Through this figure, the most human-looking of the de-
mons, Grünewald engages the viewer's sense of identification and pro-
vokes mixed emotions of fear and pity.[36] This monster is both gruesome

FIGURE 16. Grünewald, *Temptation of Saint Anthony* (detail).

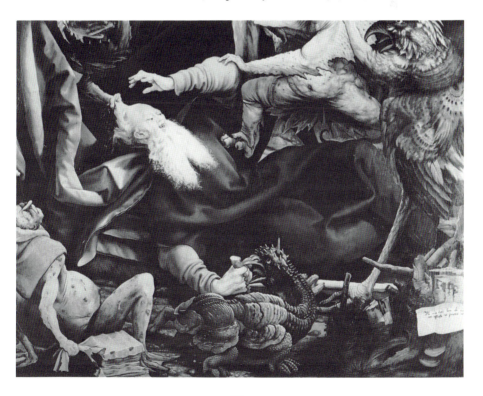

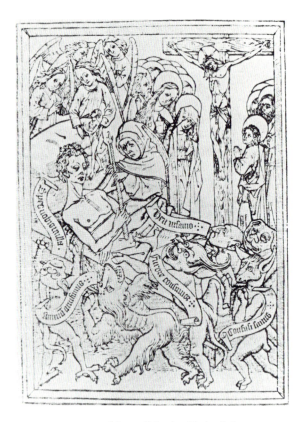

FIGURE 17. Master E.S., *Ars Moriendi*, from
facsimile ed. Cust.

and helpless. Like the Christ Child's posture in the middle state of the
altarpiece (Fig. 28), his head falls back in need of support. In his face,
deformity and pathos combine. Furthermore, Grünewald brings death
and judgment into awareness by means of vernacular references within
the grasp of every viewer.

The *Temptation of Saint Anthony* is a subject of suffering and moral
trial within a folk-narrative tradition. The composition of this panel (Pl.
3) is derived from those books of conduct for the dying Christian that
appeared especially after the middle of the fifteenth century, the *Ars
Moriendi* (Fig. 17). There the five temptations wrestle with the dying
man in an attempt to break down his allegiance to the teachings of the
Church. Disease must have been experienced as a composite testing

ground of religious commitment that would have required of those affected a leap of faith even greater than that for the normal worshiper. Accordingly, what is to be dreaded is not the manifest disfigurement symptomatic of disease, as it appears before us in the altarpiece, nor death itself, but the attendant possibility of loss of faith implied by the inscription on the *cartello*. Anthony's words, deriving from Athanasius's account of a particularly grueling struggle between the saint and the devil, are quoted from the late medieval popular version of the life of Saint Anthony contained in the *Legenda Aurea*: "Where were you good Jesus, where were you? Why were you not there to heal my wounds?"[37]

The sculptured Saint Anthony, central and enthroned, resembles a high priest and judge (Pl. 1). One tradition characterizes Anthony as dispenser of judgment and emphasizes his vengeful as well as his benevolent powers; more specifically, his capacity to heal alternates with his ability to punish through the spread of disease.[38] This entire stage of the altar presents an earthly Last Judgment (Fig. 2). Left of center (heraldic orientation) is the nightmarish *Temptation of Saint Anthony*, with monsters surrounding and attacking the saint. To the enthroned Anthony's right side, the *Meeting of Saints Anthony and Paul* presents a wooded landscape in which the two elders calmly converse (Pl. 2). Against the underlying theme of death, these two saints represent the ideal goal of this life: a tranquil and holy old age. Grünewald also presents the limited means, according to contemporary pharmaceutical prescription, for relief from the physical symptoms of disease: as mentioned above, this place of harmonious communication of the *Meeting of Saints Anthony and Paul* contains plants and herbs known to alleviate some of the effects of Saint Anthony's Fire. Certain of them may have been among the secret ingredients of two staples concocted at the Antonite hospitals: a balsam and a wine vinegar, the famous *Saint Vinage* mentioned in the statutes of the order.[39]

Beyond the use of salves and potions, there is ample documentation for one more active form of medical intervention. Medical historians generally credit Ambroise Paré with making amputation a viable procedure only after the middle of the sixteenth century; nevertheless, because gangrene frequently affected the limbs of the victims of Saint Anthony's Fire, amputation had become a specialty in Antonite monasteries a good deal earlier. In 1517 Hans von Gersdorff speaks of having undertaken one to two hundred such operations in Strasbourg's Antonite hospital. He includes in the chapter on Saint Anthony's Fire a

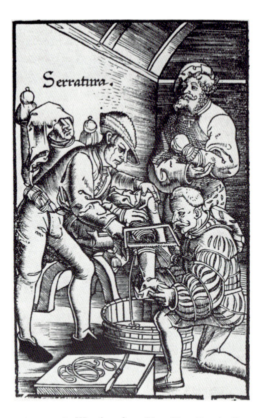

FIGURE 18. Woodcut from Hans Von Gersdorff,
Feldtbuch der Wundtartzney, Strassburg, 1517.

long description of amputation procedures and illustrates his text with
the example of a patient whose leg is being severed just below the knee
(Fig. 18).[40] A letter of 1451 from a magistrate in Colmar requests that the
Isenheim monastery send its resident surgeon to perform an amputation
at the Colmar hospital.[41] Upon visiting the mother cloister in 1502, Pico
della Mirandola's nephew reported that one was constantly reminded of
this surgical practice by the monastery's custom of preserving and ex-
hibiting amputated limbs, which we also see presented as votive offer-
ings in early woodcuts of Saint Anthony (Fig. 19).[42] Kurt Bauch has
suggested that the two halves of the Isenheim *Lamentation* predella were
originally meant to slide apart on a tracking mechanism, as one can still
observe in the predella of the nearly contemporary Blaubeuren Altar-

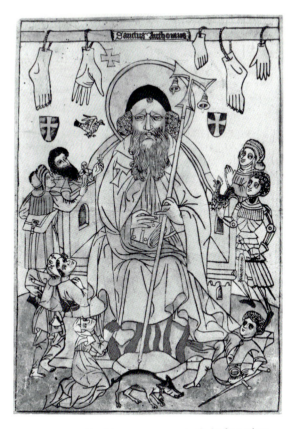

FIGURE 19. Swabian, 1440–1450, single-leaf woodcut,
Saint Anthony Abbot.

piece by Michel Erhart (Figs. 21 and 39).[43] This suggestion becomes
more compelling in light of Gian Francesco Pico's account. If the pre-
della is opened according to Bauch's reconstruction, the *Lamentation*,
split in two, would remain visible. Since the split occurs just below
Christ's knees, the left half would present the kind of sacred remnant
that Gian Francesco Pico describes. The right section, where one is led
to relate the shape, placement, and function of John the Evangelist's
cloth-covered left hand to the crosspiece of a crutch, would show Christ
himself as a model amputee.[44]

In the open state of the altarpiece, a realm defined by the limits of
historical time (Fig. 2)—with its narrative events from the saint's life,
its display of the worldly structure of institutional hierarchy, its empir-

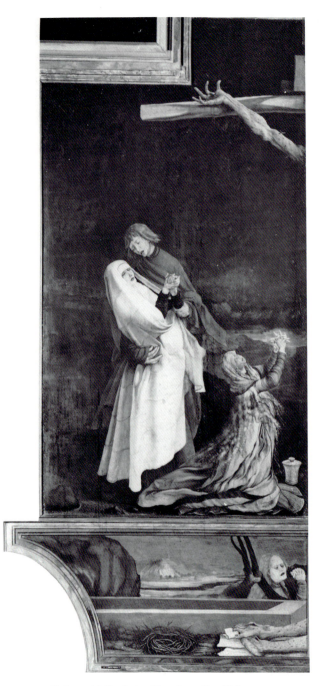

FIGURE 20. Grünewald, Isenheim Altarpiece, Crucifixion.

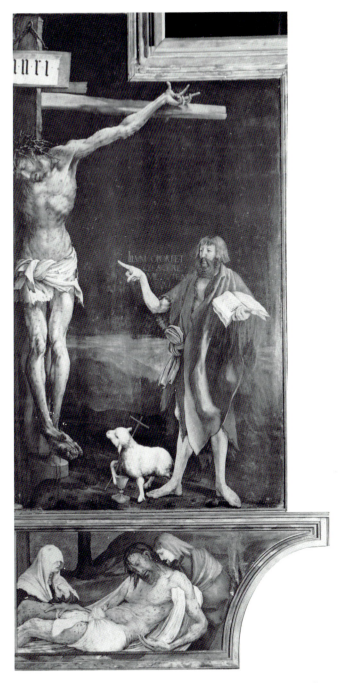

FIGURE 21. Grünewald, Isenheim Altarpiece, predella.

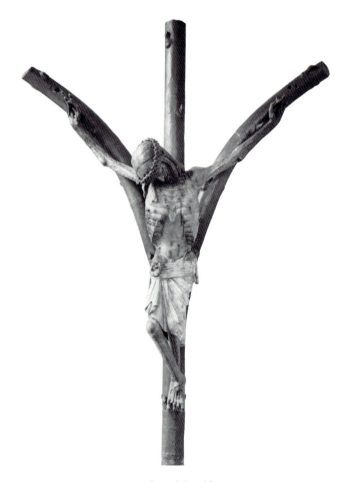

FIGURE 22. Carved Crucifix, 1304.

ical evidence of organic and symptomological phenomena—confronta-
tion and awareness are the states required of the individual viewer. Only
then would the patient be prepared to grasp the meaning of his condi-
tion; only then could he begin to fathom the significance of death. The
central Anthony, as institutional leader, calmly oversees this domain of
worldly threats and practical solutions. Contemporary illustrations of
Anthony as physician generally show him as he appears here, enthroned
or standing (Figs. 9 and 19).[45] In the closed state of the altarpiece (Pl.

7), Grünewald follows the standing format and places Anthony in the right wing as a guardian figure for the central image of the suffering Christ (Fig. 7). Here, by definition, suffering and death are intertwined.

We are faced with the two sides of death. Modeled in part on the gaunt and blemished hanging Christ of the type of the late medieval *Pestkreuz* (Fig. 22), the *Crucifixion* presents death in its imminence; the *Lamentation* shows the body's torpor in the state of death (Figs. 20 and 21). Silhouetted against the night sky, these figures appear as large as life. In contrast to the painted representations in the altarpiece's open position, they are expressive participants in a real-life drama intended as an organizing focus for a large assembly of viewers. In a broader sense, too, the viability of the Crucifixion as image and symbol lies in permitting vast numbers of people to find community in pain and suffering. In the hospital the identification with the images of the closed state of the altarpiece would have been all the more intense. The patients at Isenheim certainly shared the idea of man as sinner, in that disease was often considered a manifestation of or punishment for sin. But through Christ's sacrifice on the Cross man was redeemed. These worshipers must have approached the closed altarpiece with special gratitude, for it dramatizes this supremely magnanimous act.

Our modern sensibility can easily overlook the residual impact of the way the Gospels themselves abound with the miraculous healing acts of Christ and the degree to which this power became a sign of his mission. Later exegetes often stressed the idea of Christ the Physician, as we find in the writings of both Augustine and Jerome, the church fathers who appear on the sculptured shrine. *Verus Medicus, Solus Medicus*, Jerome calls him.[46] By the time of the Renaissance, the *Christus Medicus* figure was part of popular awareness, but it also structures what are surely the two most important altarpieces commissioned during the papacy of Leo X, nearly contemporary with Grünewald's paintings, namely, Raphael's *Transfiguration* and Sebastiano del Piombo's *Resurrection of Lazarus*.[47] Germane to the Isenheim Altarpiece is Augustine's special emphasis on the curative power of the crucified Christ: "But he bore with His revilers, because he accepted the cross not as a test of power but as an example of patience. There he healed your wounds where He long bore His own. There He healed you of an eternal death where He deigned to die a temporal death."[48]

In other specific respects, the *Crucifixion* bespeaks optimism in its content. The *Crux Taumata*, the Tau-shaped cross topping a long staff,

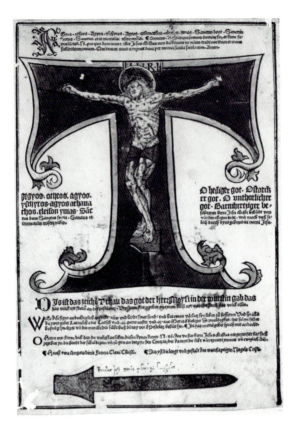

FIGURE 23. Single-leaf woodcut.

is Anthony's principal attribute. When he became patron of this complex of monasteries, it was made the monks' official insignia as well. In a tradition understood to have originated in biblical times, healing virtues were associated with the Tau;[49] this tradition informed events at the founding of the Antonite order. When Gaston, the Dauphiné nobleman whose son had been cured of Saint Anthony's Fire, decides to devote himself to the treatment of this disease, he imagines Anthony instructing him to plant a Tau, which quickly bears fruit and develops healing powers.[50] An image of the crucified Christ inscribed within the Tau-shaped cross occurs, in particular, in several late fifteenth-century prints (Fig. 23), and this coexistence of motifs is important for our further understanding of the effect of the central *Crucifixion* in the Isenheim Altarpiece. One example depicts such a combination and is also

accompanied by a text that prescribes prayer and contemplation of this image in exchange for protection from the onslaught of the plague.[51] Thus the viewers at Isenheim, through their common experience of local texts and illustrations, could attach this reassuring level of meaning to the *Crucifixion* on the altarpiece.

Moreover, in the context of the celebration of the Mass, the Isenheim *Crucifixion* and *Lamentation* can be seen as a particularly poignant and personal resolution of the long-standing theological debate over whether the substance of the Eucharist is connected to the spiritual body or to the earthly, suffering body of Christ. Not only could the patients identify with the latter, but in a hospital this sacrament takes on special significance. Christ's eternal life, expressed historically in the Resurrection and liturgically in the Eucharist, provided these patients with a model destiny for their own mutilated beings.

The expressively isolated figure of John the Baptist, to the right of the Crucifix, has always been noted by scholars (Fig. 20). They have attempted to locate both literary and visual sources to explain his presence.[52] But it is usually overlooked that John stands in front of a body of water visible in the middle distance, a clear indication of the locale of baptism.[53] The importance of this sacrament for the meaning and function of the altarpiece cannot be overemphasized and will be explored in a later chapter. For the present, let us consider its precise meaning in the hospital context. The common, cross-cultural notion of water as a purifying and rejuvenating agent, as well as the healing nature of the waters, is doubtless implied. In the Old Testament (2 Kings 5), Naaman the Syrian is cured of leprosy by dipping seven times in the River Jordan. And although a distinction is often made between the earthly, healing action of Old Testament waters and the spiritual salvation with remission of sins achieved by baptism, the idea of a healing aspect to the waters of baptism always persisted. Augustine testifies to miraculous cures during baptism, and some missals contain a special ordo for baptizing the afflicted.[54]

Many handbooks describing and advertising local mineral baths were published at the turn of the sixteenth century. Moreover, hydrotherapy and the analysis of mineral waters preoccupied Alsatian physicians just at this time.[55] The region of the Vosges Mountains, less than five kilometers from the Isenheim monastery, was, in fact, rich with thermal springs, and monasteries were often guardians of mineral baths.[56] We do not know directly that baths were recommended in the treatment of

Saint Anthony's Fire, but their use in diseases such as leprosy and epilepsy provides suggestive evidence.[57] If this hypothesis has any validity, the fact that, despite the paucity of documentation about Grünewald, he is mentioned both before and after the execution of the Isenheim panels as an hydraulic engineer becomes a tantalizing link in the possible chain of circumstances leading to the Isenheim commission.[58]

The divinity of Christ having been first revealed when John baptized him, the closed view of the altarpiece encapsulates both the divine character and his most human aspect, the suffering on the cross. Christ's dual nature is presented as an exemplar for the patients at Isenheim. Furthermore, Grünewald's formal and iconographic handling of other sections of the altarpiece mediates between this doctrinal level of communication and one that relates more directly to the immediate perceptions and experiences of the patients. For instance, the *Temptation of Saint Anthony* (Pl. 3) folds over the *Resurrection* (Pl. 6). The contrast between the two bodily states is made explicit visually through the quotation of poses occurring in the supine Saint Anthony and the sleeping soldier in the foreground of the *Resurrection*, the one bearing witness to bodily torture, the other attendant to bodily transcendence. The patients who viewed this altarpiece must have been urged to experience their own suffering as the necessary step toward spiritual ascendance.

In the closed view of the altarpiece, then, the related themes of death and illness are central and inescapable, but the viewer could also find evidence for comfort and hope (Pl. 7). In this realm of certain but sacrificial death there exists the possibility of divine intervention in the healing process and of personal transcendence and afterlife. The crucifix, the saints in the wings, and John the Baptist all communicate the possibility of safekeeping and healing.[59] Grünewald, by enlarging the standing Anthony compared to Sebastian, his structural counterpart in the altarpiece, gives shape to the notion that the power to heal was itself a miraculous or divinely inspired gift.[60] The images of the altarpiece also generated hope for remission and redemption. Through references to the blood and the water, the association with the church ceremonial—the Eucharist and baptism—meant that the entire closed stage urged active participation in the body of Christ toward an imaginative re-creation of life. Indeed, the altarpiece's fundamental message is one of promise—the promise not only of good health, for which we might settle gladly, but also of a place beyond the confines of this world. The

middle stage especially, which shows a different approach to the condition of disease, is a revelation of this future life.

In the open state of the altarpiece Grünewald depicts objects pertinent to illness and healing as realistic details in the narrative scenes from the life of Saint Anthony (Fig. 2). The closed state (Fig. 4) confronts us with the manifest theme of death, and single motifs and characters have a resonating meaning that embraces the suggestion of sustained life. This dramatic and symbolic region of Grünewald's *Crucifixion* addresses the shared knowledge of the congregation and its capacity to perceive these images as replete with associations relevant to the hospital context.

The second level presents a number of details that help us to locate yet another level of assistance to the patient (Fig. 3, and Pl. 4). Some of the furnishings in its central section seem to derive from Oriental sources. For example, the clear glass vessel on the tabernacle step (Fig. 24), with its angled handle for support of the thumb, is a shape traceable through Venice to Persia.[61] The small earthenware pot in the center foreground (Fig. 25) and the tub and musical instruments (Pl. 4) are to be seen in allegorical illustrations celebrating the domain of alchemy, that occult branch of science dealing in material transformations (Figs. 26

FIGURE 24. Grünewald, detail of *Madonna and Child and Incarnation Tabernacle* (Plate 4).

and 27). Oriental magic had seeped into the West throughout the Middle Ages, and the notion of the occult was often automatically linked to the East. Accordingly, it is rarely noticed that a script meant to look like Hebrew encircles the small pot in the foreground (Fig. 25). Frequently, in folk or mystical traditions, protective powers were attributed to words or letters and, according to Agrippa von Nettesheim's *De Occulta Pilosophia*, Hebrew especially seemed naturally endowed with such signification.[62] In fact, only the first and last letters of the script, reading from right to left, are recognizable Hebrew characters—Shin and Ayin—a choice that may not be accidental. The Shin, perhaps the most elaborate and familiar Hebrew letter, often marked Jewish residences, and it is the exposed letter on the traditional mezuzah.[63] This small object can still be seen affixed to the doorpost of Jewish homes, where it functions as a good-luck or protective charm.[64] Grünewald's alignment of the Shin with the cradle and the doorway of the garden wall is therefore important. The use of this letter is all the more pointed in conjunction with the Ayin, which is both the first letter and the first word in Hebrew for the evil eye, *Ayin Hora*.[65]

FIGURE 25. Grünewald, detail of Plate 4.

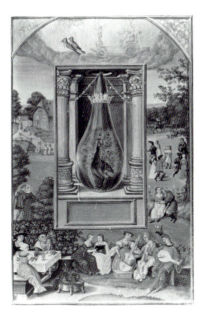

FIGURE 26. Trismosin, *Splendor Solis*—Fol. 28;
Harl 3469. f28.

FIGURE 27. *Enstehung eines Homunculus*, etching.

The infant Christ plays with a rosary and fingers two of the five golden bead dividers (Fig. 28). The rosary had become popular in the late fifteenth century as a device around which to organize prayer, but only during the papacy of Leo X—contemporary with the Isenheim Altarpiece—was it officially sanctioned by the Church.[66] Doubts about its effectiveness were associated with its propensity to serve a magical function.[67] In the first place, the rosary was generally employed in prayers for direct and immediate assistance and intervention. A defining characteristic of the linguistic structure of these prayers is reiteration, or the accretion of a series of words by repetition, a technique frequently used to induce a meditative state. Finally, the physical nature of the rosary as jewelry associated it with common necklaces or bracelets, good-luck charms or amulets—especially when, as in Grünewald's example, a pendant or charm was attached to it.[68] Here a large gold medallion falls behind the body of Christ, and a bifurcated piece of coral points to the infant's chest.

Amulets in general and coral in particular were used in fending off evil spirits and protecting against the evil eye.[69] The common belief in such an unseen force or spell, capable of causing harm to the point of death, must have seemed especially pertinent to the case of disease. In turn, various kinds of amulets and semiprecious and precious stones of different colors came to be credited with the power to ward off or heal diseases, as we find catalogued under *De Lapidibus* in the typical *Hortus Sanitatis* of the period.[70] Grünewald's musical angels wear a variety of gold rings, some mounted with red stones, on different fingers of both hands, which they display through the bowing and fingering of their instruments (Figs. 29 and 30). One of the headings in Agrippa von Nettesheim's nearly contemporary book on magic is "Of Magical Rings and Their Compositions." In this section he describes rings "inasmuch as they do fortify us against sickness, poisons, enemies, evil spirits, and all manner of hurtful things."[71] Furthermore, red stones, such as rubies and garnets, by suggesting the color of blood, were recommended to arrest hemorrhage and to nullify the effect of wounds.[72]

Several other elements in this stage of the altarpiece support my view of its purpose as a magical catalyst for protection and transformation. Most important are the three music-making angels at the left side of the central section (Pl. 4). They, of course, traditionally populate a celestial realm. But there is an equally applicable and age-old tradition of music

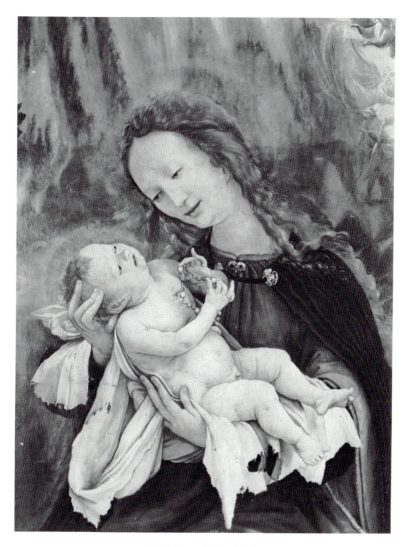

FIGURE 28. Grünewald, detail of Pl. 4.

as a curative agent. In 1 Samuel 16, David calms the tormented Saul by playing the lyre for him. The ancients attributed healing powers to the sound of various instruments: Theophrastus and Aulus Gellius thought

45

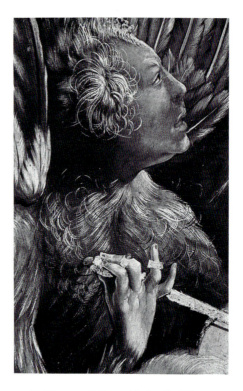

FIGURE 29. Grünewald, detail of Pl. 4.

that the flute would cure sciatica, and Democritus thought its sound
could help a victim of the plague.[73] Such speculation has a long history;
indeed, today there are many journals of music therapy. Around the
time of the Isenheim Altarpiece, discussion of the subject took place in
both musical and medical studies. Paracelsus, a trained physician, prac-
ticed what he himself called musical medicine.[74] In a late fifteenth-cen-
tury treatise on the effects of music by Johannes Tinctoris, we learn that
music lifts sadness, chases away demonic forces, causes ecstasy, helps in
the contemplation of the supernatural, and cures the sick.[75]

Such attitudes depend on two related insights. One is a recognition
of the cathartic effects of music; the other is the perceived connection
between mind and body in any illness that would admit of such a psycho-
therapeutic road to healing. Pythagoras had established a theoretical ba-

46

FIGURE 30. Grünewald, detail of Pl. 4.

sis for this notion. In his system, music became an aesthetic model for both cosmic and human nature.[76] The human body was compared to an instrument, with the soul as its music. For the Pythagorean doctor, health was the proper attunement of body and soul, and harmony became the conceptual figure for good health.[77] Theoretical and technical handbooks on music during the Renaissance connect different classes of instruments with the essential components of music; drums were related to rhythm, viols to harmony.[78] In depicting three levels of viols—bowable, stringed instruments—Grünewald embodies this aesthetic equivalent for health. Furthermore, in restricting his instruments to three, he displays the basis of a tripartite harmony that had just emerged about 1500 as the canonical revision of Pythagoras' fourfold ideal.[79]

Grünewald's extraordinary manipulation of light in this view of the altarpiece will be discussed later with respect to its consistent and meaningful exposition of theme. But it is also important to stress that in this part of the altarpiece there is an immediate and overall impact of visionary radiance, of visual vibration, as seen especially in the lustrous *cou-*

47

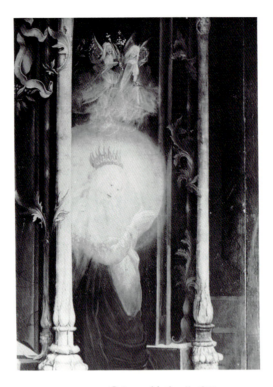

FIGURE 31. Grünewald, detail of Pl. 4.

leurs changeantes of the angels' draperies and the glowing aureoles around the tiny Virgin below the canopy and the resurrected Christ (Pls. 4 and 6, Fig. 31). The elaborate tabernacle shimmers with its gold leaf, and there are other passages of seemingly incandescent light, as at the top, where God the Father appears (Fig. 32), and in the drapery of the risen Christ. In the alchemical and astrological literature of the time, a firm tradition characterizes brilliant light, the color of the sun, and gold itself—"of all the elixirs, the highest and most potent"—as powerful agents to be invoked against the morbid influences of disease.[80] And, aside from the religious symbolism of the aureole, the literature of occult medicine in our own century gives evidence of a parallel surviving tradition: the human aura, allegedly visible, which reflects one's state of health and has the capacity for transference and healing.[81]

The applied gold, the *couleurs changeantes*, and the colors highlighted

FIGURE 32. Grünewald, detail of Pl. 4.

in white are then more than literally descriptive. If the open state of the altarpiece needed to be examined or deciphered, and the closed state contemplated, this middle state, through light and color, provokes the kind of visual fixation precedent to a trancelike state. This effect is a perceptual equivalent to the content, where occult beliefs and magical means are marshaled to combat the evil spirits associated with disease.[82] To go one step further, the fixated gaze, when confronting gems or crystal, could also modulate into the act of foreseeing.[83] That paradigm of revelation, the Heavenly Jerusalem, is envisaged as a transfiguring of the townscape into shining gems. So Grünewald celebrates with the ingredients of a painter the revelation of what lies beyond this life. It is left for us to witness the transmutation of Christ's body, covered with sores, in the predella below, into the alabaster translucence of its appearance in the *Resurrection* scene (Figs. 3 and 21, Pl. 6), an exemplary fusion of

49

the account of orthodox theology with alchemy's central aims: the purification and transubstantiation of matter.[84]

By now it seems clear that during Grünewald's working time at Isenheim, the commissioners, its resident physicians, the patients, and the artist had a thoroughgoing commitment to the importance of the altarpiece for the hospital complex. The earlier carved shrine, we recall, does not yet offer evidence of hospital iconography: Saint Anthony appears there simply in his more general role as founder of the institution of monasticism.[85] Does the later amplitude and coherence of reference to the hospital context, as I have characterized it, reflect the new preceptor's prescriptions? Or is it the artist's creative adaptation to the declared function of the altarpiece in his response to its structural givens: a monument of three changing views? Each stage of the altarpiece addresses itself to the problem of disease and healing in a special manner. The open state (Fig. 2), with the narrative scenes of Saint Anthony, presents the condition of disease, along with medical techniques for its alleviation. The closed *Crucifixion* state (Fig. 4), outlining a phenomenology of death, allows for the possibility of divine intervention and of identification with the divine. The middle state (Fig. 3) arms us against the mysterious forces of infection, offers the alternative route of psychophysical treatment, and shows us a gloriously imagined estate of the future. These approaches, which we might view as contradictory, reinforce and offset one another in dynamic equilibrium: from the prescriptions of practical or organic pharmaceutics to the surgical procedures of contemporary medicine, from popular beliefs and intellectual speculation into magical, apotropaic and cathartic devices to the established vocabulary of symbols for protection and transcendence articulated by Catholic doctrine.[86] Whereas at this moment academic medicine was taking root in the vicinity of Isenheim, the path of disease was still mysterious enough and its manifestations devastating enough for all these methods to be held in comprehensive awareness and trust.[87]

Early accounts of Saint Anthony's Fire concentrated on its physical symptoms. But John Fuller's novelistic documentary on the modern outbreak of this disease in Pont-Saint-Esprit in France in 1951 describes visions, hallucinations, and delusions experienced by the victims.[88] Those reactions bear a striking affinity to the contrasting worlds Grünewald conjures up, where we are taken from spiky forms and nightmarish territories to glowing colors and radiant visions. Modern analysis has revealed that a component of the fungus causing Saint Antho-

ny's Fire is chemically close to lysergic acid diethylamide, or LSD.[89] This, in turn, gives us some insight into the psychoneural effects of the disease on the Pont-Saint-Esprit victims, and it suggests that Grünewald's portrayal could also reflect something of the actual experiences of the Isenheim patients. Moreover, through the physiological and psychological pressures caused by their illness, these patients undoubtedly crossed certain thresholds of perception to arrive at altered states of awareness. Indeed, there is eloquent testimony for this possibility in a nearly contemporary treatise written outside the purview of academic medicine, Agrippa von Nettesheim's *Occult Philosophy*. Toward the end of this massive volume is a section titled "Concerning Rapture, Ecstasy, and Prophetic Powers Which Happen to Epileptics, to Persons in a Swooning State, and to the Dying":

> There is, in effect, a transparent force in our souls which is capable of total understanding but usually it is shrouded by the body's darkness and held back by the burdens of mortality. But sometimes those who are near death and weakened by age will experience extraordinary rays of light, because the soul is then less burdened by the senses and comprehends with greater subtlety . . . and perceives with ease those revelations presented him in his agony.[90]

Grünewald uses a pictorial language that is directly expressive, dramatizing the phenomenon of suffering as well as of mystic revelation: these features only bring out more overtly what has been implied thus far, namely, his extraordinary capacity to be affected by this context and his evident need to communicate with this special group of viewers. Indeed, if Grünewald as an artistic personality emerges any more clearly from this investigation, it is as a function of how he met the demands of this commission rather than as a result of new or more precise biographical discoveries.[91] The very paucity of information about the artist has necessitated concentrating on the issue of patronage; there it appears that the few known facts about this monument had not been fully explored and relevant information not properly mined. By integrating such material, we retrieve a crucial facet of the original milieu of the altarpiece. Merely to transfer the focus from artist to patron, it must be emphasized, is not enough. For there exists a broad network of social and cultural phenomena that inevitably helps to determine, on a conscious or unconscious level, the nature of the exchange between artist and patron. We are obliged to conjure up these qualifying winds and

weathers as well in our historical cartography. In order to do justice to the towering stature of achievement reached at Isenheim, and to the complex process by which this monument came to take its place in the cultural landscape, we must now shift perspectives and look beyond the monastery hospital.

II

PAINTING AND PRESENCE:
A CATHOLIC MONUMENT AT THE
THRESHOLD OF THE REFORMATION

As eccentric as Grünewald's panels from Isenheim may look to us in reproduction—their decisive, stepped frames stamped in isolation against the white borders of a printed page—in serving as shutters for a carved shrine, they, in fact, constitute a type of monument that was at its most popular around 1490, when the sculpture for this altarpiece was first commissioned. Tilman Riemenschneider and Veit Stoss were among the primary exponents of such carved altarpieces, which continued to be favored until the 1520s in the Rhineland and east into southern Germany and Austria.[1] Indeed, the decade of the 1490s through the turn of the century was a period of intensified spirituality in the north. A renewed sense of mission in monastic life furthered trends of piety and mysticism in society at large—impulses that had their outlet in pilgrimages and new forms of devotion.[2] Numerically, the endowment of masses and altars was at a high point, and a general increase in ecclesiastical building activity at this time accounts for the completion of the cathedrals in both Freiburg and Basel.[3]

While there is no extant document of commission for the Isenheim Altarpiece, a surviving contract for a contemporary altarpiece by a Colmar sculptor for the neighboring town of Kaysersberg reviews the conventional parts of such a monument and explains the format of the Isenheim Altarpiece as well.[4] They are: (1) the *corpus*, or core: usually a carved, boxlike structure containing the saints or the religious event on whose behalf the altar was consecrated. The open state of the Isenheim Altarpiece reveals this section in the wooden shrine generally attributed to the Strasbourg sculptor Nikolaus Hagenauer (Pl. 1)[5]; (2) the *Sarg*: the predella-like section that often represents Christ and the apostles, as in the case of the sculptural example for the Isenheim altarpiece; the predella is set on the altar and serves to raise the main section of the altarpiece from the altar table[6]; (3) the *Flügel*: the wings, a structural

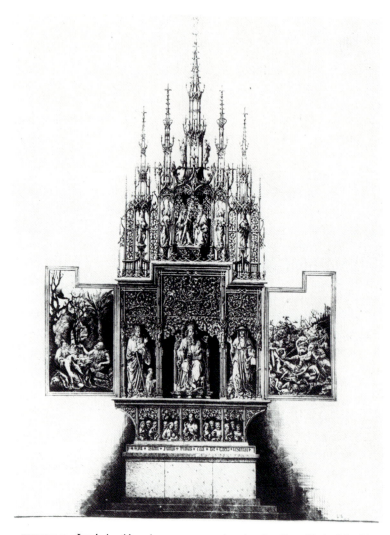

FIGURE 33. Isenheim Altarpiece, reconstruction drawing from H. A. Schmid, *Die Gemälde und Zeichnungen von Matthias Grünewald*, 1911, pl. 8.

preference of the northern European altarpiece, which differ from Grünewald's panels only in that the document calls for the more common single set to be executed in the conventional medium of carved relief; (4) the *Auszug*: now missing from the Isenheim Altarpiece, although rightly posited in several scholars' reconstructions (Fig. 33), this

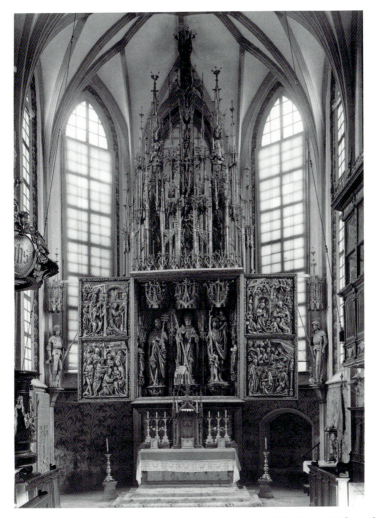

FIGURE 34. Martin Kriechbaum(?), Altarpiece, 1490–1498, Pfarrkirche, Kefermarkt.

carved superstructure would be composed primarily of skeletal interlacing and foliate ornaments, sometimes encompassing additional figures in its web. As we see in the contemporary Kefermarkt Altarpiece (Fig. 34), the *Auszug* comes to a culminating point near the cross vaulting in the apse.[7] When placed at the main altar, such a monument would frequently be positioned far back in the apse. Opened, the wings reached

nearly to the side walls and imparted to the whole the shape of a monstrance.[8] In addition, the wings provided for the changing views with which to punctuate the devotions of the church calendar. As a structure, what we have here is a microcosm of the church architecture itself. At the main altar, as Hans Baldung Grien's woodcut of 1516 shows us, the altarpiece serves as a focal point in the celebration of the Mass (Fig. 35). This type of monument takes us, in other words, to the core of Catholic worship.

This is important for us to contemplate, especially if we confront the Isenheim Altarpiece realizing that the wings by Grünewald stand in for the traditional carved relief and that, when they were added (1515–1516), the acceleration in Catholic piety had been leveling off. The paintings are, in fact, nearly contemporary with Luther's theses; less than a decade after their completion, much of the religious art in the churches of Strasbourg and Basel was being removed from view.[9] To be sure, these were

FIGURE 35. Hans Baldung Grien, *Mass and Altar*,
woodcut from Marcus von Lindau, *Die Zehe gebot* . . . , Strassburg, 1516.

56

actions motivated by Protestant iconoclasm. But the history of Catholicism itself sustained a recurring resistance to the worship of images, which derived from the Old Testament prohibition in the Second Commandment.[10] Increasing doubt about the spiritual wholesomeness of the image and possible dangers inherent in the content and effects of devotional objects marked the period immediately preceding the Isenheim Altarpiece and makes the mere existence at this date of a visual complex as monumental and striking as this altarpiece all the more remarkable.

A Hussite text as early as 1418 is revealing in its admonitory prescriptions:

> Church images can be kept in the church, but only if they are not in superfluity and not wantonly or falsely adorned, in such a way as to seduce the eyes of the communicants from respect for the Lord's body, or as to distract the mind or otherwise be an impediment. Moreover they cannot be given adoration or cult in any way, by sacrifice of candles, or kneeling, or other forms of cult that rather belong to the Divine Body. But they may be cultivated only for their bare signification of deeds done in Christ or by Christ, that the simple people may be able more readily to see such deeds through the images and thus be furthered in their devotion.[11]

If, from about 1500 and shortly after, prints with such subjects as Solomon's Idolatry or the Israelites Worshiping the Golden Calf were used to caution a Christian audience through what were perceived as classic instances of excessive veneration of material objects (Fig. 36), later evidence reveals how the tensions and apprehensions surrounding image worship were at times justified.[12] A woodcut by Michael Ostendorfer (Fig. 37), dating to five years after the Isenheim Altarpiece, depicts a throng of pilgrims approaching a statue of the Madonna that had been erected to celebrate a miracle alleged to have occurred at this site.[13] Such cultic fervor combined with commercial exploitation to contribute to the vehemence of subsequent statements against images, such as the following one by a group of Strasbourg citizens:

> It also troubles us, since no scriptures say it is right, that there is that evil idol in the choir of the cathedral, which is not only a blasphemous offence to many of our people in the city, but to all people in the whole region. For every day one sees people kneeling before it, and praying to it, while these same people obstinately refuse to

FIGURE 36. Lucas van Leyden, *Solomon Adoring Idols*,
engraving, 1514.

pay attention to God's Word as it is preached to them. And the
silver idol behind the altar in the choir is also evil, and the idols in
the entrance to the cathedral, which were recently made into rub-
ble, and now, more than ever, people light candles in front of them
during the day, which is a travesty against God and pious customs.[14]

We do well in this regard to review certain of the customs pertaining
to the original context and function of the Isenheim Altarpiece, where
the condition of disease and its inevitable association with death in-
spired the commissioners and the artist to create a monument charged
with special devotional content. A late sixteenth-century account pasted

FIGURE 37. Michael Ostendorfer, *Pilgrimage to Schöne Maria of Regensburg*, ca. 1520, facsimile of woodcut, ca. 1520.

into a manuscript from the Isenheim library indicates the changing order of vestments and mode of decor for the church at Isenheim over the course of the calendar year.[15] It also tells us of elaborately choreographed rituals replete with torches and a variety of bells that were used to embellish the services. On certain holidays, such as the Purification of the Virgin, processions occurred in the church; on Quasimodo a cross was carried and presented to be kissed by the assembled worshipers.[16] The ceremony on Palm Sunday reached outside the church to the cemetery for the rite of the "breaking of the gates of Hell," whereas Anthony's feast day required that reliquaries of the head and hands of the saint be

carried in procession.[17] Sometimes details of the liturgy would be extended into dramatic action, as on Ascension Day, when the evening prayers were followed by the "releasing of the Holy Ghost toward the sky."[18] The exposition of the Host took place on Corpus Christi under a canopy of flowers erected at the main altar. The prescribed placement of candles on the main altar, at certain times, as well as in the large and ornate chandelier that hung in mid-choir, gives us some indication of the aura that was conjured up in proximity to Grünewald's altarpiece.[19]

From a Reformation point of view, we are obviously at the edge of, if not beyond, the permissible. The dramatic gulf at this stage between belief and skepticism (not to say outright condemnation) can best be illustrated with quotations from the historian of the Antonite Order, Aymar Falco, on the one hand, and Erasmus, on the other. Falco records that in the year 1530, "We witnessed that many who suffered from this terrible illness were completely cured through imploring the patron saint and through the holy wine in which the relics of the saint's body had been immersed, and which was then applied locally to the diseased parts of the body."[20] Whereas in the 1515 edition of Erasmus' *Praise of Folly*, the humanist has this to say about the popular Saint Christopher:

> Closely related to such men are those who have adopted the very foolish (but nevertheless quite agreeable) belief that if they look at a painting or a statue of that huge Polyphemus Christopher, they will not die on that day; or, if they address a statue of Barbara with the prescribed words, they will return from battle unharmed; or, if they accost Erasmus on certain days, with certain wax tapers, and in certain little formulas of prayer, they will soon become rich.[21]

To be sure, some voices continued to declare the efficacy of religious art. They echoed Pope Gregory, who about A.D. 600 had formulated what was to remain the major defense of religious images, namely, their capacity to instruct the illiterate and help those retarded in their piety.[22] As Michael Baxandall points out, during the period we are dealing with, it was Tilman Riemenschneider, in his carved altarpieces, who seems best to have embodied these prescriptions for creating an educative instrument aimed at effecting a restrained type of piety.[23] In his Altar of the Holy Blood of 1499–1505, for example (Fig. 38), with the scale pared down and the treatment chastely monochromatic, presentation is characterized by its narrative exposition rather than its devotional address, and craft expresses dedication rather than virtuosity for its own sake. It

seems clear, by contrast, that it is not as a didactic *aide-mémoire* or gentle goad to contemplation, nor as a surrogate Scripture, that Grünewald's altarpiece operates. Neither does it make sense, from what we have thus far observed, to charge the artist with an attempted or deliberate transgression of the decorum of religious worship. Rather, any ideological definition of this monument must reckon with the exuberant confidence that it expresses in the image as a powerful and legitimate agent for spiritual transformation.

Grünewald appeals to the viewer, first of all, through the medium of painting itself. For while the format is a conventional one in the north, the Isenheim Altarpiece distinguishes itself from other examples through the primacy of painting that Grünewald's panels impart to this complex. Generally, this kind of altarpiece called for carved wings along with the carved shrine, with the subsidiary status of the wings expressed

FIGURE 38. Tilman Riemenschneider, Altarpiece of the Holy Blood, 1499–1505. Sankt Jakobskirche, Rothenburg.

through the use of low relief.[24] When polychromy was employed, as at Blaubeuren (Fig. 39), it was more a matter of applying colors than of projecting an illusion through paint, as is the case with the Isenheim Altarpiece. Even in an example containing painted panels as intricate and accomplished as those of Michael Pacher's Saint Wolfgang Altarpiece (Fig. 40), the late fifteenth-century master uses the convention common in relief sculpture of subdividing the wings into square compartments. This device is an expedient for framing the successive narrations but diminishes the optical impact of the medium itself.

By contrast, Grünewald allows the wings to serve as expansive fields of painting, and for each opening of the altarpiece he seems to concentrate on a condition or effect obtainable only in a painted world.[25] The wings of the *Meeting of Saints Anthony and Paul* and the *Temptation of Saint Anthony* harbor a wealth of descriptive details—plants, trees, feathers, skin, drapery—difficult to achieve in a medium other than painting (Pls. 2 and 3). When these wings fold over the central shrine, the entire middle stage creates an enormous screen of light and color— the essential properties of painting as a medium—with the dramatic alternations of light and dark, the iridescent and white-highlighted colors obliterating, from the point of view of perception, the existing divisions of the framing structure (Pl. 4, Fig. 3).

The closed *Crucifixion* state, with its dense and anchored color, its dark tonalities, opposes the radiant middle level in a contrast to be conjured only in paint (Pl. 7). Since the figure is the primary ingredient here, the artist creates formal continuities from one panel to another, as if to avoid the effect of compartmentalization that would likely result with sculpture under similar circumstances. One such liaison is caused by the bent-over bodies of Christ and Saint John the Evangelist in the predella and the backward arching movement of the three figures at the left of the cross in the *Crucifixion* above. This impressive stage of figures reflects a clarity and unity that are the painter's prerogative. Using monumental figures, Grünewald nevertheless communicates as only a painter could, with his elastic contouring of the figures and the drama of their placement against the dark ground.

No written documents of the time give account of the effect of the Isenheim paintings. This is all the more reason to invoke Hans Baldung Grien's altar of the *Coronation of the Virgin*, which he executed for the cathedral of neighboring Freiburg im Breisgau.[26] Exactly contemporaneous with the Isenheim Altarpiece, it provides a measure of the impact

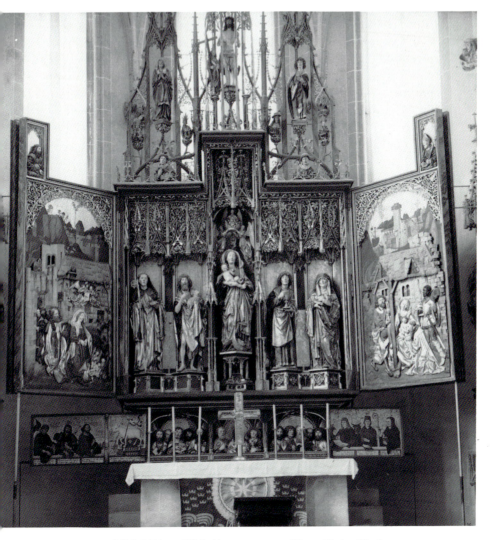

FIGURE 39. Michel Erhart, High Altar, 1493–1494, Klosterkirche, Blaubeuren.

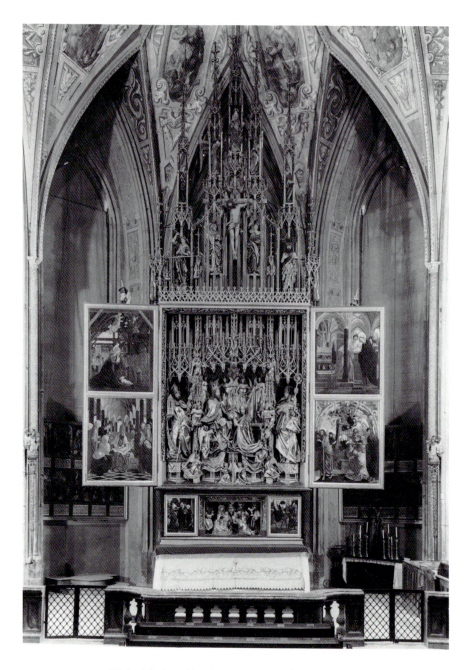

FIGURE 40. Michael Pacher, Altarpiece, 1471–1481, Pfarrkirche, Sankt Wolfgang.

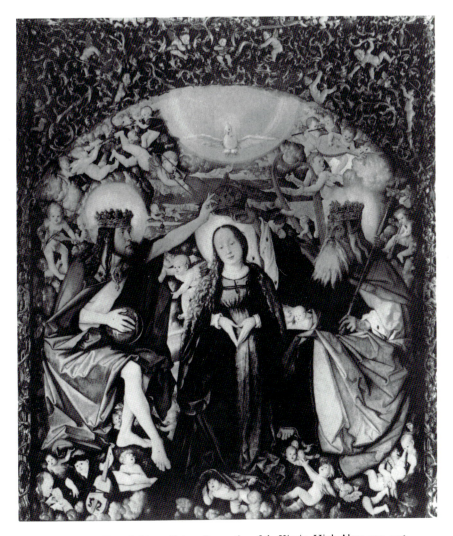

FIGURE 41. Hans Baldung Grien, *Coronation of the Virgin*, High Altar, 1512–1516, Cathedral, Freiburg im Breisgau.

of Grünewald's panels. Baldung generally worked on a modest scale in his efforts as a painter of religious subjects and of secular, occult, and moralizing themes; characteristically for German artists of the period, he also devoted much of his activity to printmaking. At Freiburg, not only does he borrow motifs from the subject matter of the Isenheim

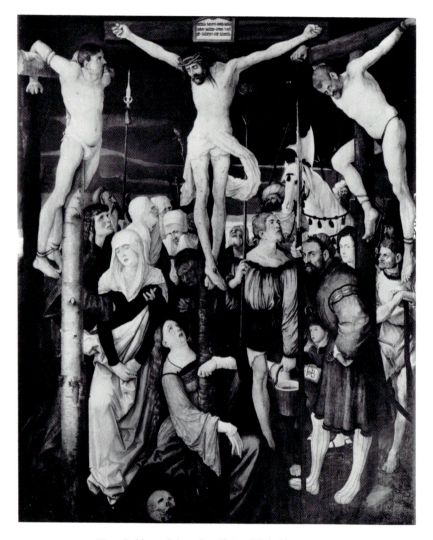

FIGURE 42. Hans Baldung Grien, *Crucifixion*, High Altar, 1512–1514, Cathedral, Freiburg im Breisgau.

Altarpiece, but it is certainly under the impress of Grünewald's work that Baldung's very ambitions and ideals for the altarpiece result in a monument consisting of huge painted panels that comprise several views.[27] From Isenheim, moreover, must have come the idea that the medium of painting could best encompass the cosmic realm quintessen-

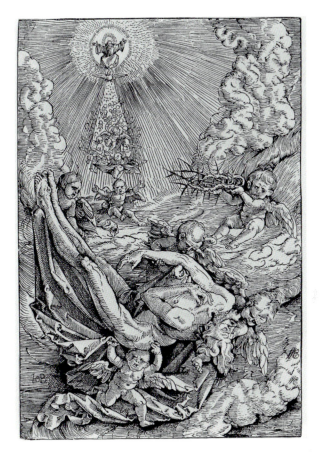

FIGURE 43. Hans Baldung Grien, *Christ Carried to Heaven*,
woodcut, ca. 1515.

tial for an altarpiece, which here pits the cloud-filled space of the *Coronation of the Virgin*, dense with music-making cherubs, against the gravitational pull of the *Crucifixion* scene (Figs. 41 and 42). The flexibility of orientation that Grünewald achieves through the painterly illusion has even filtered into Baldung's prints of this period, where, with a theme like that of Christ being carried to heaven, he defies the compositional moorings of the four corners of the page (Fig. 43).[28] Ultimately, to be sure, Baldung's attachment to the graphic, to the literal, to a vision marked by the sharp edge, the chiseled fold, and the caricatured feature, kept him from achieving the synthetic energy and transcendental expression of the Isenheim paintings.

FIGURE 44. Grünewald, *Kneeling King(?) with Angels,*
black chalk highlighted with white, 28.6 x 36.6 cm.

This comparison also reminds us that, while a magnificent if small
corpus of Grünewald's drawings has come down to us, our artist seems
not to have experimented with printmaking. Admittedly we make this
point in the absence of evidence, and with the knowledge that in es-
chewing printmaking altogether, Grünewald would have been unusual
among German artists of the time. Yet there is artistic justification for
this assertion. Even his drawings are characterized by the loose, soft
contours and coloristic atmosphere more continuous with painting than
with the graphic conventions of the woodcut or the engraving (Figs. 44
and 45). And to judge by his approach in the Isenheim Altarpiece, the
avoidance of printmaking would have been tantamount to an aesthetic
choice: a decision to let nothing interfere with his sensibilities as a
painter—a decision, in the case of the Isenheim panels, that was in turn
put to use in the formulation of their ideology as a religious image.

The modern viewer is struck by the extraordinary level of quality in
Grünewald's paintings and their unusual power of expression. From a

FIGURE 45. Grünewald, *Saint Dorothy*,
black chalk highlighted with white, 35.8 × 25.6 cm.

historical perspective we now see that their special place can also be designated as an accomplishment against the grain, so to speak, of an increasing resistance to images and of a craft tradition in which carved, wooden sculpture predominated as a medium. If we now broaden our historical scope, another facet of this work's artistic position comes into view. I am referring to the fact that this masterpiece of painting dates to just after the first fifty years of printing. Our habitual mode of organiz-

ing material for the historical survey, in its favored separation of mediums, avoids this kind of consideration. But it is appropriate historically to contemplate the ambitions of this work and its impact in terms of a visual culture confining itself increasingly to the page: to drawings, printed illustrations, and the printed word itself. Indeed, at a time that saw the proliferation of all kinds of illustrative materials through the reproductive processes of woodcut and engraving, Grünewald seems determined to reclaim presence through the condition of uniqueness inherent in the painted image. This is so much the case that even now, when photographs have made works of art from disparate periods and places comfortably familiar and when photography has refined the process of reproduction to the point, at times, of defying the assumed imperative of studying the original, seeing Grünewald's panels jolts us with the immediate experience of the singular.

At a moment when the ceremony of the Mass and communal participation in the celebration of the Eucharist were being called into question, and the doctrine of transubstantiation and its intimate association with the place of the altar challenged, prints and paintings favoring such subjects as the *Mass of Saint Gregory*, with its miraculous appearance of Christ, show us just how compelling the notion of a corporeal transformation at the altar could be (Fig. 46).[29] In the Isenheim Altarpiece, Grünewald seems to posit the unique and irreproduceable object as a perceptual equivalent of the presence to be witnessed by the worshiper at the Mass—the notion central to Catholic doctrine and ritual.

The Isenheim Altarpiece does contain specific references to the eucharistic rite, such as the chalice on the ground line of the closed state which receives the blood spurting from the lamb's wound (Fig. 47). By and large, however, such references are evoked through painterly metaphors rather than strictly liturgical motifs. In the closed state, for instance, variations on the color red stand out against the dark background (Pl. 7). In conjunction with the subjects of the Crucifixion and the Lamentation, the use of red is an obvious way of conjuring up the blood of Christ for the celebration of the Eucharist. Moreover, Christ's livid, sore-covered flesh in the *Crucifixion* and the *Lamentation* is a choice that would have provided the special audience of the hospital with a strikingly relevant physical image through which to perceive the process of transubstantiation. How different in this respect is this northern work, under the auspices of a provincial monastery, from the major Roman commissions of the time. Raphael's Vatican fresco of about five

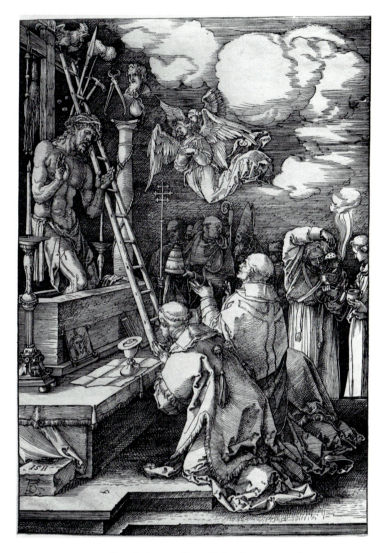

FIGURE 46. Albrecht Dürer, *Mass of Saint Gregory*, woodcut, 1511.

years earlier, in the Stanza della Segnatura, affirms the doctrine through the intellectual forum of debate, while his slightly later example, in the Stanza del'Eliodoro, shows Pope Julius himself standing by at the celebration of the Mass; these are pictures that display eucharistic politics rather than eliciting the experience of transubstantiation itself.

Earlier I showed that Grünewald incorporated many kinds of printed

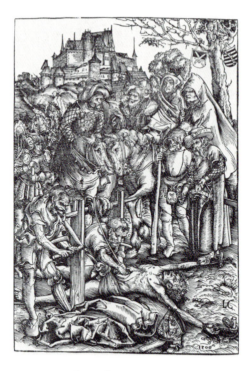

FIGURE 47. Lucas Cranach the Elder, *Martyrdom of Saint Erasmus*, woodcut, 1506.

materials in this altarpiece, sometimes by way of an underlying source, for instance, with the *Ars Moriendi*, or in drawing on information to enrich the imagery, whether from medical handbooks, life stories of the saints or popular broad sheets. But a comparison with certain prints of the period helps us to clarify a basic distinction between two modes of addressing the viewer. While prints, of course, transmit information visually, they function essentially in the manner of the written discourse they are meant to illustrate. For instance, the fact that narration through serial presentation characterizes an appreciable segment of early engravings and woodcuts suggests how the linear sequence of writing underlies this pictorial conception. Furthermore, the illustrations in contemporary scientific manuals, such as herbals, rapidly developed a graphic syntax to mediate between the world of natural appearances and that of conveniently legible signs. In certain single sheets, such as Cranach's *Martyrdom of Saint Erasmus* of 1506 or Dürer's engraving of *Saint Eustace* of ca. 1500 (Figs. 47 and 48), we find that even though these were created

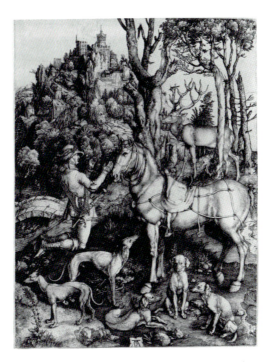

FIGURE 48. Albrecht Dürer, *Saint Eustace*, engraving,
ca. 1500.

independently of texts, their small size and elaborate detail turn the
viewer's role into a kind of deciphering, that is, into a procedure more
like reading than looking. One's eyes explore, traveling from point to
point, surveying the scene on pages that constitute their subjects much
as a narrative description might. By contrast, the commitment in the
altarpiece is suggested by its direct appeal to visual perception—to what
can be experienced through seeing alone, as opposed to the verbal les-
sons of a text.

Like the priest holding high the Host for the congregation, Grüne-
wald's presentation uses demonstration rather than a written model of
narration. Sometimes this is evinced in the process of translating biblical
motifs into visual form, where the spectator receives fresh and imme-
diate access to notions well known through their transmission by writ-
ten texts. For instance, what could be a more thoroughgoing and mov-
ing transformation of the idea of John as foreteller or support for Christ
than the way John's foot, in the *Crucifixion* scene, overlaps and, in effect,

becomes the hind leg of the lamb (Fig. 49)? What better equivalent for his place as intermediary between Christ and man than the shifting point of view Grünewald uses, causing us to see the group around the Virgin slightly from above, Christ slightly from below, and John the Baptist straight on (Fig. 20)?

In other parts of the altarpiece, the artist articulates for the viewer, through strictly pictorial means, as with the use of light, established doctrines concerning the nature of the body of Christ. In the middle stage, there appear to be four implied zones that account for the earthly and spiritual states of Christ's body in alternating sequence (Fig. 3). Surveying the entire visual field from left to right, we see: (1) the Annunciation—the spirit housed; (2) the Virgin in glory, embodying her destiny as sacred shrine; (3) the Virgin and Child in a landscape, symbolizing earthly entrance; and (4) the Resurrection—the spirit liberated. Grünewald underscores these divisions through differing modes of light. The two zones referring to the body's earthly existence are defined by areas illuminated from an outside source. The two spiritual zones are dark and contain objects that emit their own light.

FIGURE 49. Grünewald, Isenheim Altarpiece, closed state (detail).

Grünewald's exquisitely skillful use of gesture serves as a key to his strategies of presentation. If we look at John the Baptist's elongated forefinger pointing up at Christ's body in the closed state of the altarpiece (Pl. 7), we know we are in a world that reveals by showing rather than by telling its stories. Indeed, the epideictic gesture both commands precise attention and serves as a bridge to another appointed feature. This dual property can serve as a functioning model for the way motifs relate to one another throughout the altarpiece, where interpretive associations also derive from the process of looking.

For example, our initial observation that the chalice, a receptacle for the blood that issues from the lamb's wound in the *Crucifixion* section, is on a vertical axis with the chest wound of Christ in the *Lamentation* predella (Pl. 7) leads to an awareness of an arrangement of motifs according to zones of meaning—conceived longitudinally across a single layer of panels, as well as through the layers of panels in depth. When the central section is opened, we notice that the infant Christ supported by the Madonna is on a vertical axis with the dead Christ supported by John the Evangelist (Fig. 50). This constitutes part of a more general interweaving of the state of Christ's birth with that of his death. In the *Crucifixion*, the pose of the swooning Virgin alludes to her pregnancy. The section of the predella with which she is aligned—the empty tomb and the crown of thorns (Fig. 51)—indicates an identification between the agony of birth, the first separation, and that of death. When both central panels are folded to the sides, it is noteworthy that the *Meeting of Saints Anthony and Paul* folds on top of the *Annunciation*, both conspicuously scenes of meeting or visitation (Pls. 2 and 5). The structural parallel between these two events relates to other important ways in which the life of Saint Anthony is linked with that of Mary and Christ. Here Anthony visits the aged Paul to receive the ultimate wisdom from him, while Mary is imbued with the Holy Spirit.

Unlike contemporary works in the Vatican, whose iconographic programs may seem to precede their visual realization and have an existence apart, like a musical score, the Isenheim Altarpiece, with the relationships and hierarchies its physical structure provides, reveals its patterns of meaning during and through one's direct experience of it. To invoke once again the original viewer's context is to realize that even our drawing forth of concordances and cross references of form and meaning would have been part of this direct experience. For we can assume that, in contrast with the modern viewer, the inhabitant of the monastery saw

the altarpiece over a relatively long period of time, and repeatedly, so that its successive stages could be synthesized through memory projection.

Paradoxically, the written inscriptions that appear on the altarpiece also underscore the power of demonstration and a confidence in the possibility of revelation through direct perception. This facet of its content brings up the important consideration of typography. For if it is through an implied reaction to the burgeoning supply of mechanically reproduced illustrations that the Isenheim Altarpiece asserts the nature of presence for the viewer, we should examine as well its position in relation to printed texts: in relation, that is, to the printed word.

By the time the altarpiece was completed in approximately 1515, Europe, northern Europe in particular, was experiencing the transition from manuscript to print and the rapid proliferation of all kinds of texts: Bibles, life stories of the saints, such as the *Legenda Aurea*, spiritual guidebooks, medical and naturalists' handbooks, geographies, classical histories, and epics.[30] Isenheim, a town that has by now disappeared

FIGURE 50. Grünewald, Isenheim
Altarpiece, middle state (detail).

from all but the most detailed regional maps, was on a major thorough-
fare between northern Europe and Italy. With the Antonites as papal
physicians, Isenheim was a likely resting point for travelers to and from
Rome.[31] It was located, moreover, at the hub of four important printing
centers—Strasbourg-Basel/Augsburg-Paris—at less than a day's journey
from Basel, with its growing university and publishing industry.[32] The
way to Strasbourg, some ninety kilometers from Isenheim, would likely
have been interrupted, for instance, in Sélestat, birthplace of the hu-
manist Beatus Rhenanus and seat of a significant library and circle of
humanists. In Strasbourg, through the vehicle of subsequent publica-
tion, the cathedral's great chancellor, Geyler von Keysersberg, had made
of the sermon a powerful expository tool for interpreting anew the val-
ues and goals of Christianity.[33] There, too, only recently, the peregri-
nations of Erasmus, whose career, above all, was wedded to publishing,
had brought him to the illustrious resident literary society, the Sodalitas
Litteraria; its membership was responsible for translating and annotat-

FIGURE 51. Grünewald, Isenheim
Altarpiece, closed state (detail).

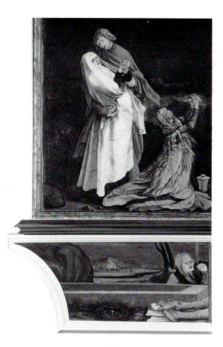

77

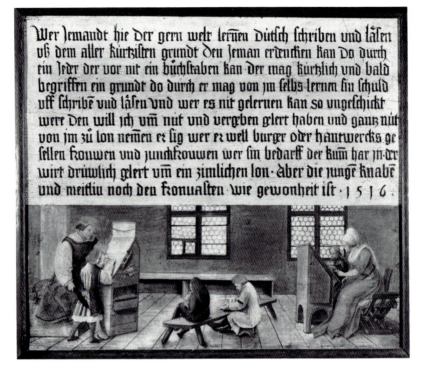

FIGURE 52. Ambrosius Holbein, Schoolmaster's Sign, panel, 1516.

ing the classical authors, establishing pedagogical reform in the school system, and raising in a formal way, through publication, the issue of national identity for the region of Alsace.[34]

Printing objectified writing and the possibility of a new precision in the placement of text on the page furthered philological studies, facilitating more elaborate commentary and more extensive translations. Greater availability of written materials and more numerous kinds and treatments of texts created new pressures toward literacy. That a place like the monastery at Isenheim had an extensive library is not surprising, but the written word was also coming into the province of differing segments of society.[35] Surviving signs that advertise reading and writing lessons, contemporary with the Isenheim Altarpiece, picture peasant folk and include women and children (Fig. 52). Shortly, too, Protestant ideology was to place increasing value on the word, as individual Bible reading began to supplant ceremonial participation in a movement away from the devotional image and the altar and toward the scriptures.[36]

In the Isenheim Altarpiece, written inscriptions appear on each of its levels; they betray an epigraphic sophistication made possible through printing. Each one is in a different script: Roman lettering for the passage from the Gospels in the closed state, Gothic lettering for the sentences from Isaiah in the middle state, and cursive script for the *cartello* in the *Temptation of Saint Anthony* in the open state.[37] Each, affixed to a different field, derives from a distinct category of religious writing (the Gospels, a liturgical book, and the Lives of the Saints, so that a tripartite hierarchy of significance is suggested. But rather than proclaim the superiority of the textual world, Grünewald creates a particular dialectic between word and image in each stage of the altarpiece to establish the primary impact or resonating effect of the visual form. In the panel of the *Temptation of Saint Anthony*, for instance, we find him weighing the one against the other.

At the lower right corner, on the *cartello*, is the inscription "Ubi eras ihesu boni, ubi eras? Quare not affuisti ut sanares vulnera mea?" ("Where were you good Jesus, where were you? Why were you not there to heal my wounds?") (Fig. 53). This poignant plea, evocative of Christ's words to God the Father at the Crucifixion, are attributed to Saint Anthony in Athanasius's biography of the saint. But the *cartello* at the right corner is a compositional counterpart of the diseased demon at the left (Fig. 16). The pathetic figure thereby becomes a visual embodiment of the verbal supplication on the *cartello*. At this moment of changing patterns of literacy in Europe, we find other contemporary instances of the juxtaposition of visual evidence with verbal description, as in the above-mentioned placard advertising reading lessons, dating to 1516, now in the Basel Museum (Fig. 52). Here a discursive text is objectively illustrated, presumably for those not yet able to decipher the words. We can posit an audience for Grünewald's panels too, composed of literate and illiterate alike, which these two modes, writing and depicting, take into account. Nevertheless, in the *Temptation of Saint Anthony*, the representation of this most human-looking of the demons, at the viewer's eye level, is an image so charged in its power to attract and repel that its message overwhelms the textual fragment associated with it.

In the closed state of the altarpiece, appearing in the triangular space bounded by John the Baptist's bent right arm, are the words attributed to him in the Gospel according to Saint John 3:30—"Illum oportet crescere me autem minui" ("He must increase, but I must decrease")(Fig. 54). Here Grünewald both contracts and extends the significance of the sentence. For if there is one motif that most viewers remember as an

FIGURE 53. Grünewald, *Temptation of St. Anthony* (detail).

emblem for the Isenheim Altarpiece, it is John's extraordinary pointing
gesture. Indeed, his tense forearm and elongated index finger have a di-
rect deictic force that far exceeds the impersonal, third-person formu-
lation with which the inscription sets out. At the same time, these pro-
phetic words from the Gospel of Saint John achieve a status of
universality through Grünewald's presentation of the red Roman ma-
juscules floating against the night sky. And the suggestion in the state-
ment of a broader theme of growth is taken up throughout, sometimes
with the depiction of actual vegetation, as in the *Meeting of Saints An-
thony and Paul* (Pl. 2), or through the vegetal motifs that serve as archi-
tectural ornament, as on Saint Sebastian's column or especially on the
gold tabernacle (Pls. 4 and 7). Even Christ's body on the cross seems to
be identified with a tree, its expansive chest covered with sores,
scratches, and thorns like the trunk and bark, the feet gnarled like roots,
and the hands opened like branches (Fig. 20).

FIGURE 54. Grünewald, *Crucifixion* (detail).

The middle stage contains the quotation from Isaiah 7:14—"Ecce virgo concipiet et pariet filium et vocabitur Emmanuel" ("Behold, a virgin will conceive and will bear a son and he will be called Emmanuel")—in the Virgin Annunciate's open book (Fig. 55). Here Grünewald manages at first sight to obliterate the inscription through its location in the overpowering and hypnotic painterly context that is the middle stage. Furthermore, the *Annunciation* scene, more than any other section of the altarpiece, is shaped by the performative ingredients of mystery plays and of the Mass itself in the way it transposes these prophetic words into dramatic act. Spanning a bay in an ecclesiastic interior, two narrow rods support curtains that have just been opened to unveil this scene (Pl. 5). We know that during the celebration of the Mass the priest was sometimes hidden by such a curtained section of the church to dramatize the sacred moment of transubstantiation (Fig. 56), and that surviving mystery plays narrating the Annunciation sometimes call up the Angel Gabriel from such a curtained space at the appropriate time in the liturgy.[38] Even the book itself partakes of this character of revelation, its pages seeming to have flown open miraculously to the prophetic passage.[39] Finally, as naturalistic as the *Annunciation*'s architec-

tural setting appears to be—a Gothic building probably similar to the now destroyed church in Isenheim—the artist distinguishes between foreground and background space by coding the colors of the rib vaults to familiar moral and emotive attributes. As perceptual signs for Isaiah's message, the red ribs covering the Virgin and the place of the Incarnation signify martyrdom and sacrificial love; over the windowed bay in the background—container for the dove of the Holy Spirit, the shelf of unopened books, and the light—the rib vaults are green, color of promise and hope.[40]

The status of visual presence in the Isenheim paintings, marshaled in support of a Catholic vision to challenge the ontology of the printed image and the printed word, is confirmed through comparison with certain post-Reformation paintings. Perhaps the most characteristic type is the so-called *Allegory of Law and Grace*, as exemplified by the panel from the Gotha Museum (Fig. 57).[41] Iconographic parallels to the Isenheim

FIGURE 55. Grünewald, *Annunciation* (detail).

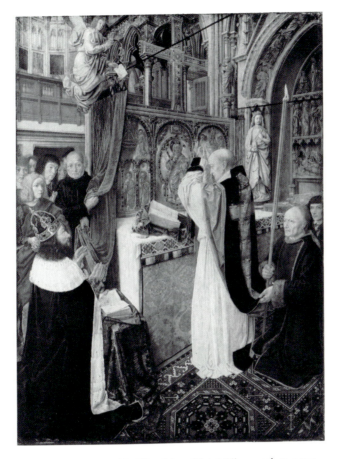

FIGURE 56. Master of S. Giles, *Mass of Saint Giles*, panel, ca. 1490.

Altarpiece are evident. The subject shares its symmetrical distribution around a central axis (a tree with living and dead branches), with the middle layer of the altarpiece where the Incarnation tabernacle is thus divided from the Madonna and Child (Pl. 4). The presence of John the Baptist and the lamb at the foot of a crucifix also recalls those important features in the Isenheim *Crucifixion* (Pl. 7). But at Isenheim the painted images are the culmination of a complex process of imaginative visualization on the part of the artist and express a newfound unity in pictorial transformation. The eschatological program of the altarpiece successively reveals itself to the worshiper as it opens out to a paradisiacal fu-

FIGURE 57. Lucas Cranach and workshop, *Allegory of Law and Grace*,
panel, 1529.

ture. By contrast, the Reformation picture divides Old and New Testament scenes down the center like the two sides of an open book. Repeatable, stock motifs in additive combination enunciate the moral lesson of the *Allegory of Law and Grace*. Indeed, at its ground line, explanatory inscriptions establish corresponding zones for the subjects in the pictorial field above, word determining image as in the sequential dynamic of a cartoon strip.

We know this subject to have issued from the workshop of Lucas Cranach.[42] But as a picture type it seems less the willed product of an individual artist's design than a statement drawn from and reiterated by communal lore. On the question of perceptible artistic persona, it is not that Grünewald imposes himself on viewers of the Isenheim paintings—an impression that could be understood as informing the stylistic stamp of certain examples of contemporary Italian art. Rather, Grünewald was committed to expressing the work's uniqueness, which—in the face of printing—the combination of scale and exposition through the painterly medium could best insure.

One cannot fail to bring into this discussion Dürer's most impressive paintings, the "Apostle" panels, now in the Munich Alte Pinakothek, which he donated to the town hall in Nuremberg (Fig. 58). As tokens of his belief in the cause of the Reformation, Dürer's "Apostles" have in common with Cranach's picture their Protestant message. But where Cranach seems to be merely the vehicle for the dissemination of preexisting iconographic fragments, Dürer bequeaths his own artistic persona in these panels—his grand conception, his stage or phase of style: that presentation pared down to essential figures shaped as if to illustrate the notion of an old-age style. When the literature on these panels has not simply seen them as a product of Italian influence, it has rightly associated their mode of representation with Dürer's Lutheran conviction.[43] But the way such a stylistic choice actually operated for him in terms of Protestant ideology has not been fully clarified.

With Dürer's vested interests as an artist, it is not surprising that he took a conservative position in the iconoclastic controversy.[44] At the same time, from a Protestant perspective, one must ask what his justification would have been for these extraordinary figures that share with the Isenheim Altarpiece, whatever their original purpose, a grandeur of conception for painting? Here again the issue of the written word comes into play.

It should be recalled that written inscriptions appear at the ground line of these panels. Apart from a modern tendency to undervalue the possible significance of writing when it appears in a picture, as opposed to, let us say, on a medieval manuscript page, here the minuscule scale of the script could seem ludicrous in conjunction with panels so large unless we stop to consider several factors. The inscriptions, quotations from the writings of the four evangelical saints, were clearly important to Dürer. Their message, in the German language of Luther's Bible, serves to promote the Lutheran cause through its cautionary advice against Catholic powers as well as the radical followers of Luther.[45] Furthermore, we know that Dürer expressly commissioned a professional calligrapher to execute the inscriptions, despite the fact that he himself had just published a treatise on lettering the year before.[46] I think we must assume that Dürer wanted the inscriptions to exist as concrete script on a manuscript page rather than as representation within a pictorial space. When we discover that the human eye is physiologically incapable of encompassing both figures and writing simultaneously, but must undergo a shift in focus so extreme as to necessitate a viewer's com-

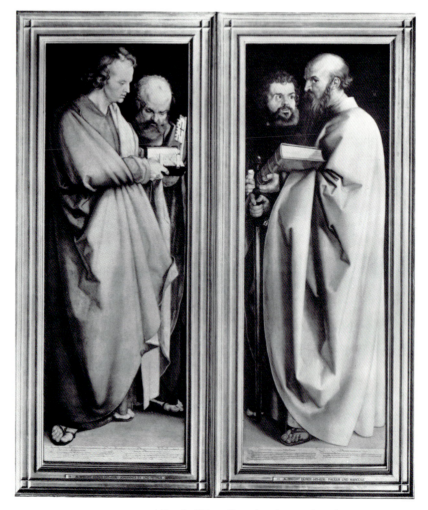

FIGURE 58. Albrecht Dürer, *Four Apostles*, panel, 1526.

plete change of position in space, a motivation for the late, "simple" style suggests itself.

These monumental figures were not destined for visual delectation. The distinctions among their attributes, their facial features (for instance, the eyes), even the sharp color contrast between the garments of John and Paul in the foreground, Dürer maintains for didactic purpose.[47] Once observed, these magnified essences of humanity impress

themselves on the viewer's consciousness and, as conceptual embodiments, make their reappearance in the mind's eye—a reverberating process that was doubtless meant to accompany and illuminate the deciphering and understanding of the all-important written words.[48] By contrast, the Isenheim Altarpiece reveals itself as an immanent occurrence. Both in terms of sheer scale—we are confronted by a world seemingly able to encompass our own bodily size—and as a container of radiant light and color, these panels combine to elicit immediate and intense response, and, as we have seen, they present certain tenets of Catholic doctrine as processes to be sensed directly by the worshiper.

Geared toward an experience of communion rather than of private contemplation, the Isenheim Altarpiece faced a manifold audience, which it now remains to consider. Obviously the monks at Isenheim were the primary recipients. At the same time, our discussion of the function of this altarpiece in a healing program at the monastery hospital has helped us to imagine also a nonliterate group that the artist and the commissioners had to serve. One needs, in other words, to account for different levels of address, with the use of expressive language pitched to the uneducated worshiper, as well as motifs and images whose range of associations might more readily be understood and coordinated by a literate group.

As modern historians, we frequently narrow the scope of a work's possible reception by hypothesizing a homogeneously educated audience—one perhaps better designed to understand our own efforts at historical reconstruction than to reflect the rich cultural repertory of a period shared across boundaries of class and occupation. Nor have the tremendous contributions in the last decade to the study of popular culture totally resolved the problem. In their shift to such evidence as popular prints and broadsheets, these studies may neglect just this possibility of simultaneously existing strata of social referents incorporated by a single masterpiece like the Isenheim Altarpiece.

If this way of functioning as a system of communication—to a variegated audience on different levels—seems unique in its manner or urgency, we must realize that a kindred drive clearly motivated the field concerned above all with the problem of communication, namely, the theory and practice of contemporary preaching. In the countless handbooks on preaching that were printed about the same time that the Isenheim Altarpiece was first commissioned, the issue pivots on the prescribed use of vernacular tongues in addition to the Latin language. Ul-

rich Surgant's popular *Manuale Curatorum* supplies lessons for the pastor: "tam latino quam vulgari sermone practice illuminatum."[49] And the printer's preface to a 1506 edition of Jean Gerson's manual on preaching declares its publication in both French and Latin to conform to the original goals of the Chancellor of Nôtre-Dame in Paris: "Lequel pour ledification tant des gens d'eglise que des laiz: il a escript tant en latin qu'en francois."[50] Closer at hand, Geyler von Keysersberg, as an orator, seems to have embodied that alternation between the intimate and the formal in an approach parallel to what I have been describing. The direct and personal language with which he would on occasion appeal from the pulpit as if to an individual member of the congregation must be contemplated for its effect against the backdrop of the intricate, rose-colored vaulting of Strasbourg's gigantic cathedral as it spun its way heavenward.[51]

At the same time, we must remind ourselves that it is in the nature of the visual arts, as of music, to be capable of speaking to even the most uneducated member of its audience. Indeed, Grünewald's powerful visual effects and the tangible connections and contrasts that he provides for the viewer are marshaled to encompass such a group. But even in relation to the monks at Isenheim, the aim in this altarpiece was to put forward a space unencumbered by the scaffold of a written syntax. The familiar scholarly method of accounting for the subject matter of Renaissance painting through the identification of literary sources for its imagery diverts our attention, in the case of the Isenheim Altarpiece, from this defining feature of the artist's approach. The wonder of ascension, the shock of death, the inspiration of revelation, the immanence of suffering: these are conveyed as experiences beyond the text, beyond narration and strict illustration, and in the nature of presence itself.

III

FIDES EX AUDITU:
JOHN THE BAPTIST,
BAPTISM, AND JUDGMENT

N o character in any of Grünewald's paintings stands before us as calmly and resolutely as does John the Baptist in the *Crucifixion* scene from the Isenheim Altarpiece (Fig. 59). We see the way his feet meet the ground, their broad spread providing firm support for his erect stance near the foreground plane, the fine edges of the saint's upright body fixing him against the nocturnal background. Yet there is an irony here: martyred before the death of Christ, John the Baptist is the one personage represented whose participation is chronologically unwarranted at the time of the Crucifixion. This should be enough to make us contemplate the significance his presence imparts to the altarpiece.[1] But there is more. We have already noted some of the features associated with John: the body of water behind him in the background, the inscription floating above the crook in his right arm, the lamb at his foot. Let us now interrogate him more fully from within the fabric of Grünewald's overall exposition. The resonating or burgeoning effect of meaning of this single figure can orient us to the supernatural terrain charted by the altarpiece. In doing so, it will touch on the mechanism of vocal address, audience, and reciprocal recognition. What follows will in turn reveal the poignant project at Isenheim of affirming a harmonious Catholic world view at the brink of a period of spiritual crisis.

I return to a point already made in the first chapter, namely, that the sacrament of baptism emerges as a capital theme in the Isenheim Altarpiece. This is not simply to identify an iconographic or liturgical feature—a procedure that would seem to advance the scholar's need to bring under control the spiritual dimensions and cult value inherent in such a work of religious art. Rather, it must be emphasized, this altarpiece calls up a wider perspective accessible to anthropological scrutiny. Through references to exorcism and judgment, it shifts our scope on baptism from the assumption of a familial ceremony enacted upon in-

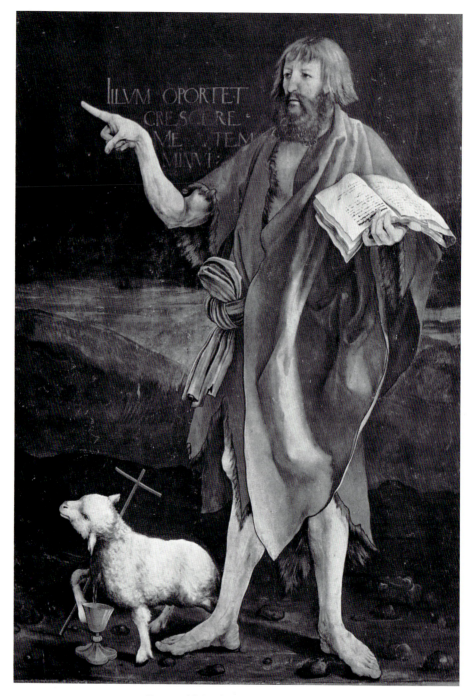

FIGURE 59. Grünewald, Isenheim Altarpiece, *Crucifixion* (detail).

nocent, preconscious beings to let us fathom a theology that, in principle, entailed the full risk of active commitment to belief in the face of the harshest moral struggle. For the Antonite monastery and those in its orbit, baptism's priestly rituals of healing and the believer's spoken testimony of faith hold special drama. But beyond its function as a prescribed rite of the Church, baptism, together with the eucharistic sacrament, constituted the mythic core of expectancy for Christian life. Moreover, the sacrament of baptism was the vehicle through which were structured universal preoccupations with the passage from birth to death, the trials of maturation, and the mystery of time subsequent to death.

The Baptist saw and implemented a new era, and the inscription "Illum oportet crescere me autem minui" ("He must increase, but I must decrease") suggests the process of transfer from one predominating order to another. Patristic commentary is at pains to clarify the meaning of this sentence. In the writings of Saint Augustine, for example, the increasing and decreasing is linked to the waxing and waning of the sun. In practice, Augustine explains, John's birthday, June 24, occurs just after the summer solstice, when the days grow shorter, whereas Christ's birthday, at the winter solstice, inaugurates the gradual lengthening of the daylight hours.[2] This quality of diminution and intensification of light may be a motivating factor in the sharp contrast between the bleak atmosphere of the Crucifixion scene and the brilliant effects of light in the second level of the altarpiece. Grünewald also embodies this process of exchange of scale graphically by enlarging Christ's body on the cross compared to any of the attending figures.

Just as the figure of John the Baptist in the *Crucifixion* and the inscription beside him account for the passage from an old to a new order of time, so, too, the inscription on the second level of the altarpiece signals the process of initiation from one existential state to another that gives the rite of baptism its significance. In the *Annunciation* panel are the words from Isaiah 7:14–15—"Ecce virgo concipiet et pariet filium: et vocabitur nomen eius Emmanuel"—that are traditionally understood, according to Christian exegesis, to herald the birth of Christ (Fig. 55). They commonly appear in Annunciation scenes, but Grünewald follows this prophetic statement with the next line from Isaiah, which is rare in visual representations: "Butyrum et mel comedet: ut sciat reprobare malum et eligere bonum" ("He will eat curds and honey until he knows how to refuse evil and choose the good"). Milk and honey are two of

the foods of paradise; alternatively they can be considered the staples of a primitive existence.³ Paul's letters shed light on the deeper application of this formulation. In Hebrews 5:12–15, lamenting his people's need to relearn what it should already have been capable of teaching—the basic moral lessons of God—Paul addresses them, saying, "You have gone back to needing milk, not solid food. . . . Truly, anyone who is still living on milk cannot digest the doctrine of righteousness because he is still a baby. Solid food is for mature men with minds trained by practice to distinguish between good and bad."⁴

The fig branch in the center of the middle stage summons up this capacity for moral discernment as a sign of maturation, attendant on the ability to digest the "solid food" of Christian doctrine. Arching over into the world of Christ's birth, the fig tree is a symbol of the Advent season and harbinger of the messianic kingdom (Fig. 60).⁵ But its leaves also recall the tree of knowledge from the Garden of Eden, that well-spring for the moral categories brought forth by man's original sin: the primal knowledge of the body that, in the Catholic view, necessitated Christ's appearance in the world as redeemer and judge.⁶ For the Christian citizen, the initiatory rite of baptism provided the arena for the renunciation of evil and, ultimately, for the journey through the body to the spirit that is the goal of the Christian life. The formal imprint of this journey we see in the ascending diagonal from the Madonna's book in the *Annunciation*, through the heads of the two Madonnas in the central section, up to the aureole encompassing the resurrected Christ (Fig. 3).

For our purposes it is noteworthy that the words appearing next to John the Baptist, taken from the Gospel of Saint John 3:30—"Illum oportet crescere me autem minui"—are spoken after John's baptism of Christ. Reacting to his followers' queries about Jesus, the Baptist says, "You yourselves can bear me out: I said: I myself am not the Christ; I am the one who has been sent in front of him. The bride is only for the bridegroom; and yet the bridegroom's friend, who stands there and listens, is glad when he hears the bridegroom's voice. The same joy I feel, and now it is complete. He must grow greater, I must grow smaller." Augustine's commentary on this sentence takes us to Matthew 3:11: "I indeed baptize you with water into repentance; but he that cometh after me is mightier than I, whose shoes I am not worthy to bear: he shall baptize you with the Holy Ghost and with Fire."⁷ This statement vividly conveys Christ's growing strength and John's awareness of his diminishing role as it is expressed through the distinction between their bap-

FIGURE 60. Grünewald, Isenheim Altarpiece, *Madonna and
Child and Incarnation Tabernacle* (detail).

tizing functions: from worldly healing and expiation to spiritual purifi-
cation and transcendence effectuated by Christ's sacrifice. The baptism
of repentance and cleansing of sin are emphasized in the closed state
through the kneeling Magdalene, who is on the same foreground plane
as John the Baptist, and whose raised, wringing hands and splayed fin-
gers are the only motif overlapping the background water on the left
side of the cross (Fig. 61).

This baptism with "the Holy Ghost and with Fire" is the cosmic trial
conducted by Jesus at the Last Judgment. At the end of the Gospel of
Saint Mark, Christ himself straightforwardly affirms the juridical deter-
minant in baptism when he says, "He who believes and is Baptised will
be saved, he who does not believe will be condemned."[8] Once again,

FIGURE 61. Grünewald, Isenheim Altarpiece, *Crucifixion* (detail).

Grünewald's presentation of the figure of John the Baptist is germane. The biblical metaphor of John as witness to the Christ is expressed in terms that would have been familiar to viewers from the repository of rhetorical expressions proper to courts of law, as we can observe in the influential late medieval legal digest known as the *Sachsenspiegel*, which was widely copied, translated from Latin to the vernacular, and circulated before the sixteenth century.[9] In it, scripted explanations combine with lively drawings to record the range of possible "courtroom" proceedings. Centering especially on the gestures that had become formulaic accompaniments to the spoken transactions, these illustrations show an exaggerated indicatory gesture like the one of Saint John when they render a testifying witness (Fig. 62).[10]

Moreover, John the Baptist's presence in the *Crucifixion* completes the traditional Deësis group of Last Judgment representations. From a heraldic point of view, we have Christ in the center, the Baptist at his left, and the Madonna at his right side.[11] The fixed wings of Saints Sebastian and Anthony amplify this reference, alluding by synecdoche to the realms of paradise and hell (Pl. 7). To Christ's right, Sebastian's partially nude body and the light, airy landscape indicate a state of purity. Angels visible in the sky complete the suggestion of a paradisiacal realm. The voluminously clothed Anthony, to Christ's left, stands against a dark background. With a demonic creature attacking at his window, this panel conjures up the zone of hell.[12]

In discussions of the development of the triptych in northern art, it has not been sufficiently stressed that the format ensues, in part, from a need to inscribe a Last Judgment topography—with its moralized left and right sides—onto the thematic program.[13] This eschatological realm, usually available through the heraldic reading of the forms, but secondary or latent in content, was the prominent feature in Romanesque and Gothic architectural sculpture, where it would often provide the theme for one of the tympana of a church. Christ's role as judge in the last and final determination of man's destiny, dramatized by the act of reckoning between good and evil, between salvation and damnation, constitutes the climax of Catholic cosmology. When an artist like Hieronymus Bosch once again moves the *Last Judgment* to the manifest level in his triptychs of about 1500 (such as *The Haywain* and *The Garden of Earthly Delights*), we can surmise that both personal and cultural preoccupations with death and with the limits of time lend new fervor to the treatment of this traditional theme.[14] It is a theme that would

FIGURE 62. Heidelberger Sachsenspiegel (detail),
manuscript, ca. 1320. Cod. Pal. Germ. 164, fol. 28.

necessarily have been at the forefront of consciousness (as I have already
suggested), where the goal, as at the Isenheim monastery, was to care
for those afflicted with disease.

As we touched on in the first chapter, the dispensing of judgment is
an important aspect of the authority of Saint Anthony and pivots on his
power to cure the sick, as well as to inflict disease. In the open view of
the altarpiece, we find Anthony enthroned like a judge at the center of
a Deësis-type of triumvirate (Pl. 1).[15] Two small wooden figures at the
saint's feet kneel in homage as they offer their respective gifts, a rooster
and a small pig (Fig. 5b). We know from written and visual records that
the giving of such comestible tokens as payment or "insurance," in par-
ticular by a client-citizen to a lawyer or judge, was common social prac-
tice.[16] In the worldly reflection of the Last Judgment that is the open
state (Fig. 2), the *Meeting of Saints Anthony and Paul*, to the right of the
sculptured Anthony, presents a sacred grove remote from civilization, a
space for the two holy men to commune in peace. The wing of the *Temp-
tation of Saint Anthony*, at the enthroned Anthony's left side, is the living
hell, with monsters and demons invading the space and attacking the
saint.[17]

The Isenheim Altarpiece is, in fact, replete with demonic features, some of which we have already discussed. In the *Temptation of Saint Anthony* scene (Pl. 3), animalistic demons torture the saint by beating him, pulling his hair, tugging at his garments, and biting his hand. In addition, small devilish creatures in the background seem to be stoking Anthony's hut, while others are fending off a battalion of tiny angels that descend from the sky. In the closed position of the altarpiece, in the wing flanking the *Crucifixion*, a pig-snouted devil tears apart the window grating behind the standing Saint Anthony as he blows his foul breath into the saint's space (Fig. 7). Anthony's relation to the demonic world derives from the historical account of his temptation, but also specifically depends on his connection to disease. As disease was thought to indicate the presence of sin, so the particular illness known as Saint Anthony's Fire was frequently paralleled with the fires of hell.[18]

Instigating man to his original sin was Satan, the embodiment of evil, who remains a constant antagonistic force in the mythological system of Catholicism. Within the sacramental economy, it is baptism that forces the individual most dramatically to confront the sin within himself and the quotient of evil lurking in the world as a persistent threat to even the true believer.[19] It should be recalled that Christ's own temptation by the devil, which occurred immediately after his baptism, was thus inextricably associated with it.[20] In the Isenheim Altarpiece, the *Temptation of Saint Anthony* scene (Pl. 3) graphically projects a worldly echo of Christ's arduous trial. The period before baptism is marked by a parallel struggle, when the catechumen is perceived to be morally imperiled. Considering the hospital context of the Isenheim monastery, it is important to note that this moral condition was frequently envisaged as ethical illness, disease, or even as a state of possession.[21] Indeed, baptism came to be seen as effecting no less than a conversion from the realm of Satan to the path of Christ, enacted ritually through a sequence of movements of the body and declared vows of renunciation and allegiance on the part of the candidate.[22]

But so strong were the pressures of possible evil that even this prescribed behavior was deemed insufficient. Thus, with baptism as the ultimate curative, a series of apotropaic and exorcistic procedures has also been contained in the Catholic form of this rite. The marshaling of a magical defense system, characteristic of the apotropaic approach, forms part of the liturgical dramatization of the conflict with the devil in the ceremony of baptism—as, for example, in the anointing of the catechumen with oil.[23] We noted in the first chapter how the altarpiece incor-

porates apotropaic devices, such as the coral on the rosary held by the Christ child and the gems in the angels' rings. The need to ward off impending attacks by evil forces appropriately occurs in this middle state of the altarpiece, which projects a realm of the future.

The figure of Saint John the Baptist in the Isenheim *Crucifixion* bears traces of motifs to be associated with exorcism. Pointing energetically with his right index finger toward the crucified Christ, John appears to initiate a process based on a set of prescriptions taken from the book he holds open with his left hand (Fig. 59). With its soft vellum cover, this text is distinct from the hard-covered books in the *Annunciation* scene. In this respect and in the way it is held, it repeats the manuscript used by Saint Cyriac, in Grünewald's Frankfurt panel of this saint, who is engaged in performing an exorcism (Fig. 63).[24] Also suggestive are the brooches worn at the neck by the angels in the middle state of the altarpiece, the best preserved and most elaborate of which is that of the Annunciate angel (Pl. 5). Like an inverted pineapple with foliage at the top, this brooch encloses what seems to be a dark faceted stone within its polygonal rim. It is identical to one of the two brooches worn by Saint Cyriac and in that context has been directly associated with exorcism.[25]

To us, the ritual of exorcism may seem merely formulaic. In early Protestantism, moreover, this antidemonic component of baptism became a point of contention, was judged to be excessively freighted with magic and superstition, and was progressively purged from the Protestant liturgy as it crystallized. This is evident, for instance, in a German version of the rite from Strasbourg, dating to 1513 and revised in 1525 and 1530.[26] To imagine the original energy with which exorcism motivated and determined the shape and meaning of the baptismal rite, however, we need only look to the Gospels and the importance given there to the exorcistic acts of Christ, as in the transference recounted in Mark, Luke, and Matthew of the demonic spirit from the Gerasene man to the herd of pigs.[27] When Christ admonishes the disciples for failing to cure a possessed boy, he equates this power with the capacity for faith or belief.[28] As these qualities, in turn, are the precondition of the baptized, so, according to the Gospel of Saint Mark, Christ includes exorcistic healing in his mission to the disciples.[29]

If, through its pictorial strategies, the Isenheim Altarpiece enforces the notion of presence essential to the eucharistic sacrament, as I argued in the preceding chapter, in affirming baptism, Grünewald suggests a powerful auditory address. Such a characterization may seem out of

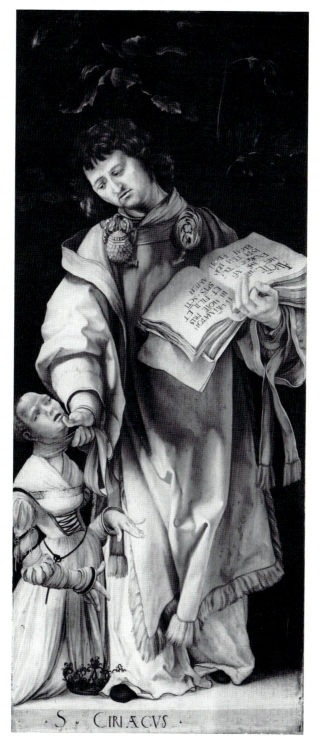

FIGURE 63. Grünewald, *St. Cyriac*, panel.

place: how can a painting convey sound? Or, more narrowly, this kind of feature may appear anachronistic in the period we are dealing with—more appropriate to the sophisticated testing of boundaries between the media and the manipulation of perceptual expectation in late nineteenth-century experiments with synesthesia by composers, painters, and poets such as Verlaine, Baudelaire, and Debussy. In Grünewald's panels, the most striking auditory feature is, of course, the group of music-making angels in the middle section of the altarpiece (Pl. 4). This iconographic motif does occur in countless examples of altar painting. But with the effect of vibratory radiance of light that envelops Grünewald's angels as they vigorously bow their instruments, the artist creates a perceptual equivalent for the harmonious chords of a musical sequence that seem to well up within the pictorial space and resound in the viewer's world. But Grünewald's is not merely a virtuosic conjuring of sound with the brush. There is evidence of a broader acoustical program.[30] We are on firm historical ground, moreover, if we invoke the sign that served as a primary attribute for Saint Anthony himself—the bell, which embraces, through its auditory function, the conflicting forces inherent in the drama of baptism, from the repelling of evil spirits to the assembling of the faithful.[31] Let us further recall that in echoing the circumstances of God's testimony at the baptism of Christ, pastoral guidebooks around the time of the Isenheim Altarpiece clearly affirm the basic ingredients of the sacrament of baptism to be not only the water but also the spoken word, *verbum*. "Materia Baptismi est aqua simplex elementaris, forma sunt ista verba. Ego Baptiso te. . . ."[32] Accompanying immersion or aspersion with water, a precise verbal utterance by the priest is required, along with the vows pronounced by the candidate, without which the ceremony is not valid.[33] Furthermore, the catechetical method of indoctrination of the uninitiated, that is, of the candidate who awaits baptism, was a strictly oral exchange of questions and answers in preparation for the baptismal rite.[34] Indeed, just as this interrogatory dynamic, geared toward the catechumen's testimony of faith, fuels passages in contemporary sermons, so it may be a useful guide to understanding Grünewald's mode of address.

Throughout the altarpiece, the artist explores the realm of the oral and the auditory, with a sense of the life and community signaled by vocal utterance. At times Grünewald posits antithetical existential states of nature by opposing modalities of sound. In the *Temptation of Saint Anthony*, the monstrous figures wielding sticks, clubs, and bones pro-

duce the sound effect of beating or knocking (Pl. 3). With their open snouts and beaks, the demons appear to grumble, while the distortions in the saint's physiognomy create the impression of whining or shrieking. In a general atmosphere of cacophony, this wing contrasts sharply with the *Meeting of Saints Anthony and Paul* at the other side (Pl. 2). There the seated figures engage in harmonious conversation. Dialogue, spoken communciation between the two elders, projects the condition of human culture with which to counter the chaos of the *Temptation*. The wings on which these are superimposed, moreover, the *Annunciation* and the *Resurrection* of the middle stage, present a supernatural version of these binary extremes (Pls. 5 and 6). The transmission of the *logos*, the divine word, is the basis for the *Annunciation*, the wing under the *Meeting of Saints Anthony and Paul*. In the *Resurrection*, the panel over which the *Temptation* folds, a cosmic thunder seems to accompany Grünewald's transfiguring light—"the violent earthquake" that we read about in Saint Matthew's account (28:1–5), which has sufficient force to topple the guards and unearth the large background boulder.

A dialectic between the oral and the written is suggested by the treatment of the two Saint Johns in the *Crucifixion*, where John the Baptist, on one side of the cross, is a counterpart of the Evangelist on the other side (Fig. 20). Jan van Eyck had already followed a tradition linking these two saints on the outside of his Ghent Altarpiece, where they are juxtaposed and paralleled through their common representation in grisaille (Fig. 64). In the Isenheim Altarpiece, they both wear red garments and possess a physiognomic likeness, their identical reddish-brown, blunt-cut hair distinct from any of the other hairstyles in the altarpiece (Pl. 7). Furthermore, they are bound together structurally by the fact that John the Baptist stands in the main section of the closed state on a vertical axis with the John the Evangelist in the predella below.

Certain key features also serve to differentiate these two figures. The Baptist's bare feet relate to his ascetic life, but from the Old Testament comes the important connotation of standing on hallowed ground. He wears an animal-skin tunic in accord with the Gospel account evoking his period of preparation in the desert wilderness, a time recapitulated in Anthony's hermetic life. The Baptist's full beard, an attribute of the sage and prophet, prompts our understanding of the red cloth mantle draped over his left shoulder, which contrasts with the tunic and creates an apparently separate unit including the open book in his left hand. From the Old Testament story of Elijah (2 Kings 2), the mantle signifies

the prophet's special gifts. Christ himself calls John the Baptist the new Elijah, as in Matthew 11:13–15, when he says, "Because it was towards John that all the prophecies of the prophets and of the Law were leading: and he, if you will believe me, is the Elijah who was to return. If anyone has ears to hear, let him listen!"

In turn, John the Evangelist's guardianship of Mary is graphically presented in the main section; his elastic right arm, encircling from behind, cradles her; his left hand touches her elbow. Moreover, the predella pictures him in the unusual position of sole supporter of the body of Christ. From his Gospel are taken the words for the large-lettered inscription next to the Baptist. But the fact that John the Baptist stands independently on one side of the cross, while John the Evangelist is rendered physically contingent through his supporting function, seems to express the superiority of the prophetic voice over scriptural record—a priority also underscored visually through the Baptist's stance directly above the hunched John the Evangelist of the predella.

What then of the prophecy of the new Elijah? The most far-ranging forecasts of the prophets of the Old Testament were unable to imagine what John was to see. Yet comprising the inscription that attends John the Baptist in the Isenheim *Crucifixion* are words cast more as verdict or prescription than outright prophecy: "Illum oportet crescere me autem minui." If we examine the original context of this sentence, we find that these are among the last words uttered by John. They mark a shift from his active voice to the narrator's description to Christ's increasing verbal authority in a rhetorical equivalent for the role in the Gospel of preaching as a charismatic sign first for John and subsequently appropriated for the Christ. Moreover, preaching is intimately linked with the acts of baptizing and healing.[35]

During the generation before the Isenheim Altarpiece, renewed confidence in the restorative and inspirational effects of preaching informed the activity toward reform within the Catholic church.[36] The frequent appearance in print of contemporary preaching manuals, such as the popular ones by Johann Ulrich Surgant and Guido da Monte Rocherii, along with the publication of classic examples of the genre such as Augustine's *Liber de arte praedicandi* and Thomas Aquinas's *De Arte praedicandi*, testify to this concern.[37] These small pastoral guidebooks cultivate the sermon as a significant vehicle of communication, carefully treating its ideal components, as well as the desired attributes of a preacher. In one of his own sermons, the greatest northern preacher of the period, Geyler von Keysersberg, expresses his conviction about the

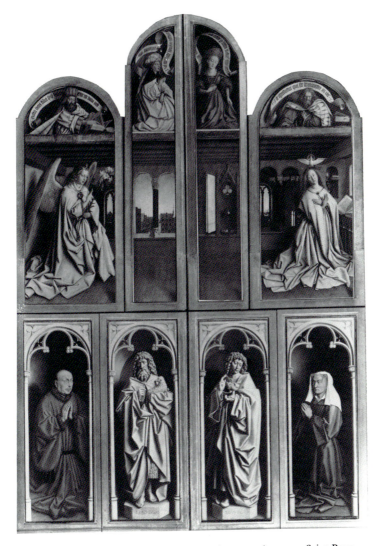

FIGURE 64. Jan van Eyck, Ghent Altarpiece, exterior, 1432. Saint Bavo, Ghent.

radical alterations in perception and belief made possible through preaching. He focuses on John the Baptist, who was thought to exemplify the direct channel between prophecy and preaching. John practiced what Geyler calls "Novitas in predicatione," shaping a language out of words never before conceived for the sermon.[38]

A potential for the novelty of utterance and a sense of the unique and compelling presence that sound creates must fuel the awareness of any gifted orator. In the case of Geyler von Keysersberg, it seems to have inspired a mode of discourse that posits example after example to be observed and contemplated by the audience in the present tense of revelation or the durational present of meditation. From *De Arbore humana*:

> And he who bites into that thing in a healthier and ripe place: leaving the other ones. The whole earth is like a kind of round fruit according to the philosophers: in the middle of which according to the theologians is hell in the center, having four chambers just as the fruit also has kernels inside. The first chamber is hell in which the devil and the damned are restrained, and this section is rotten: Christ does not touch that part. The second is the limbo of the children and this part is bruised, not rotten; They of course do not feel physical suffering, but only (that of) loss: and Christ has not touched them either.

> (Qui mordet illud in saniori et maturo loco: alia relinquens. Tota terra quasi quoddam pomum rotundum secundum philosophos: in cuius medio secundum theologos in centro est infernus/ habens quatuor cellulas (heusslin) sicut pomum habet et nucleos inclusos. Prima cellula est infernus/ in quo diabolus et damnati compressi/ et hec pars putrida est: hanc Christus non contingit. Secunda est limbus puerorum/ et hec est pars livida (molsch) non putrida: non enim habent penam sensus/ sed damni solum: et necque hos contigit Christus.)[39]

Indeed, if we read passages of these sermons, not as possible literary sources—although there are common thematic threads—but rather in terms of their structure, and listening for the echoes of their spoken delivery, we will come closer to the strategies of appeal to an audience that Grünewald employs as a painter. His panels, for instance, in their vivid picturing of themes from religious and spiritual history, may be seen as concretizations of those parts of Geyler's sermons that urge the worshiper to re-create such scenes in his imagination. From the sermon on penitence and the suffering of Christ:

> Let each person consider what great pains the heart has endured when that most desired countenance which the angels and all the

saints desire to gaze upon was sullied with spittle and other impure things, with the striking of cheeks: there someone pulls at his beard, there at his hair, there someone pinches him, there they scratch him, hit him with their fists, kicked him with their feet—all fell upon him.

(Bedenck ain yeklich mensch/ was grossen schmertzen hat der herz geliten do das aller begirlichest angesicht in woelichs die engel begeren zu sehen und alle hayligen/ wurd vermailiget mit spaichlen und andern unrainen dingen/ mitt backen straichen/ da rauffet im ainer seinen bart/ da sein har/ da zwicket in ainer/ da kratztensy in/ schlugen in mit feüsten/ stiessen in mit fussen fielen all über yn.)⁴⁰

Or from the *Granatapfel*:

Thus look with holy David at the face of your holy spouse as he hangs on the cross and seek constant rest in the mark of his sacred wounds.

(So schaw mitt dem heiligen David in das angesicht deines hayligen gesponsen/ da er hangt an dem creütz Und such state ru in den zaichen seiner hailigen wunden.)⁴¹

In another, more dialogical approach, a passage from Geyler von Keysersberg's *Von den sieben Schwerten* shuttles between the direct address of the preacher's exhortation to the congregation and his own projection, in quotation, of a worshiper's response, transposing the worshiper into a member of the dramatis personae in a struggle against suffering and an affirmation of faith.

When you have been touched by vice and impurity and burn with heat, cry up to God out of the writings in the Pater Noster to dispel the Devil. Sire, deliver me from evil, Call to God with Saint Peter. Domine salva nos perimus. Sire come to our aid: we sink and shall decay. When no medicine works any more then one must call on the beloved saints. Like Saint Anthony. Where this same fire comes on one it burns off a limb or a hand. Thus call on him (Anthony) as a remedy against the fire of impurity to pray to God for you that He should come to your aid and not leave you to perish in the evil flaming heat.

(So du mit den laster und unkeuschait geruert bist worden/ und bryñest von hitz/ schrey auff zum Got versetz den teüfel aus der geschrifft im Pater Noster. Her loesz mich von übel/ Rueff zum got mit Sant Petro. Domine Salva nos perimus. Herr kom uns zum hilff/ wir geen under und woellen verderben. Weñ Kain artzney meer wil helffen/ muessman die lieben heiligen anrueffen. Als Sant Anthonium. Wa ain das selb feür ankompt/ breñet es im aiñ schenckel oder ain hand ab. Also rueff in an für das feür der un-keüschait/ got für dich zum bitten/ das er dir zum hilff komt/ und dich in der boesen flackerenden brunst nit woll lassen verderben.)⁴²

Thus, in the open state of the altarpiece, the dialogue in the *Meeting of Saints Anthony and Paul* and the interpretive debate suggested among some of the apostles in the sculptured predella open out more pointedly to engage the viewer in the *Temptation of Saint Anthony* scene. We discussed in the preceding chapters how the placement of the *cartello* at the lower right corner of this panel links it structurally to the diseased demon at the left, and how Grünewald provokes the viewer's sense of identification by placing these features at eye level (Fig. 16).⁴³ In addition, the *cartello*'s orientation—flat, up against the picture plane—and its cursive script are formal equivalents for the direct address of entreaty of the inscription, with its imploring question to Christ, "Where were you good Jesus, where were you? Why were you not there to heal my wounds?"—words that, once pronounced, also become the viewer's utterance.

Rhetorical shifts in direction in Geyler's sermons negotiate between third-person narrative voice and citation of the words of a biblical character who, by virtue of being presented in spoken quotation, addresses the audience directly.

Without help God created heaven and earth with all its embellishments. But the poor sinner that Lazarus should signify for us, who has once again revived and come back to original innocence, he is more and greater to God than the first Creation, for the conversion of the sinner requires self-help along with the mercy of God. As Saint Augustine speaks to the sinner and says: He who created you without your help did not wish to make you righteous without your help. Therefore you initiating person, do not cherish lightly your conversion but be thankful that the sentence of eternal damnation is not imposed upon you and that after many sins you

are summoned to enter into a new state of being. . . . As God speaks through the prophet Joel, so he says in the second chapter of Joel: Turn to me with all your heart, with fasting and lamenting, and then I shall turn to you.

(Gott hat on hilff beschaffen hymmel und erd mit aller irer zier. Aber der arm sünder den uns Lazarus bedeüt soll der wider erkückt werden und in die ersten unschuld komen ist got dem herren mer und groesser dan die erst schoepfung wann die bekerung des sünders bedarff auch aigen hilff mit sampt + barmherzigkait gottes. Als Sannt Augustein redt zu dem sünder und spricht. Der dich beschaffen hat on dich mag nit gerecht mach en dich on dein selbs hilff. Darumb du anhebender mensch schaetz nitt ring dein bekerung und biss danckber das nich ueber dich verhengt werd das urtail der ewigen verdamnuss und das du nach vil sünden bist gevordert in ain anhebens vesen. . . . Als er (God) redt durch den propheten Johel so er spricht Johelis ii capitulo. Kerent euch zu mir mit gantzen eüwerem hertzen mit fasten und weinen so wil ich mich zu euch keren.)[44]

In the Isenheim *Crucifixion*, John the Baptist is such a "third-person" mediating figure, who establishes the frontality of the crucified Christ or the Madonna and Child as equivalent to the vocative case. Indeed, most of the altarpiece's imagery partakes of their direction forward, outward, and confronting the audience, in an approach based not so much on the illusionistic intention of a perspectival space as on the inescapable if intangible appeal of vocal projection.

It is also in the realm of eloquence that we must consider the gestural language present in the altarpiece. In his other pictures, Grünewald focuses on movements of the body largely by exploring the elaborateness and motility possible for certain gestures of the hand: the pointed displaying of fingers, one after another, in arched succession, as they hold on to an object, as in the Stuppach Madonna or the Saint Lucy panel (Fig. 65), the flexing of the hands against the line of the wrist, as in the depiction of the possessed girl in the Saint Cyriac panel and the attacking figure behind Christ in the Munich *Mocking of Christ* (Figs. 63 and 66). These remind us of the potential for idiosyncratic or arbitrary, seemingly localized, energy of gestural expression that can punctuate a pictorial field in northern art when compared to the apparent issuing of gesture from the core of the body and the more organic link between

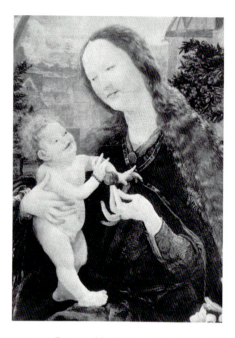

FIGURE 65. Grünewald, *Virgin and Child* (detail).

internal motivation and outward manifestation, evident in the Italian treatment of the body's activities.

Nothing prepares us for the range and force of the gestural repertory contained in the Isenheim Altarpiece, an eloquence shaped by variety, placement, and scale. Here again it is the forearms and hands especially that bear the labor of this articulation—the taut, gnarled, agonized hands of Christ on the cross, driven open, electrified by a piercing charge (Fig. 67); the offering up of her own wringing hands by the kneeling Magdalene (Fig. 61), her splayed fingers and those of Christ underscored by their representation in silhouette; the pointing gesture of John the Baptist repeated in the figure of the Hermit Paul and the Annunciate angel (Pls. 2 and 5). John, with forefinger extended from fist, points up at an angle. The Annunciate angel stretches the index finger forward, adding to it the third finger, his peach-colored drapery windswept in the wake of this command. The Hermit Paul reiterates the pointing forefinger, but his hand approaches with palm turned upward, in this way receptive to his saintly guest. On the opposing wings of the altarpiece, this combination of quotation and altered orientation of ges-

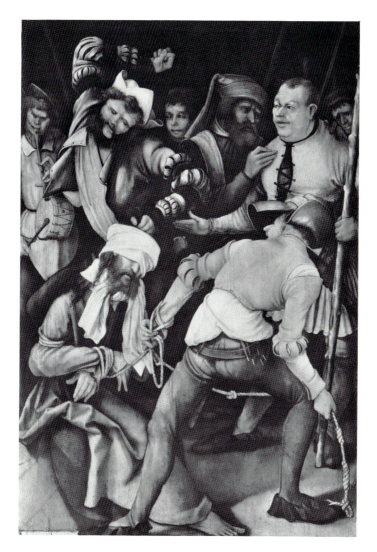

FIGURE 66. Grünewald, *Mocking of Christ*, panel.

ture is evident in the shielding left arm and hand of Saint Anthony in
the *Temptation*, with a defensive and protective palm down, and the
foreground soldier in the *Resurrection*, whose upturned palm reveals
him to be overcome by the miracle of Christ's rebirth (Pls. 3 and 6). In
the central section of the middle state, with the Madonna and Child and
angels, gestures not of direction but of manipulation abound—fingers

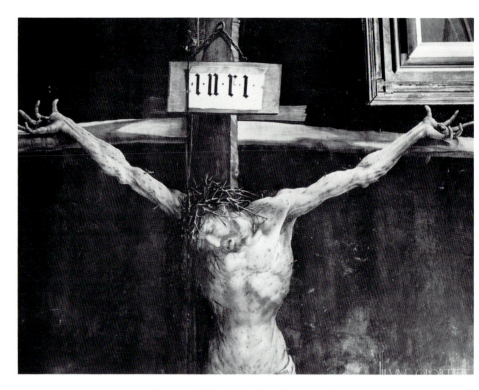

FIGURE 67. Grünewald, Isenheim Altarpiece, *Crucifixion* (detail).

holding, pressing, straining, arching in relation to the objects within their grasp (Figs. 28, 29 and 30).

In its dedication to shelter those afflicted with Saint Anthony's Fire, the Antonite Order, we recall, was dealing with a group of patients who, either through gangrenous deterioration or amputation, often lost use of their extremities, as we see in the raised left arm of the diseased demon in the foreground of the *Temptation of Saint Anthony* (Pl. 8). The psychological impact of gesture in the Isenheim Altarpiece, striking in itself, needs further to be calculated for its effect in relation to this physical deprivation among the membership of its original audience. At the same time, it is not enough to locate this movement of the body only in terms of its converse—absence—or of its disposition in space. Rather, the richness of this language is a substitute for and percussive accompaniment to the oral realm of spoken utterance. This linking of manual gestures to the auditory sphere has a longstanding tradition and wide

application in Western culture, beginning with the teachings of ancient rhetoric and continuing in medieval theoretical works that associate gestures with musical tones.[45] Having filtered by ca. 1500 into the prescriptions for dramatizing the church liturgy, as well as the customs of preaching, this connection between gesture and sound also permeated the secular world of pedagogy and statesmanship.[46]

From the monastic context, where, in certain cases, the rule of silence prevailed, systems for body movement and gestural signing come down to us.[47] It is important that in these instances, through the withholding of speech, the issue of sound is also at stake. At Isenheim the language of gesture for the most part breaks the boundaries of such systematized codes of meaning and seems to achieve power instead from roots extending back into ancient repositories of significance and association. For instance, Grünewald shows a number of hands folded, as with the Madonna, the Magdalene, and Saint Sebastian, in the closed state of the altarpiece (Figs. 6 and 61). Although the early modern period often assigns to this gesture the meaning of prayer, here it is more than a mere emblem for praying. Grünewald shows no two examples exactly alike. One pair of hands has fingers in a "V" formation; in another the fingers are interlaced; one example has the right hand cupping around the left fist. We cannot be sure what these variations signal, but their underlying unity of expression seems to draw upon a notion of bondage, or a state of being bound, that has been understood by anthropologists to lie behind this shaping of the hands for the ritual of prayer.[48] Furthermore, especially in the predella with the dead Christ (Fig. 21), we become aware that the folded hands, the extremities of the body turning back to be contained within the larger boundary of the horizon or the framing edge, the arms and hands kept within the outlines of the trunk of the body (Fig. 68)—all become markers of silence, an eloquent contrast to the auditory field established by the gesticulation of the other figures.

With this plenitude of gestures before our eyes, we as modern viewers witness a complex choreography of communication destined for the actual presence of a congregation of worshipers. As gestural language implies a give-and-take, so we are describing a phenomenon very different from the self-effacing devotional response of a viewer to the iconic effect of, for instance, the Byzantine apse mosaic, with its frontal, monumental, ethereal image of Christ, or different from the private piety that was elicited by the conceptual core of the Protestant image. Our viewer/worshiper is participant, respondent, protagonist in his role as active per-

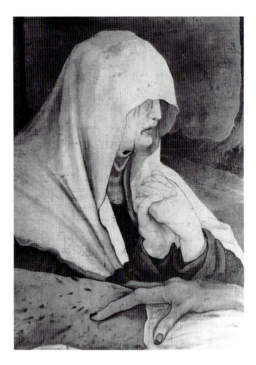

FIGURE 68. Grünewald, Isenheim Altarpiece,
predella (detail).

ceiver or, to put it in terms of baptismal thinking, as alert member of
the faithful. Much as the rite requires the candidate's profession of faith,
the Isenheim Altarpiece, through its introduction of the phenomenon
of sound, may also be understood as dramatizing the repeated equation
made by Christ in the Gospels between faith or belief and the ability to
hear.[49]

Grünewald brings to the forefront the auditory address that was fun-
damental to the world of the Bible. The covenants with Noah and Abra-
ham were proclaimed by God. He revealed himself to Moses through
the sound of his voice and thundered his commandments to Moses on
Mount Sinai. The Old Testament reverberates with the declamations of
its prophets. In the beginning was the spoken word; Christ was the
Word Incarnate. It is important to recall that both historically and litur-
gically the word spoken and heard is the substance of baptism. It was at
the time of Christ's baptism that God first affirmed the divinity of his
son. Simultaneous with the visible evidence of the Holy Spirit in the

form of the dove was the oral testimony (Matthew 3:17, Mark 1:11): "This is my Son, the Beloved, My favor rests on Him"—the voice as palpable witness.

John's raised right forearm supports his pointing index finger, elongated and silhouetted for emphasis as it juts outward and upward; in this manner John intercedes on behalf of the victim and sufferer as well as the judge. Grünewald pursues the tight connection between the Baptist and the crucified Christ by displacing all but the right arm of the body of Christ to John's side of the central split in the panels of the closed state (Fig. 20). Historically, of course, the two are coupled at the time of the baptism of Christ. A body of water is visible behind John— a geographic marker, as I suggested earlier, for the crucial role his ministry over Christ's baptism plays in the unfolding of the Christological drama.[50] Central to baptismal doctrine is the coupling of the wood of the cross with the waters of life, the dualism of death and transcendence, the expansion of life through death.[51] Saint Paul elaborates on this promised journey from earth to heaven: "Do you not know that all of us who have been baptized into Christ Jesus were baptized into his death? We were buried therefore with him by baptism into death, so that as Christ was raised from the dead by the glory of the Father, we too might walk in the newness of life. For if we have been united with him in a death like his we shall certainly be united with him in a resurrection like his."[52]

As our eyes travel through the figure of John the Baptist and the crucified Christ to the middle stage of the altarpiece, this prospect of the sacrament of baptism comes into view. A dark curtain and a fig branch create a vertical divide between what appear to be two compositional halves (Pl. 4). At the right side, the Madonna confronts us holding the Christ child. Her position, seated on the ground, connotes her earthly existence. But Grünewald suggests that this is an ideal or heavenly landscape rather than an actual earthly location, since he depicts this Madonna in tremendous scale, populates the landscape with Marian symbols, and shows God the Father in heaven as an embodiment of light.[53] To the left, a tiny crowned female figure appears in the doorway of an elaborate gilt tabernacle. With her head surrounded by an aureole comparable to that of Christ in the *Resurrection*, with light shining on her womb, and a clear glass vessel facing her on the step below her feet, she surely also represents the Madonna. This florid architecture filled with an angelic corps plays host to what must be the celestial Mary, obverse of the earthly Mary in the landscape at the right.[54]

One music-making angel has spilled out from the tabernacle to take his place on the ground line continuous with the right side of the composition. He consolidates this continuity if we imagine the acoustical unity that his music-making forges, a continuity also made tangible by the household motifs along the foreground plane. But precisely the placement of these objects indicates a significance beyond their apparently pedestrian nature. At front and center they adhere individually to the two sides of the composition, confirming the terrestrial/celestial dualism that is the essence of this scene. The small chamber pot to our right, aligned with the cradle and on the side of the seated Madonna and Child, denotes the earthly domain (Fig. 69). The wooden tub, with its white cloth covering, is encompassed by the zone of the heavenly tabernacle, on an axis with the glass vessel and subject to the serenade of the music-making angel next to it—all of which sanctify and elevate this

FIGURE 69. Grünewald, Isenheim Altarpiece, *Madonna and Child and Incarnation Tabernacle* (detail).

humble water-bearing receptacle to the liturgical level of a baptismal font.[55]

Not only does the Isenheim Altarpiece contain these essential references to the baptismal rite, but we should also mention that in this monastery church the place of the altar seems to have been fused with the site for distribution of the baptismal water. Early inventories of the church at Isenheim list a brass baptismal font that stood in the apse directly behind the altar.[56] Thus, too, Grünewald's painted predella lays the foundation for a theology of baptism (Fig. 21). It covers, we recall, the sculptured predella with Christ and his apostles. In so doing, the dead Christ is a concrete projection of the eucharistic sacrifice. Positioned on the altar table, as the unchanging support above which two of Grünewald's painted views pivot, his predella marks the Crucifixion as a sign of triumph over death. Supporting the middle stage's apocalyptic vision of Mary Ecclesia as New Heaven and New Earth, it initiates the pathway to revival through death that is at the core of the baptismal sacrament.

We have throughout been tracing the interconnections of form and content among the three openings, or stages of this altarpiece. Now there also comes to mind more precisely the idea of transformation expressed in the German nomenclature for this type of monument of changing views, *der Wandelaltar*, and we stop to appreciate in a new way the actual structure of the Isenheim Altarpiece as vehicle and medium for the themes of initiation and passage articulated here as part of the theology of the baptismal sacrament. We further begin to imagine how the openings might have been revealed during the cycle of the ecclesiastical seasons, with the closed *Crucifixion* state relating to the period of Lent. Our consideration of the figure of John the Baptist helps us to anchor this time frame. From the early days of the Church, the Easter ceremony was organized around the sacrament of baptism.[57] Holy Week would culminate in the Easter vigil, including the blessing of the oil and the baptismal fonts and concluding with the candidate's participation in baptism itself. This ceremony took place at night between Holy Saturday and Easter Sunday and marked a shift in the candidate's life from a trial period of self-examination, fasting, and penitence to one of purification and grace.[58] Paralleling the transition from the Entombment to the Resurrection of Christ, a powerful formal contrast was also instituted. Once baptized, the candidates would file back into the darkened church, each carrying a lighted candle, and the mood would shift sud-

denly from mournful anticipation to exaltation and thanksgiving, which we see mirrored in the change from the closed *Crucifixion* state to the brilliant opening of the middle section that celebrates the everlasting life of Christ.[59]

In its assertion, first, of the visual, as we discussed in the previous chapter, and second, of the auditory sphere, the Isenheim Altarpiece puts us in mind of the theoretical discussions in contemporary Italian Neoplatonism. There a hierarchical ranking of the senses placed hearing as a close second to sight, the noblest sense—contemplation through the eyes being considered the pathway to the divine. Sight and sound were thus elevated from the more tangible or mundane senses of touch, taste, and smell, and, as a pair, they formed the more abstract, intellectual, and spiritual channels for perception.[60] This hierarchy may be implicit in the Isenheim Altarpiece, not on a theoretical level so much as on an experiential one: seeing and hearing are the ontologically appropriate perceptual realms in the case of the sacraments of the Eucharist and baptism. Moreover, for baptism, each of the candidate's senses was primed to be open to the grace of God and militant against the evils of temptation. The traditional pastoral gestures thus had the purpose of engaging the entire sensorium of the catechumen: ears, eyes, nose, mouth, in an effort to induce an ideal state of receptivity as well as defensiveness.[61] That these liturgical gestures of the priest derive from and reiterate the different healing procedures of Christ in the Gospels (the laying on of hands, the touching of the eyes, the application of saliva, and so forth) takes us back once more to the hospital context.[62]

At Isenheim, promoting the efficacy of the Eucharist through the visual presence generated by the altarpiece and celebrating the auditory/oral sphere, in turn a defining component of the sacrament of baptism, also reminds us that among the symptoms of Saint Anthony's Fire were the psychoneural effects of visual and auditory hallucinations; in appealing especially to these sensual paths, Grünewald could, as I suggested earlier, have been privileging these "supernatural" experiences of the monastery's patients.[63] But if the Isenheim Altarpiece addressed a congregation in extremis, strictly speaking, might the condition of disease not be understood as a metaphor for the crisis that threatened the Catholic community at large?

The focus on Eucharist and baptism does, in fact, evoke the milieu of Luther. In the reformer's drive for purification, these are the only two

sacraments that he was to preserve, documented as they are by the Gospels themselves.[64] Furthermore, a goal at Isenheim, in community with Luther's, was to create the direct communication between God and man that had been obscured by the trappings of politics and ceremony. But instead of Luther's project of dismantling ecclesiastical hierarchy in favor of a priesthood of believers, might not the monastery's special audience have become an inspiring model in the attempt there to reexperience and redefine the nature of a Christian universe? If for Luther the legitimacy of the Eucharist and baptism was their status as divinely instituted signs containing the promise of forgiveness, Grünewald, by contrast, through his experience at Isenheim, searches out and taps these two preeminent sacraments of the Catholic church for their ultimate and mysterious powers of transport and transformation.[65] It is a measure of the artist's achievement that he went beyond the creation of what is probably the last of the huge and complicated "religious machines," as this work has been called in reference to its heroic descent within a tradition established by Jan van Eyck's monumental Ghent Altarpiece.[66] The dense structure of communication that comprises the Isenheim Altarpiece modulates between the institutional realm of religion and that of private conscience as it speaks to a new tension between the organizing space and time of ritual and the existential imperatives of suffering and bliss, of birth and death. Thus it stimulates our own surviving impulses toward the sacred sphere; we as modern viewers still sense those charismatic sources and mythic roots of its visual expression.

IV

AFTERLIFE OF A MONUMENT

In Grünewald's work at Isenheim we see that the altarpiece as a type of monument could—in principle was meant to—hold a universe in its grasp. It encompassed life and death, punishment and salvation, the earth as well as the heavens, the natural and the supernatural, history as well as prophecy. The vehicle for this vision of universality was the painterly medium.

Indeed, from a historical perspective, the highest points of energy and viability for the medium of painting in the West are often to be identified with the times and places in which religious imagery was called upon in the service of the altarpiece as a pictorial type. Accordingly, as we scan the modern paintings in our museums and galleries, it is worthwhile to ponder the origins of the movable picture: the category of picture that first utilized the wooden panel, later the canvas, as support for its representations, and that was framed and oriented to confront a viewer's upright posture. When we undertake this exercise, we are drawn inevitably back to the cult practice that found its focus in the image placed on the altar, facing the congregation, in the Catholic church.

Our habitual vantage point on the history of the movable picture tends to reveal more about the later vicissitudes of the medium. We consider, for instance, the transformations of its subject matter into the secular genres: the portrait, the landscape, the still life—subjects in Protestant Holland in the seventeenth century that were geared toward an increasingly open market for art; or we reflect on the subsequent handling of the canvas by French Impressionist painters, with their spontaneous, casual presentation of fleeting experiences of perceptual life.

As the movable picture entered the museum precinct, earlier examples—religious art in particular—were stripped of their former affective power, a development that has informed much of my discussion. At the same time, the museum as an institution turned into its own "temple for art" (to paraphrase Goethe, writing about his first visit to the Dresden Gallery).[1] Aesthetic veneration could supplant religious devotion. And

the public nature of the salon and the museum created a new variety of charisma on the part of the paintings exhibited within these pristine sanctuaries—a "performance value," as it were, in exchange for the original magnetism of a work, such as an altarpiece, in the context of cult worship.[2]

The greatly enlarged public and the augmented status that these nineteenth-century exhibition spaces provided for easel painting have deeply affected Western thinking about pictorial art. Often deliberately, sometimes unconsciously, we treat the movable picture as a universal and timeless format for artistic expression. Of course, nothing could be farther from the truth. One need only think of illustrated manuscripts in medieval Europe or in Muslim Persia and India; alternatively, we can invoke the scroll as a field for the arrangement of words and images in China and Japan; or, again, the broader, transcultural and transhistorical phenomenon of mural painting.

The regional commissaries' report of 1794 on the Isenheim Altarpiece, with which I opened this study, is the finale in an unspoken drama: the decline of one of Western painting's major traditions. Perhaps guided by a Romantic striving toward the wholeness of phenomena, and moved by an encounter with painted images whose creator they could not properly identify, the report's authors clearly fathomed the breadth and coherence possible for the world of an altarpiece. How otherwise to explain, in what should have been the mere dispatch of bureaucratic duty, the unexpected eloquence of their plea on behalf of the reconstitution of the Isenheim Altarpiece? Or should we, first of all, ask ourselves by what persisting spiritual energy this work was salvaged, dismantled, hidden from view at the moment of the Revolution's anti-ecclesiastical terrorism? Or, well before that era, how Grünewald's altarpiece could have weathered the pressures of the Reformation? These turns of fate are strange to chart, the more decisive because they interrupt an afterlife for the altarpiece that barely skirts oblivion, the more dramatic because they served to deliver Grünewald's panels to a modern world prepared to respond to their powers.

The year 1853 marks the beginning of the modern phase of the history of the Isenheim Altarpiece. For then it resurfaced as the pièce de résistance of the newly formed collections of the Musée d'Unterlinden, after having been stored in the Colmar library for the entire first half of the

nineteenth century.[3] With the beginnings of train travel, and with photography and journalism providing potential publicity for works of art, the stage was set for Colmar to become at least an occasional stopping place for connoisseurs from neighboring parts of Europe.

Nevertheless, Heinrich Alfred Schmid, the first committed Grünewald scholar, looking back on his career, recalled that as late as 1900 he could not interest a single publisher in a monograph on Grünewald.[4] The eventual publication in 1911 of Schmid's book on Grünewald and the Isenheim Altarpiece signifies a shift in cultural climate.[5] What occurred during this interval? As I have tried to reconstruct the original manner of communication of the Isenheim Altarpiece, now we must retrieve the context for the new awareness of Grünewald's work in the twentieth century. Such an awareness cannot be assessed only on the aesthetic level of changing tastes; we must begin by uncovering some of the artistic, psychological, intellectual, and political factors that made the concentrated attention and study embodied in such a monographic treatment both possible and welcome.

Schmid was on the faculty of the German University in Prague at the time his book on Grünewald was published by W. Heinrich, who was located in Strasbourg. But our consideration of its genesis takes us, first of all, to the city of Basel and to the last quarter of the nineteenth century, for it was this city that laid claim to Schmid's intellectual and professional life. There he not only spent his last thirty years but had also first studied art history under the great cultural historian Jacob Burckhardt. With Heinrich Wölfflin, his classmate, Schmid journeyed across Italy during these student years.[6] Eventually Wölfflin became Burckhardt's successor to the chair of art history at Basel, and it was Schmid who filled that chair in 1901 when Wölfflin was called to Berlin.[7]

Schmid is known mainly for several fine monographic studies, but his career was eclipsed by the great pioneers of art history such as Alois Riegl and the brilliant disseminators in the subsequent generation such as Erwin Panofsky and Walter Friedlaender. In Schmid's collected essays and lectures, however, one discovers a thinker of keen methodological and pedagogical awareness, as well as a critic with considerable foresight and the courage of his convictions.[8] Where his later study on Holbein, Basel's most distinguished artist-citizen, might seem a safe choice for a resident art historian, his interest in Grünewald had no such obvious sanction.[9]

Schmid had already turned his attention to the artist in 1894 in a publication accompanying the opening festivities of the Basel Historical

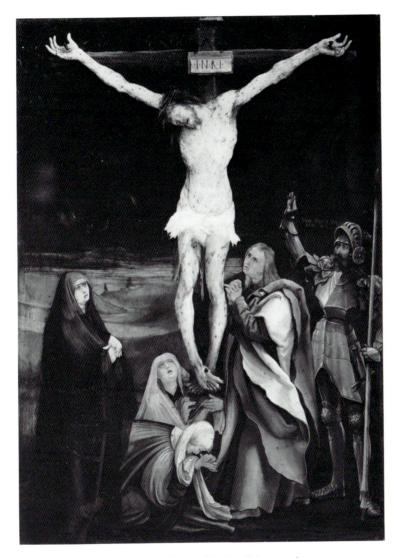

FIGURE 70. Grünewald, *Crucifixion*, panel.

Museum.[10] There the point of departure for his discussion had been the small *Crucifixion* panel by Grünewald in the Basel collection (Fig. 70), which Schmid esteemed as one of the treasures of the museum. Because Grünewald was virtually unknown at the time, Schmid took the occasion to convey some information about the artist.[11] In what amounts to

the kernel of his later monograph, he presents a refined list of attributions, a chronology, and an eloquent attempt to characterize Grünewald's singular style. Schmid speaks of a painterly approach, expressive distortions, and a striking use of color.[12] He is encouraged by what appears to be a gradual reawakening of interest in Grünewald and the Isenheim Altarpiece, beginning with references in several handbooks and artistic encyclopedias around the middle of the nineteenth century.[13] But underscoring the confidence in his own critical appraisal is the affinity he perceives between Grünewald's style and that of certain artists at work in his contemporary milieu.[14] A key figure in this respect is another Basel citizen, a friend and protégé of Burckhardt and later comrade and adviser to Schmid, the painter Arnold Böcklin.

Böcklin—who, were it not for the efforts of recent revisionist histories of the nineteenth century, would largely have disappeared from our awareness—was unquestionably an important figure during his own lifetime. His extravagant personality, energetic productivity, and poetic imagination earned him the support of such thinkers as Burckhardt and Wölfflin.[15] So great was his stature that within a few years after his death in 1901, the critic Julius Meier-Graefe saw the need to reconsider his reputation.[16] In Meier-Graefe's attempt to identify the steps in a history

FIGURE 71. Arnold Böcklin, *Dead Christ with the Magdalene*, 1867–1868.

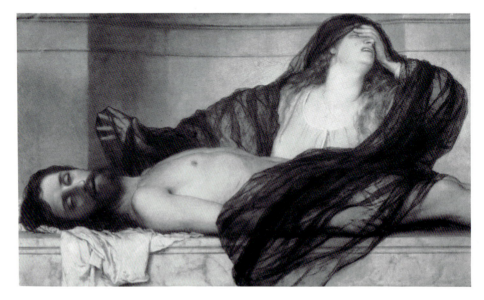

of progressive artistic style, Böcklin suddenly became the reactionary cause célèbre, jeopardizing the very future of art. But others continued to view this painter as a uniquely modern sensibility. The distinguished director of the Berlin Gallery of Modern Art, Hugo von Tschudi, for example, whose forward-looking taste for the French Impressionists put him at the center of a biting controversy in the cultural politics of early twentieth-century Germany, took such a position in print.[17]

For our purposes, it is noteworthy that Schmid wrote extensively on Böcklin, starting in the 1890s when the two men had become friends[18]; indeed, Böcklin probably stimulated Schmid's interest in the Isenheim Altarpiece. He is the first artist we know to have made repeated visits to Colmar, beginning in the late 1860s.[19] Böcklin had grappled with its effect during his conception of the *Dead Christ with the Magdalene* (Fig. 71).[20] In Schmid's earliest writings on Grünewald, he drew attention to Böcklin's admiration for the German master, pointed to a temperamental affinity between the two, and emphasized that a receptive audience for Grünewald's masterpiece now existed among contemporary artists who, like Böcklin, were possessed of a new coloristic freedom.[21] Whether or not this connection between Grünewald and Böcklin is apparent to us, Schmid, Böcklin, and other contemporary critics found it

FIGURE 72. Arnold Böcklin, *Battle of the Centaurs*, tempera on canvas, 1873.

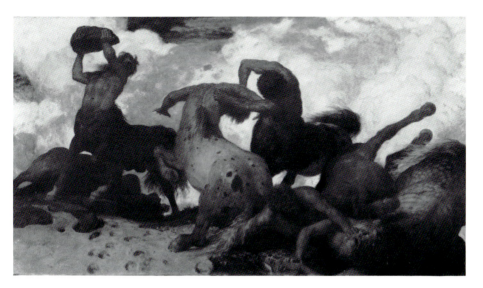

to be compelling.[22] In any event, that the appeal of the Isenheim Altarpiece for Böcklin and his identification with Grünewald's project had become stumbling blocks in Böcklin's relationship with Burckhardt teaches us something important about the emergence of Grünewald in the critical landscape.

As early as the 1850s, Burckhardt, that champion of the values of humanism and individualism associated with the Italian Renaissance, and of a Mediterranean and classical ideal of form, had predicted a great future for Böcklin.[23] The painter's combination of technical facility and literary erudition, his researches into legends and symbols of distant mythological worlds, appealed—as did Delacroix for Baudelaire—to Burckhardt's search for an artistic persona comparable to the grand master of the Renaissance past (Fig. 72). Predictably, Burckhardt had promoted an Italian sojourn for the Basel painter, who settled in Rome and Tuscany for several years, overlapping there with Burckhardt—this at a time when, for example, Courbet and Delacroix had already chosen the alternative routes to Holland and North Africa.[24] Under what circumstances Böcklin came to be interested in the Isenheim Altarpiece we cannot be sure, but considering the artistic path that Burckhardt had laid out for him, the Isenheim Altarpiece would have held the lure of a forbidden fruit. Several accounts convey Burckhardt's dissatisfaction with Böcklin's orientation toward the expressive excesses of northern art as they seemed to be embodied in Grünewald's masterpiece.[25]

What may seem to be merely an incident of Basel's cultural lore has, of course, a broader base of concern and a wider resonance. In German-speaking Europe, the period culminating around 1910 sustained various pressures that challenged the priority of classical norms and increasingly gave vent to a need for accommodating alternate stylistic modes. On a theoretical level, the work of Wilhelm Worringer is fundamental in this regard. Acknowledging Riegl as his forerunner in the decision to treat non-European, non-figural art, Worringer focuses on the language of ornament in his 1906 dissertation, which appeared in repeated editions from 1908 as *Abstraction and Empathy*.[26] In 1910 the sequel, *Form in Gothic*, returns to European art and aims to evaluate the phenomenon of the Gothic style against the grain of an ideological bias favoring the artistic values of the Mediterranean and classical world.[27] Worringer's Gothic, present in the interlacing dynamism of the vaults of Gothic cathedrals, was nevertheless a transhistorical phenomenon. In its striving for the transcendental, and in the taut and intricate linearity of its rep-

resentations, Worringer located a Nordic, indeed Germanic drive for expression. A section entitled "The Vicissitudes of the Gothic Will to Form" discusses the way even certain individual artists of the sixteenth century, when closely scrutinized, reveal this Gothic character. Here Grünewald enters with a Gothicness, as Worringer describes it, that "comports itself as a painterly pathos."[28]

Thus the reorientation of theory and criticism toward non-Western, non-classical modes created a new place for the Isenheim Altarpiece. It further gained prominence by its ability to straddle the sensitive ideological axis marked by modernism, on the one hand, and nationalism, on the other. The case of Hugo von Tschudi allows us to gauge nationalism at the time as reflected in the politics of art: official censure of his purchase of French Impressionist pictures for the Berlin Gallery of Modern Art resulted in his departure from the directorship of the museum.[29] By contrast, the newly forged association between medieval expression—in particular, the notion of Gothic—and the Germanic gave value to the Isenheim Altarpiece as a national treasure, an object perceived to have grown from roots planted deep within German soil. This attribution was all the more pointed because of the location of the altarpiece in Alsace, that region traditionally torn in its identity between France and Germany. The sense of German national identity and of a German patrimony gripped some of the most advanced artists and thinkers of the period. Both Max Beckmann and Wilhelm Worringer fought with the German army during World War I.[30] At the outbreak of the war, Beckmann took it upon himself to contact Wilhelm von Bode about the possibility of storing Grünewald's masterpiece in the Kaiser-Friedrich-Museum in Berlin to avoid any possible danger.[31]

In the preface to a third edition of *Abstraction and Empathy*, published, like *Form in Gothic*, in 1910, Worringer notes that the very problems of representation and the goals for artistic expression that he had initially posed in theoretical terms had gained topical interest through contemporary artists' sharing of similar concerns. By this date, painters like Beckmann, Nolde, Marc, and Kirchner had already gone far in establishing a distinctive vocabulary of form. Distorting the shapes of nature and transfiguring the natural world through the emotional and associative use of color, they moved toward abstraction while at the same time they aimed to encompass more charged, even religious iconographies (Fig. 73). By the time Worringer's two essays were published and Schmid's book on Grünewald had appeared, these artists were also writ-

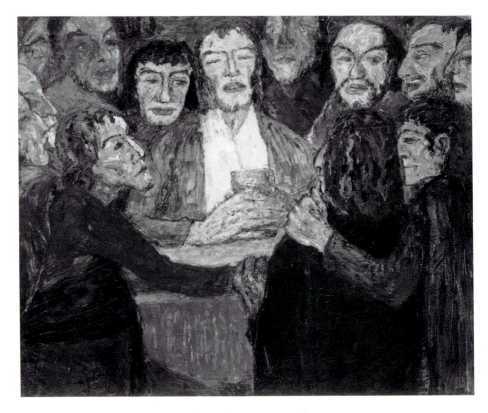

FIGURE 73. Emile Nolde, *Last Supper*, oil on canvas, 1909.

ing about their own work. The journal *Pan*, which became their special forum, is filled with discussions on "The New Painting." Above all, as Franz Marc put it, this kind of painting constitutes "a bridge into the realm of the spirit," a departure from the natural world, "back to the images of inner life."[32]

Kandinsky, who was in Germany and France by the late 1890s, had also been publishing his ideas about art. *On the Spiritual in Art*, formulated in essays from 1909-1910 and published late in 1911, brings to elaborate philosophical conclusions the need for painting to tap an emotional and spiritual reservoir through the vehicle of pure forms and, especially, pure color.[33] That Kandinsky's text was immediately successful in Germany—it came out in three editions during its first year in print—demonstrates the extent to which its public was ready to receive such ideas.

Thus much as one must admire the courage behind the international outlook of Julius Meier-Graefe's criticism, the implication in his writing that modernism and French painting were to be equated must have had an alienating effect on Germany's contemporary artists.[34] Although they undoubtedly identified with Meier-Graefe's confident search for the progressive in art, his prescription for a future in which the medium of painting would refine itself down to its optical essentials (a future apparently already at hand for him in contemporary French painting) left little room for the project of the Expressionist painters.

In the midst of these debates, the Isenheim Altarpiece could fill an evident need. Grünewald's altarpiece seemed to address artists like Beckmann and Nolde directly as a heroic precedent for their own aspirations toward the spiritual basis for art and the transforming power of painting with respect to nature. They empathized with its excruciatingly felt and ecstatically transcendent religiosity, its poignant distortions of form, and its intense shifts in light and color.[35]

As a young painter, Beckmann visited Colmar in 1903.[36] One might specify indebtedness to the Isenheim Altarpiece in his wartime drawings of hospitalized soldiers or in the predilection for the large-scale triptych format in his paintings (Figs. 74 and 75), but in a more general sense the experience of this monument of painting never left Beckmann. Now Emile Nolde also refers to Grünewald as the most powerful of all painters and draws the Isenheim Altarpiece into a lineage of the greatest examples of Germanic artistic expression.[37] In a note of greeting to his publisher, dated September 17, 1909, Rainer Maria Rilke refers to the entire day spent in front of Grünewald's panels in the Unterlinden Museum in Colmar.[38] The capacity of these paintings to elicit a state of absorption measurable by sheer time spent in their presence is something Elias Canetti also records in his autobiographical journals some twenty years later.[39] Gershom Scholem tells us of Walter Benjamin's lifelong fascination with the Isenheim Altarpiece, stemming from a student visit to Colmar just after the publication of Schmid's monograph.[40] Indeed, the impulse on the part of these artists and writers to bear witness to its extraordinary imagery is pervasive. The urgent need for its images to be confronted and contemplated by means of careful visual scrutiny made the large-format folio of reproductions a favored type of publication for the Isenheim panels right through to the 1930s. It undoubtedly was responsible for the printing as early as 1907 of an oversized folio volume of plates that comprises the entire first installment of Schmid's book on

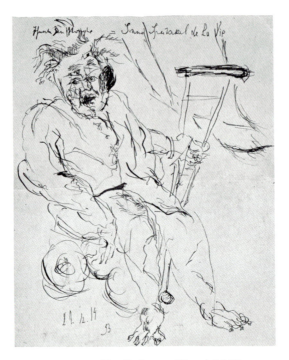

FIGURE 74. Max Beckmann, *Wounded Soldier*,
pen and ink, 1914.

Grünewald.[41] Benjamin and later Canetti kept such reproductions in
their living and working spaces, a perpetual externalization, it would
seem, of the altarpiece's haunting impact.[42]

Another early writer on Grünewald confirms what Schmid had as-
serted in his reminiscences; in a July 1904 article, Fritz Baumgarten re-
marks, "Even a short time ago Grünewald was barely known, . . . now
he has become one of the primary names in art, not only in his native
Germany but in France and the Netherlands as well."[43] This apparent
turning point in the artist's reputation at mid-decade, and the claim of
interest in him that extended to France and the Netherlands, rests
largely on the attention paid to Grünewald and the Isenheim Altarpiece
by Joris-Karl Huysmans, the French writer of Dutch ancestry.[44] With
some ten published novels to his credit, Huysmans had also regularly
been writing art criticism since about 1880, so that when his "Les
Grünewalds du Musée de Colmar" appeared in *Le Mois littéraire et pit-
toresque* in March of 1904, it was bound to attract attention—especially

because he made it the lead essay of a separate publication, *Trois Pri-mitifs*, in 1905.[45] In contrast to the gradual broadening of interest in Grünewald that was intensified by nationalistic identification in German-speaking Europe, the circumstances underlying Huysmans's essay reveal the other important pathway to the burgeoning celebrity of the Isenheim Altarpiece.

The locus of such an examination lies about fifteen years earlier, for Huysmans had already written on a picture by Grünewald before the time of Schmid's first essay; he included a descriptive evocation of the *Crucifixion* now in Karlsruhe (Fig. 76) near the opening of his 1891 novel, *Là Bas*.[46] There we encounter Durtal, a writer and the central character, who argues with his friend Des Hermies about the state of the contemporary novel. Reflecting on this exchange, alone in his study, Durtal calls to mind a recently seen *Crucifixion* by Grünewald. In the elaborate mnemonic reverie that ensues, we find a fascinating mixture of the critic's keenest observation of a work of art with the fiction writer's meditation on an experienced event. Compared to Schmid's system-

FIGURE 75. Max Beckmann, *Departure*, oil on canvas, triptych, 1932–1935.

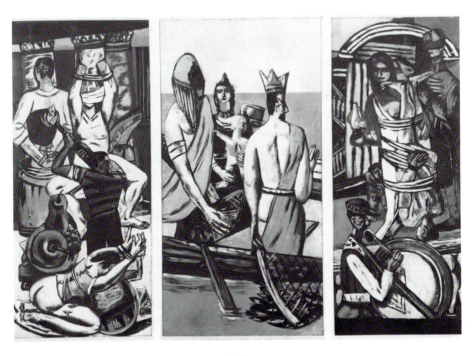

FIGURE 76. Grünewald, *Crucifixion*, panel.

atic analyses of Grünewald's pictures, which were buttressed by a range of documentary finds, Huysmans astounds us with a personally charged version of the traditional narrative figure of *ekphrasis*, as he charts the narrator's apperception and renders a fully moving world. It may be just such a sustained response to Grünewald's panels that Schmid's 1907 folio of reproductions aimed to trace and, in effect, wordlessly realizes.

Durtal uncovers, in the process, a philosophical goal for the novel as a genre and takes us, by extension, to the crux of a perceived impasse in contemporary French art. The intellectual conflict in the German context stemmed from the veneration of a chronologically and geographically alien classical tradition. In France of the 1890s, for a writer identified with the cause of modernism, the realist position of Flaubert and the brothers Goncourt and the naturalism associated with Zola's prolific output constituted the dominant mode of vision. Initially Huysmans had considered himself a follower of Zola in a movement salutary for the illusions of Romanticism. But in *Là Bas*, through the vehicle of Grünewald's picture, he articulates what had become a broader-based discomfort with the complacency and limitations of the naturalist or materialist point of view.[47]

In the face of the offical academic art, Huysmans had remained an eloquent spokesman for the Impressionist painters and true to his special regard for Degas's urban characterizations. But the rationale behind his occasional yet intense shifts of focus to artists such as Félicien Rops, Odilon Redon, and Gustave Moreau is germane here.[48] In a brief comment on the Salon of 1881 he refers to the "bizarre talent" of Odilon Redon, this painter "of the fantastique," of the "nightmare translated into art" (Fig. 77).[49] And in the novel *À Rebours* of 1884 he describes two works by Moreau (Fig. 78): "Going back to the ethnographic sources of the nations, to the first origins of the mythologies. . . . There breathed from his pictures, so despairing and so erudite, a strange magic . . . borrowing from literature its most subtle suggestion, from the art of the enameler its most marvelous effects of brilliancy." His description reveals yearnings for the precious, the literary, the magical, and the mythic in painting, values not to be admitted within the framework of immediate perceptual experiences of light, color, and movement of the Impressionist picture.[50]

With *À Rebours*, Huysmans had staged a rarefied escape from naturalism into a private, aesthetic realm. In *Là Bas*, Grünewald's painting allowed the writer to project the more extreme demand his own sensibilities were making on reality and art—a demand, moreover, reflected in the work of other artists and thinkers at that moment. About five years before the publication of *Là Bas*, several critics had already noticed the preference for metaphor and the altered rhythm of phrasing in the evocative poetics of writers like Mallarmé and Verlaine. The "idea" made tangible, the priority of dream, hallucination, sensation—these

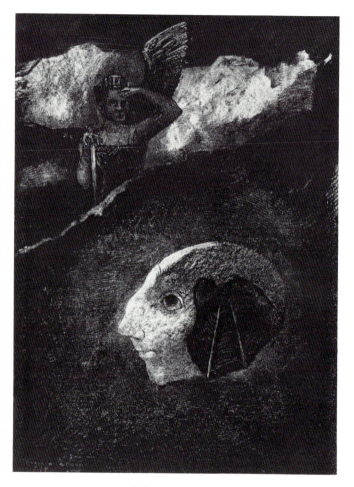

FIGURE 77. Odilon Redon, *Limbo*, lithograph,
IV of "Dans le Rêve," 1879.

were characteristics associated in the name of Symbolist style.[51] By then,
in the visual arts as well, in contrast to the world of the Impressionists,
Gauguin's provincial landscapes could be layered with the crucified
Christ and conjoined with ancient biblical visions. And under the pres-
sure of Van Gogh's writhing brush, mundane household furnishings
and shapes from nature came to be possessed with the pungent mean-
ings of a sacred world.[52]

With good reason, Huysmans pictures a crisis of art and of science in

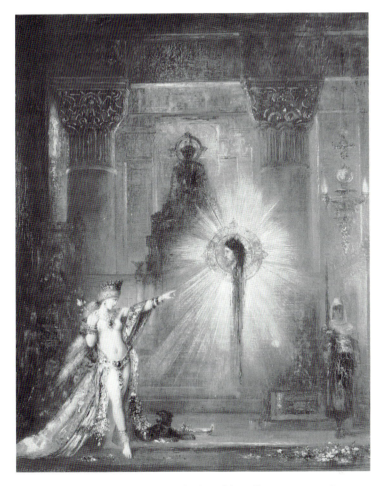

FIGURE 78. Gustave Moreau, *The Apparition*, oil on canvas, ca. 1876.

Grünewald's haunting distortions. His fixation on the torturous suffer-
ing of the body of Christ in Grünewald's *Crucifixion* is surely the
underside of a century glutted by an academic ideal of form to which
realism was one response, caricature another. At this very moment,
Jean-Martin Charcot, like Huysmans, was confronting with unflinching
gaze the grotesque, the mutilated, and the disfigured in his clinical prac-
tice at the Salpêtrière on the edge of Paris. We should recall that two
years earlier, combing the history of art for representations relevant to
his cases, he had included a reproduction of the diseased demon from the

133

Isenheim *Temptation of Saint Anthony* panel in his study, *Les Difformes et les malades dans l'art* (Pl. 8).[53]

Guided by the newly established confidence in the efficacy of careful symptomological recording for the treatment of disease, Charcot was especially involved in investigating those extreme bodily states—convulsion and paralysis—that also figure extensively in Huysmans's 1891 novel.[54] Legendary in the culture of contemporary Paris—Charcot's experiments are a topic of conversation in *Là Bas*—and of course, in the annals of professional psychiatry were the great neurologist's revisions of the etiology of such phenomena from the neurophysiological realm to that of individual psychodynamics.[55] We can measure the interest in such bodily conditions shared by Huysmans and Charcot by observing their receptivity to Grünewald's images, and by noting the way both writer and physician posited the dominion over the physical body by nonorganic forces. Interestingly, Huysmans chose to bypass these compelling common denominators, focusing only on his conflict with Charcot's attitudes. As a scientist, Charcot was necessarily engaged in rationalizing such manifestations, while Huysmans and others insisted on the inherent mystery of these conditions and on the possibility for the miraculous and the demonic whereby religion had invested them with meaning.[56] Armed with Grünewald's *Crucifixion*, the writer waged his war against the blindnesses of scientific positivism.[57]

A hundred years after the Revolution had excised the Catholic church from France's governing structure, and a succeeding century had vacillated in opportunistic reappropriation of Vatican allegiance to cement temporal power, Grünewald's dramatic image of Christ's passion looms before Huysmans in all its directness. Through it, he encountered a newfound possibility for the spiritual and the transcendent precisely by means of a confrontation with the real. In *Là Bas*, he summarizes:

> Never before had naturalism transfigured itself by such a conception and execution. . . . Grünewald had passed all measure. He was the most uncompromising of realists, but his morgue Redeemer, his sewer Deity, let the observer know that realism could be truly transcendent. A divine light played about that ulcerated head, a superhuman expression illuminated the fermenting skin of the epileptic features. . . . These faces, by nature vulgar, were resplendent, transfigured with the expression of the sublime grief. . . . Grünewald was the most uncompromising of idealists. . . . He had gone

the two extremes. From the rankest weeds of the pit he had extracted the finest essence of charity. . . . In his art was revealed the masterpiece of an art obeying the unopposable urge to render the tangible and the invisible, to make manifest the crying impurity of the flesh and to make sublime the infinite distress of the soul.[58]

If the Christ that Huysmans found in the Musée d'Unterlinden when he traveled there in 1903 was "less frightening" than the one he had seen in Kassel, this judgment may reflect a greater ease or sense of resolution that, for a variety of reasons, guided him when he wrote his critical essay "Les Grünewald du Musée de Colmar." For one thing, the status of early Netherlandish and German Renaissance painting was more secure by the time Huysmans published his essay on the Isenheim Altarpiece in 1904. Indeed the wording of the title of the 1905 publication, *Trois Primitifs*, which was to include the Grünewald essay, itself reflects the impetus for a heightened critical awareness of early northern painting in those years. A huge loan exhibition, titled "Les Primitifs Flamands," had taken place in Bruges during the summer of 1902, and thousands of tourists attended. Huysmans made the trip in the company of the Abbé Mugnier, who would be his companion for the voyage to Colmar.[59] One of the earliest temporary exhibitions to have international impact, it stimulated the first wave of scholarly interest in northern painting.[60] Sharpening connoisseurship by presenting a great diversity of artists' works, as well as offering facilities for comparative analysis, the show attracted reviews in which one can observe a weighing and measuring of individual styles.[61] This kind of growing expertise is evident in Huysmans's own essay, where he assumes the notion of a coherent oeuvre and discusses, side by side with the Isenheim Altarpiece, other paintings attributed to Grünewald. Reviews of the exhibition provided the opportunity for basic characterizations and conceptual generalizations about early Netherlandish and German painting. These also seem to be reflected in Huysmans's essay. The achievement of Italian Renaissance art as a resuscitation of ancient pagan models was perhaps the received notion with which critics stood in wonder before the religiosity of these northern pictures and the sense of Christian faith with which they were imbued.[62] When one writer uses the term "réalisme mystique" to pinpoint in the pictures hanging in Bruges their near-miraculous coupling of meticulous realism with promised levels of symbolic meaning, his

words recall the response of Huysmans to Grünewald's Karlsruhe *Crucifixion*.[63]

Unlike the case in German-speaking Europe, these cultural politics in turn-of-the-century France were, on the whole, outside the academic context. Yet one contemporary French scholar is significant for his intellectual affinity with the aspirations of the Symbolist artists, and it comes as no surprise that Huysmans took special note of his work. Émile Mâle's first book on Gothic art appeared in 1898, and in a series of publications in the next few years this art historian embarked upon a gradual unfolding of the iconographic programs of French cathedral sculpture.[64] As he saw it, cathedral architecture provided the stage for a layering of meaning within a coherent system of signification—an iconographic model that must have held any Symbolist artist in thrall. Indeed, theirs was a common drive toward an understanding of the underlying symbolism of all representation.[65] But equally congenial, especially to Huysmans, must have been this scholar's approach to the explication of Christian themes and personages in sculptural representation. Mâle sought their roots in the action of medieval mystery plays and in popular literature such as the Golden Legend—in other words, in the living traditions and practices of the dynamic Catholicism that Huysmans was intent to find in his own environment.[66] In the years between *Là Bas* and *Trois Primitifs*, Huysmans had increasingly immersed himself in the surviving remnants of Catholic life in France (as his publications of these years clearly show), studying the history and liturgy of the Church, its saints and heroes; through his personal acquaintance with such members of the clergy as the Abbé Mugnier; and by occasionally retreating to the monastic life.[67]

With Alsace still German territory at the time of Huysmans's essay, the concomitant lack of nationalistic pressure in his appreciation of Grünewald—a German artist—may have permitted the writer's tolerance for the hazy personal profile of the artist available to him.[68] Rather than attempt to embroider events toward the structure of biography, Huysmans focuses on the original context of the altarpiece and on the Antonite Order at the Isenheim monastery, probing this material more than artistic intention for possible determinants of the imagery.[69] He pictures the early audience and is particularly receptive to the sense of community in suffering that the altarpiece would have offered to the patients in the monastery hospital. That he also intuited the healing messages of the altarpiece and the miraculous power to cure that was

believed to reside in certain saints, relics, or holy objects is suggested by his trip to Lourdes earlier that year. The great pilgrimage site for the infirm had already provided the context for one of Zola's novels and was to become the subject of Huysmans's last book.[70] Indeed, "miraculous cure" was also an active interest of science at this time. Charcot had been successfully treating age-old, apparently incurable conditions such as blindness, paralysis, and convulsions—precisely the kinds of afflictions that had motivated the healing acts of Christ in the Gospels. In an essay of 1897, "La Foi qui guérit," Charcot attends to records of magical healing and sees in this mythic tradition a pattern of circumstances identical to those he was encountering in patients with hysterical symptoms.[71] Shifting the center of gravity from healer to patient, he discusses the necessary suggestibility of the subject, a kind of "faith" on which modern techniques of hypnosis also rested. Charcot's obvious attempt at demystification nonetheless conveys the awesomeness of such physical states and the drama of human volition and capacity for their removal.

The ingredients of the battle against scientific positivism could be seen to pivot on such an issue as miraculous cure, but Huysmans, claiming his own identity as a convert, increasingly came to envisage any extension or alternative to the limits of naturalism as comprehensible only within the Catholic experience. Indeed, toward the end of his life, when he published *Trois Primitifs*, it was no longer the postindustrial, materialist mentality that was his primary target. Hence, too, a changed polemical orientation in Huysmans's Grünewald essay suggests itself, not so much from internal evidence as by the act of its inclusion under one cover with the essay entitled "Francfort-sur-le-Mein." The writer focuses in that essay on two paintings in Frankfurt's Staedel Museum, a *Madonna and Child* by the Master of Flémalle and a curious Italian *Portrait of a Lady*, now attributed to Bartolomeo da Venezia (Figs. 79 and 80). The Italian, secular subject clearly appealed to the Huysmans of *À Rebours*: "What is this enigmatic being, this lovely and implacable androgyne, who is so astonishingly cool as she provokes?" Flémalle's Madonna, on the other hand, was favored by the post-*Là Bas* Huysmans: "The Virgin derives above all from the domain of the liturgical and the mystical."[72] His strategy is to treat them—the one viewed as pagan, the other obviously Christian—as antithetical moral realms: "the two opposite regions of the soul . . . the two extremes of painting, the heaven and hell of art."[73] But this polemic becomes more urgent as he reintroduces the theme that so prominently initiates the essay: a vista of Frank-

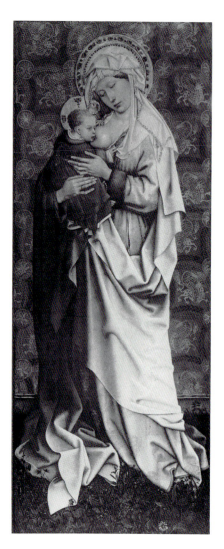

FIGURE 79. Master of Flémalle, *Madonna and Child*, panel.

furt establishes it as a city marked by its dominant Jewish population. Thus Huysmans punctuates a passage of vituperative anti-Semitism by finally imagining Flémalle's Madonna surrounded by the infidel.[74] When the writer characterizes the Isenheim Altarpiece, however he may marvel at the virtuosity of its painterly handling or wonder about an enigmatic

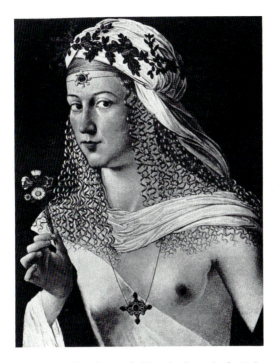

FIGURE 80. Bartolomeo da Venezia, *Portrait of a Lady*.

motif or symbol, he never loses touch with the essential piety the altar-piece addresses—as if by placing this essay before the one on Frankfurt he buttresses the endangered Madonna and Child; as if through Grüne-wald's panels, the intensity of early Christian commitment could still touch the modern world.

Nearly the entire decade preceding *Trois Primitifs* had witnessed a France racked with racial conflicts given vent by the Dreyfus Affair—conflicts that Huysmans perceived as direct threats to the status of Catholicism and consequently to what he felt was an integral aspect of France's identity.[75] As the destiny of French culture increasingly depended, for him, on the victory of Christian faith over non-belief, the coincidence in date between Huysmans's study on the Isenheim Altarpiece and legislation resulting in the official separation of church and state in France remains suggestive.[76]

We close this chapter of cultural history by summoning up a somewhat later date: 1917. The United States enters the three-year-old war in Europe on the side of Britain and France against Germany. The locus

of military conflict is the western front, including Belgium and the regions of Alsace and Lorraine. The Isenheim Altarpiece is moved for the second time in its history. Now, having addressed a generation prepared to identify with its language of vision, having been discovered by both artists and critics, having received the sustained scholarly treatment of a monographic study, the altarpiece is sent to Munich's Alte Pinakothek for safekeeping.[77] There it receives the threefold tribute that we pay to works of art in this museum age: restoration work is undertaken; its residence at the Pinakothek is the occasion for fresh photographic documentation; and, finally, Grünewald's altarpiece from Isenheim is placed on exhibition for all of cosmopolitan Munich to see.[78] An exponentially augmented stage of notoriety is thus inaugurated for Grünewald and the Isenheim Altarpiece.

How noteworthy the altarpiece became during its stay in Munich is clear, for instance, from the way it begins to appear in the personal journals and correspondence of Munich's resident intelligentsia. In a letter persuading his friend and patroness, Marie von Thurn und Taxis, of the value of a visit to him in Munich, Rilke adds the postscript: "That the Isenheim Altarpiece (Grünewald) is here from Colmar, you certainly know?!"[79] Several letters to Rilke from Katharina Kippenberg reveal that she and her husband, Rilke's publishers, were awaiting an essay by him on the Isenheim Altarpiece. They themselves had proposed this subject as a worthy instrument by which Rilke might pierce a worrisome writer's block during this period.[80] Thomas Mann's diaries of late 1918 record his visits and those of his family to the Pinakothek for the purpose of viewing the altarpiece. Characterizing its striking contrasts in mood and theme, he concludes that Grünewald's were among the strongest paintings he had ever seen.[81]

While the altarpiece during its stay in Munich also predictably triggered a new wave of scholarly publications, the increased attention to Grünewald was not restricted to an intellectual elite.[82] French and German newspapers of the time report that hundreds of viewers filed by the altarpiece every day.[83] Toward the end of the war, emotional throngs entered the Munich museum, drawn there by Grünewald's altarpiece, in front of which the aspirations and disillusionments of a tired German nation came into focus.[84] Both the patriotic energy that had bolstered a sense of national identity at the outset of the war and the present feelings of loss were rehearsed before Grünewald's paintings.[85] When it became clear that Alsace would revert to French hands and that the altar-

piece would also have to be returned to what was now French territory, a defeated Germany clung in possessive attachment to this artistic treasure, so that France had to press for its restitution.[86]

The altarpiece made the trip back to Colmar in the fall of 1919, leaving in its wake conflicting interpretations of the Munich sojourn. The Germans, claiming to have saved the monument from destruction, now felt deprived of what had come to represent to them the quintessence of German civilization. The French suspected German bad faith, calculated abduction, and even rape in the heavy-handed restoration procedures that had been forced upon several of the works from Colmar.[87] With the return of the Isenheim Altarpiece to a French Alsace, France now became more systematic in its adoption of this treasure. Soon, for example, the first French-language monograph on Grünewald was to appear. Louis Réau, its author, had in an earlier article demonstrated his sensitivity to complexities in the modern critical reception of the altarpiece and had generously credited Schmid's research on Grünewald.[88] In the 1920 monograph, Réau features Huysmans's important writings on Grünewald. Furthermore, while not debating Grünewald's place as a German artist, the French scholar points to the origins of the Antonite order in the heart of France, the Dauphiné, and to the survival of Burgundian iconographic traditions in the altarpiece, thus establishing the coherence of its destiny in France.[89]

Now that the work was more than ever cherished in France as a masterpiece, a sense of increasing familiarity undoubtedly alternated with its appeal as an object from an alien culture to attract several members of the Surrealist circle. Pablo Picasso had ushered in the decade by exploring the formal imprint of the subject of the *Crucifixion* in a small painting; a suite of drawings done in Boisgeloup in the fall of 1932 pursues the theme in connection with the Isenheim Altarpiece.[90] One of the sheets suggests the outlines of the kneeling Magdalene as well as the standing Saint John the Baptist on either side of the cross (Fig. 81). As his drawings shift between positive and negative treatment of ground versus figure, the imagery quickly metamorphoses into agglomerations of bonelike shapes and skeletal grids remote from the Grünewald source (Fig. 82).[91] The imagery in the altarpiece obviously mingled with Picasso's own evolving language of violence and suffering, which was to culminate in his rendition of *Guernica*. Yet interestingly Picasso himself affirmed the suite's inspiration in the Isenheim Altarpiece when the drawings made their public appearance a few months later. They were

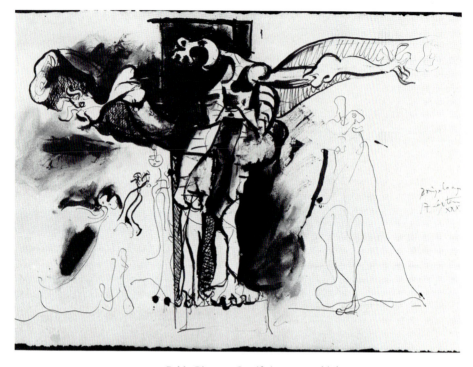

FIGURE 81. Pablo Picasso, *Crucifixion*, pen and ink, 1932.

included in the first issue (June 1933) of the Surrealist publication *Minotaure*, where the table of contents lists them: "Suite de dessins de Picasso, exécutés d'après la *Crucifixion* de Grünewald (Musée de Colmar)."[92]

During these years Grünewald also became an important locus for shared values in Picasso's friendship with Christian Zervos and Paul Éluard and a vehicle for the articulation of their common artistic aspirations. Zervos, who began to publish his monumental catalogue raisonée of Picasso's work in 1932—the same year the artist had turned his attention to the Isenheim Altarpiece—brought out a large portfolio of plates of the altarpiece in 1936.[93] He dedicated this volume to Picasso and Éluard.[94] In the introduction, Zervos centers on Grünewald's drawing as the sign of his artistic independence and power to visualize the real and the surreal. More than mere linear notation, drawing became for Zervos the medium of true poetic eloquence—a point of view seemingly arrived at in conjunction with Éluard and Picasso. During this

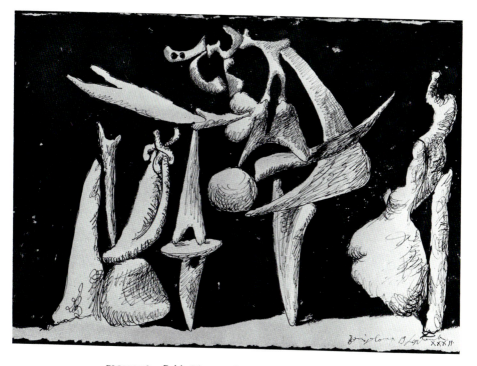

FIGURE 82. Pablo Picasso, *Crucifixion*, pen and ink, 1932.

same year of Picasso's meeting with Éluard, the latter spoke at the opening of a Picasso retrospective in Barcelona.[95] Here the poet declared the potential of drawing to exist as a social fact, like language and writing, a genuine means of communication. Picasso in turn made a portrait sketch of Éluard and presented him with a second drawing celebrating the artist's friendship with the Zervoses and the Éluards.[96] On it Picasso renders fragments of a Calvary scene and refigures the hulking arms of a Christ on the Cross from the Isenheim-related Boisgeloup drawings. A pasted caption that serves as title of the sheet—"Le Crayon qui parle"—expresses the artist's own belief in a poetics made possible by the language of line.

If we speculate about modern responses to Grünewald's masterpiece, another place where one might expect to find evidence is in the writings of Albert Schweitzer. Who, in the twentieth century, better embodies those ideals that converge in the Isenheim Altarpiece—the religious

spirituality, the healing mission, and the aesthetic transcendence? An Alsatian by birth and upbringing, Schweitzer energetically identified with both the French and German ingredients of his homeland, his life making a mockery of the national rivalries ingrained in the history of this region. With his penchant for the memoirist's record, his silence on the subject of an encounter with Grünewald can in all probability be explained by the fact that it was a regular part of his experience. It is Stefan Zweig in 1932 who connects the two when he writes of a memorable visit to Schweitzer in Alsace.[97] On his way to the town of Günsbach, Zweig interrupts his journey to see the cathedral in Strasbourg and the Isenheim Altarpiece in Colmar.[98] The aura of Schweitzer's personal presence and the effect of hearing him play Bach's music on the local church organ later combine with a mental picture of the Isenheim Altarpiece and the Strasbourg cathedral to produce a feeling of overwhelming integration that accompanies Zweig on his return trip. But as the train passes one Alsatian town after another, he suddenly realizes that the familiar ring of their names stems partly from recalled reports of statistics of war dead. That very day, having witnessed the highest capabilities of mankind, what remains for him is a terrible impression of the unbridgeable extremes of human behavior. During this same year, as we will see, the Isenheim Altarpiece was to provoke other instances of such perceptions of irreconcilability and the tragic sense of a world split asunder.

On May 20, 1931, a prodigiously gifted young German scholar named Erwin Panofsky delivered a lecture on the problem of meaning in the visual arts.[99] Against the grain of art appreciation, connoisseurship studies, and the histories of style that were at the origins of art history, Panofsky was attempting to reorient the discipline in a more intellectual and humanistic direction. Treating the Renaissance picture as the equivalent of a text with multiple levels of reference, Panofsky posits a method aimed at deciphering meaning. He sets out by examining the nature of description—for him the foundation of interpretive discourse—and presents, for the purpose of illustration, Grünewald's *Resurrection* panel from the Isenheim Altarpiece (Pl. 6). A first level of concrete analysis, he suggests, would characterize the colors or light in this picture, without even attaching such names as rock or person, without identifying Christ or his state of ascension. What seems like a circumspect, didactic procedure goes to the quick of Panofsky's commitments as a scholar. For by using this most expressive example of religious art to make such a point, he represents formal analysis as a severe state of dissociation.

By the time this lecture was published, in 1932, Panofsky was beginning to divide his academic year between Hamburg and New York, where he had been invited to teach by New York University.[100] The introduction to *Studies in Iconology* of 1939, which was to become the most famous methodological statement of purpose of the English-speaking Panofsky, well known to scholars across disciplines, is, in substance, the same as the 1932 publication.[101] Among the changes of emphasis between the two versions that have lately come under review, one point has never been examined or even mentioned: Grünewald disappears from the American version of the essay. Replacing the *Resurrection* is a scene from life—the famous lifting of the hat as a sign of greeting between two acquaintances. To be sure, especially since both versions were initially lectures, they were certainly calculated to appeal to their respective publics. What had become a familiar reference for the German audience (Panofsky uses the words *"beliebiges Beispiel"* and *"berühmte Auferstehung"* ["an arbitrary example" and "the celebrated *Resurrection*"]) would have been somewhat esoteric in the America of 1939.[102] But a more complex estrangement may have further dictated the omission.

By 1939, of course, German politics had turned Panofsky from a distinguished academic visitor into a refugee scholar. Even if Panofsky's escalating privilege in American academe succeeded in anesthetizing his personal fears, wounds, and sense of outrage about events in Nazi Germany, even if Grünewald's work as such were not bound up for this scholar with notions concerning Germanic identity that he might at the time have aimed to avoid, Grünewald and the Isenheim Altarpiece had in fact taken the platform of a bitter public controversy a few years earlier in the Nazi party's policy on the arts. This controversy also stems from the year 1932, when the composer Paul Hindemith first conceived the opera *Mathis der Maler*.

By the second half of the 1920s, Hindemith was exploring the functional context of the musical piece (in his so-called *Gebrauchsmusik*), as well as the possibility of an active engagement on the part of the "consumer"/listener (in the *Lehrstücke*), with the aim of retrieving a socially integrated place for music.[103] In the opera *Mathis der Maler*, inspired by the life of Grünewald and structured dramatically around themes from the three successive views that comprise the Isenheim Altarpiece, Hindemith addressed the subject of the artist's destiny. He set the opera at the time of the peasant wars of the early Reformation, but the theme obviously reflected his own conflicts.[104] Hindemith's Grünewald is a

successful painter in the hands of an enlightened, ecclesiastical patron until a *crise de conscience* makes the artist reject what he comes to perceive as his alienated role in order to participate in the cause of political revolution. Hindemith conjures up the broad scope of German tradition as he weaves old folk melodies and church chorals into his compositional score.[105] And his own program notes to the first full-scale performance of the opera make it clear that his choice of Grünewald was also meant to glorify that tradition: "From the animating spirit of one of the greatest artists that we ever possessed."[106] Why then, when Wilhelm Furtwängler presented it for approval as part of his proposed schedule for the 1934 season, did Göring, on behalf of Hitler, block the project?[107] On the level of plot, the opera's resolution was certainly unacceptable. In a final revelation, the artist returns to his work on the altarpiece and prepares for death with the conviction that his only mission can be truth to his art and to his own gifts as a painter. As for form, I suspect that Hindemith's compositional freedom of interplay between traditional elements and contemporary tonalities and sequences must have been perceived as a special brand of modernist indulgence and irreverence. Notwithstanding an emotional performance of Hindemith's symphonic excerpts from *Mathis der Maler* that Furtwängler managed to bring before the public, the opera could not be performed.[108]

Unwilling or unable to exploit the potential of Grünewald as an artistic hero, the Nazi era's befuddled relationship to the painter is also manifested in the second major monograph on the artist, which appeared in 1938 and serves as an end point for our discussion.[109] W. K. Zülch, its author, had been publishing on Grünewald throughout the twenties.[110] As mentioned earlier, it was Zülch who, through archival research, finally uncovered the artist's real name, Mathis Gothart Nithart, and added pertinent facts about his life in the obvious attempt to tame the beast of mystery and myth, as revealed by the book's title, *Der historische Grünewald*. A provincial nationalistic bias flavors this otherwise well-intentioned book, and the copyright page proudly announces its printing in the *alter Schwabacher* typeface, the Gothic type that was for a time favored by the Nazis as an emblem of genuine German culture—this at a moment when Grünewald's fame had already crossed the ocean, not to speak of European national boundaries. A monograph by an American author, Arthur Burkhard, had come out in 1936[111]; and, as we have seen, the man fast emerging as the most famous living artist in the Western world, Pablo Picasso, had engaged in a dialectic with the

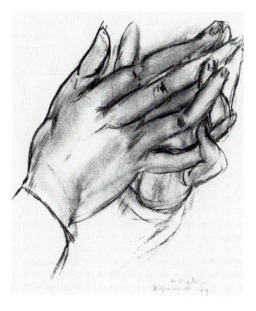

FIGURE 83. Henri Matisse, *Study of Folded Hands*,
conté crayon on laid paper, 1949.

Isenheim *Crucifixion*. Indeed, that Picasso probably never went to Colmar but worked from reproductions seems partly to have sustained a conviction, expressed also by Zervos in his portfolio on the Isenheim Altarpiece, about the universal reach of Grünewald's language.

The Allied victory, the subsequent shift in balance of power, and a resulting economic and political internationalism eventually provided Grünewald with the more open and neutral field for reception that his reputation by then demanded. Entering the canon of the survey courses that proliferated in American colleges during the postwar period, as well as the textbooks written to serve these introductions to the visual arts, Grünewald could also become part of a climate of more relaxed delectation. A specialized study in English, for example, examines his small but extraordinary corpus of drawings.[112] At the same time, the aged Matisse turns to the quiet, meditational aspect of the Madonna's gesture in the Isenheim *Annunciation* in preparation for his decorations at the Chapelle du Rosaire in Vence (Fig. 83).[113] Surely it was for the sake of its unforgettable, many-paneled format and its affirmation of the painterly medium as field for color and light that the Isenheim Altarpiece was

Ellsworth Kelly's first projected stop when the young American painter returned after service in the army to live in Paris in the late forties.[114]

Even now, the effect of Grünewald's panels reverberates. At a moment when the future of painting had itself seemed problematic, its recent revitalization, in part through neo-Expressionist energies—in the United States and Europe, particularly in Germany—again creates the potentially charged circumstances for identification with Grünewald's vision. Is this, from an outsider's perspective, what Jasper Johns is acknowledging in the paintings he exhibited in 1984 and 1987? Although the word had spread of his borrowing from Grünewald, Johns gives the viewer no chance to decipher this source as he overturns and overlaps the image, presents it in hatched rendering, and causes it to dematerialize before our eyes (Fig. 84). A master craftsman in an age of mechanical reproduction, Johns goes full circle. He draws from a masterpiece of the history of painting an image to be noticed only in a photograph of his work, where we can more readily examine from all sides. Not only from the difficulty of the search does there come the shock of recognition. For the image we find hiding like a memory trace is that of the pathetic diseased demon from the foreground plane of the *Temptation of Saint Anthony* (Pl. 8). What precisely the figure signifies for Johns one can only speculate on. One thing is certain, however; in coming to rest on this embodiment of suffering, Johns (perhaps unintentionally) has evoked the context that originally provided the Isenheim Altarpiece with its reason for being.

We have moved from the manifold effects of the Isenheim Altarpiece in the monastery at Isenheim and within the wider realm of religious belief and ideology in the sixteenth century to explore the changing but equally complex hold on viewers that—having outlived its integrated function—this monument has exercised in the modern world. Let us close by considering the unique attempt to characterize Grünewald as a painter that was undertaken by a direct contemporary of the artist. In his *Elementorum rethorices libri duo* of 1531, Philip Melanchthon clarifies the critical terminology relevant to rhetoric by invoking styles of painting. For this purpose he ranks Grünewald in relation to two other great German painters: Albrecht Dürer and Lucas Cranach. The humanist classifies Dürer's work in terms of the *genus grande*, Cranach's the *genus humile*. Grünewald, in turn, represents a level mediating the two, the *genus mediocre* (not the "mediocre" of modern English usage).[115] Once,

I confess, this judgment seemed no more than a conventional formulation to me. But in the context of my examination of the impact of the Isenheim Altarpiece in modern times, Melanchthon's words open onto an important aspect of Grünewald's art.

The *genus grande* with which Melanchthon compares Dürer applies, of course, to that artist's monumentality of conception (one thinks especially of such works as the Munich "Apostle" panels [Fig. 58]), to the theoretical underpinnings of his art and its self-willed relation to the Italian model. A productive tension results from the way his pictures alternately ignore, depart from, and embrace that implied canon of style. Equivalent to a public rhetoric, a language of authority, this mode of discourse is noticeably absent from the more limited, vernacular dialect—one might say "burgher courtliness" (called *gracile* by Melanchthon)—of Cranach's representational world.

Thus, too, Grünewald's *genus mediocre* comes into focus. If Melanchthon used the term in the sense of an intermediary stage between *grande* and *humile*, it was not merely a middle ground. Grünewald's world was singular and personal, direct in its appeal, and—so Melanchthon may be suggesting—remote from the Italian model of style. Yet the grandeur of statement of which this artist was capable and which he accomplished in the Isenheim Altarpiece also needed acknowledgment. (Indeed, in modern times, scholars driven to account for its power have, in the absence of any documentary or precise stylistic evidence, hypothesized an Italian voyage for the painter.) The *genus mediocre* of Grünewald's painterly style could be simultaneously awesome and inviting. However impressive, its religious thematics permitted—still do permit across the centuries—direct access to the viewer, who is encouraged to explore its depths.

Through the medium of painting, Grünewald created at Isenheim a heightened sense of the present. In this altarpiece of changing views, he stimulated the viewer's faculties of memory and association and guided the worshiper toward enlightenment and hope. Today the painterly illusion defies even the altarpiece's dismembered state to address all our channels of perception, challenging us to scale its aesthetic heights. But no canon of beauty can adequately assist us in taking its measure. As in that supreme convergence of natural elements—the view from a mountain peak—rugged reality and transcendent vision unite.

FIGURE 84. Jasper Johns, *Untitled*, encaustic and collage on canvas with objects, 1984.

NOTES

1. Reprinted in H. A. Schmid, *Die Gemälde und Zeichnungen von Matthias Grünewald*, Strassburg, 1911, 345, "Rapport des Cns Marquaire et Karpff dit Casimir, Commissaires nommés par Arrêté du Directoire du District de Colmar (15, Octobre 1794)": "La dislocation des Figures et des Peintures de cet Autel seroient inexcusables, si ce n'étoient les dangers auxquels il étoit exposé pendant que le Vandalisme exercoit toutes ses fureurs," ("The removal of the statues and the paintings from this altarpiece would be inexcusable were it not for the danger to which it had been exposed during the time that the furies of Vandalism were rampant.") ". . . A l'égard de L'Autel, il paroit nécessaire de le rétablir dans son ensemble, qui seul Caractérise toute sa beauté et sans lequel on ne pourroit transmettre à la Postérité que des fragmens qui pris et considérés isolément ne prêteroient à aucun effet et ne seroient autre Chose que L'Histoire d'un Ouvrage mutilé."

2. André Waltz, "Comment fut créé le Musée des Unterlinden," *Bulletin de la Société Schongauer à Colmar*, 1923–1933, 47–55. The museum, containing the Isenheim Altarpiece, was opened to the public on Apr. 3, 1853.

3. This description by Franz Chr. Lerse, who had been a friend of Goethe's during his student years in Strasbourg, is reprinted in H. A. Schmid, *Die Gemälde*, 1911, 329–38, and dates from between 1777 to 1793.

4. "Renaissance Art: the Work of Art as a Whole" was the title of a College Art Association panel in San Francisco, 1972, where I first outlined this direction. The session, chaired by Marilyn Lavin, presented a set of examples that reflected an increasing attention in the early 1970s to individual works within their original contexts. An outlet for this approach was the "Art in Context" monograph series edited by John Fleming and Hugh Honour and published by Viking Press, New York.

5. Michael Baxandall, *Painting and Experience in Fifteenth Century Italy*, London, Oxford, and New York, 1972.

6. Michel Foucault, *Madness and Civilization*, trans. Richard Howard, New York, 1965; idem, *The Order of Things*, New York, 1970; idem, *The Birth of the Clinic*, trans. A. M. Sheridan Smith, New York, 1963.

7. See, for example, relevant portions of Lotte Brand Philip, *The Ghent Altarpiece and the Art of Jan van Eyck*, Princeton, N.J., 1971; L. D. Ettlinger, "The Liturgical Function of Michelangelo's Medici Chapel," *Mitteilungen des Kunsthistorischen Institutes in Florenz*, XXII, 3, 1978, 287–304; Elizabeth C. Parker, *The Descent from the Cross: Its Relation to the Extra-Liturgical "Depositio" Drama*, New York and London, 1978; Barbara G. Lane, *The Altar and the Altarpiece*, New York, 1984.

8. Numa Denis Fustel de Coulanges, *The Ancient City: A Study of the Reli-*

gion, Laws, and Institutions of Greece and Rome, trans. Willard Small, Gloucester, Mass., 1979; cross-cultural studies by Mircea Eliade, such as *The Sacred and the Profane*, trans. Willard R. Trask, New York and London, 1959; ed. Susan Vogel, *For Spirits and Kings: African Art from the Paul Tishman Collection*, New York, 1981; Suzanne Blier, *The Anatomy of Architecture: The Ontology and Metaphor of Batammaliba Architectural Expression*, Cambridge, London, and New York, 1987.

9. Clifford Geertz, "Deep Play: Notes on the Balinese Cockfight," *The Interpretation of Cultures*, New York, 1973, 412–53; Natalie Zemon Davis, "The Rites of Violence," *Society and Culture in Early Modern France*, Stanford, Calif., 1975, 152–87. See prefatory remarks in Victor Turner, *The Ritual Process*, Ithaca, N.Y., 1977; ed. Victor Turner, *Celebration: Studies in Festivity and Ritual*, Washington, D.C., 1982. For an application of this orientation to works of art, see papers from the 1985 College Art Association session chaired by Svetlana Alpers, "Art or Society: Must We Choose?" published in *Representations*, 12, Fall 1985.

10. William M. Ivins, Jr., the first curator of prints at the Metropolitan Museum of Art, is notable in calling attention to fundamental changes in the formulation and distribution of knowledge brought about with the beginnings of printing and printmaking. See, for example, *Prints and Visual Communication*, Cambridge, Mass., and London, 1953. With Elizabeth Eisenstein's *The Printing Press as an Agent of Change*, 2 vols., Cambridge, London, and New York, 1979, as the most comprehensive treatment to date, the essays of such historians as Natalie Zemon Davis and Robert M. Kingdon have contributed greatly to our general awareness of the impact of this new technology. See their respective contributions to *Aspects de la propagande religieuse*, ed. H. Meylan, Geneva, 1957.

11. Walter J. Ong, S.J., *The Presence of the Word*, New Haven, 1967. In this context, my growing appreciation of the characteristics of preliterate, oral traditions, as in ancient epic, has been greatly stimulated by the assumptions and procedures in classical studies, starting with Albert B. Lord, *The Singer of Tales*, Cambridge, Mass., 1960, and, currently, Gregory Nagy, *Comparative Studies of Greek and Indic Meter*, Cambridge, Mass., 1974; idem, *The Best of the Achaeans*, Baltimore, 1979; Laura Slatkin, "The Wrath of Thetis," *Transactions of the American Philological Association* 116, 1986, 1–24.

12. See, for instance, the essays in Jane P. Tompkins, ed., *Reader-Response Criticism*, Baltimore, 1980; Hans Robert Jauss, *Toward an Aesthetic of Reception*, trans. T. Bahti, Minneapolis, 1982; see also the introduction to this book by Paul de Man.

13. Wolfgang Stechow, ed., *Northern Renaissance Art 1400–1600*, Englewood Cliffs, N.J., 126f. (trans. H. W. Janson from the A. R. Peltzer edition of the *Teutsche Academie der Edlen Bau-, Bild- und Mahlerey-Künste*, Munich, 1925, 81f.).

14. See especially the research of Walter Karl Zülch, which culminated in his monograph on the artist, *Der historische Grünewald*, Munich, 1938, documents 355–93.

15. Heinrich Geissler, "Meister Mathis—Leben und Werk," in Max Seidel, ed., *Grünewald, Der Isenheimer Altar*, Stuttgart, 1973, 15–37.

16. Ibid.; see also Anton Kehl, *Grünewald Forschungen*, Neustadt a.d. Aisch, 1964.

17. Von Sandrart, for instance, mentions three impressive altarpieces by Grünewald that were originally housed in the cathedral at Mainz. They were allegedly destroyed in a shipwreck while en route to Sweden during wartime in the early part of the seventeenth century. See above, note 13.

18. Roland Barthes, "The Death of the Author," *Image, Music, Text*, ed. and trans. Stephen Heath, New York, 1977, 142–48. Jonathan Culler, *Structuralist Poetics: Structuralism, Linguistics, and the Study of Literature*, Ithaca, N.Y., 1975; Stanley E. Fish, *Is There a Text in This Class? The Authority of Interpretive Communities*, Cambridge, Mass., 1980.

19. See correspondance in H. A. Schmid, *Die Gemälde*, 1911, 315–17.

20. Already revealing this combination of anonymity and celebrity is a late sixteenth-century poem originally affixed to the back of the altarpiece. In translation: "This art comes from the grace of God / When God denies, then all's for nought. / All should praise this work God wrought / For this art comes from God." H. A. Schmid, *Die Gemälde*, 1911, 332; attribution to Dürer recorded, 325.

21. Thus, for example, a level of engagement characteristic of the specialist's investigations marks the writings of the most varied spectators of the altarpiece, often, in fact, forcing the issue of the particular viewer's place in history, as well as the exigencies of the original role of the altarpiece. Here one thinks of John Berger, whose viewing of and simultaneous writing on the Isenheim Altarpiece in 1963 and again in 1973 becomes the occasion for a self-monitoring of changing perceptions against the backdrop of varying social and political conditions and expectations. Linda Nochlin, whose historical focus as a scholar has been nineteenth-century French art, published an essay—first destined for integration into a novel—entitled "Mathis at Colmar—A Visual Confrontation" (New York, 1963), an intense meditation on the different sections of the altarpiece.

22. *Chronik der Anna Magdalena Bach*, (Italy, West Germany), 1968, a screenplay by Jean-Marie Straub and Danièle Huillet. Significant in the context of my remarks is the actual collaboration in 1981–1982 of the historian Natalie Zemon Davis, the scenarist Jean-Claude Carrière, and the director Daniel Vigne on the screenplay for the film *Le Retour de Martin Guerre*.

CHAPTER I

1. Saint Athanasius, *The Life of Saint Anthony*, Robert T. Meyer, trans. and ed., New York, Ramsey, New Jersey, 1978; Migne, *Patrologia Graeca*, 26, 1887, 835–976; Peter Brown, "The Rise and Function of the Holy Man in Late Antiquity," *The Journal of Roman Studies*, LXI, 1971, 80–101; idem, *The Cult of the Saints*, Chicago, 1981; idem, "The Saint as Exemplar in Late Antiquity," *Representations*, 1, 2, Spring 1983, 1–25.

2. Adalbert Mischlewski, "Die Antoniter und Isenheim," *Grünewald: Der Isenheimer Altar*, Stuttgart, 1973, 256–66; idem, *Grundzüge der Geschichte des An-*

toniterordens bis zum Ausgang des 15. Jahrhunderts, Cologne and Vienna, 1976, Chap. 1.

3. H. A. Schmid, *Die Gemälde und Zeichnungen von Matthias Grünewald,* Strassburg, 1911, 89f.

4. Pilot de Thorey, "Étude sur la sigillographie du Dauphiné," *Bulletin de la Société de Statistique,* 9, Grenoble, 1879, 155–56.

5. Le R. P. Hélyot, *Dictionnaire des Ordres Religieux,* Vol. 1, Paris, 1947, 259–65; G. Vallier, *Armorial des Grands-Maîtres et des Abbés de Saint-Antoine de Viennois,* Marseille, 1881, 17; Paul Stintzi, *Les Antonites d'Issenheim,* Mulhouse, 1972; "Les deux statues du Maître-Autel d'Issenheim," *Revue Alsacienne,* XIV, 11, 1912, 47–50; H. A. Schmid, "Zwei wiedergefundene Figuren vom Isenheimer Altar," *Strassburger Post,* 64, 18 Jan. 1912.

Innocent IV (pope 1243–1254) exempted the house from the bishop's jurisdiction, placing it directly under papal protection; in addition he granted it permission to collect alms. Clement IV, in 1265, extended to the Antonites the privilege of keeping herds of pigs and allowing them to roam freely in the streets. These provided nourishment for the inhabitants of their monasteries and could be sold outside. Boniface VIII, at the end of the thirteenth century, reconfirmed these privileges. In 1502 Emperor Maximilian donated his coat of arms to the order. A. Mischlewski, "Die Antoniter und Isenheim," in *Grünewald: Der Isenheimer Altar.,* 1973, 255–66.

6. F. Schaedelin, "La Commanderie de Saint-Antoine à Froideval près Belfort," *Revue d'Alsace,* 1931, 285–305; A. Mischlewski, ibid., 264–65.

7. See Introduction, note 3.

8. St. Jerome, "The Life of Paulus the First Hermit," *Nicene and Post-Nicene Fathers of the Christian Church,* eds. P. Schaff and H. Wace, New York, 1893, 299f.

9. Some of these ideas were first put forth in a paper delivered at the *Table Ronde Internationale*: "Grünewald et son oeuvre," Strasbourg-Colmar, Oct. 1974. My thanks to Professor Albert Châtelet for inviting me to participate in this conference and in the eventual publication of the papers in a special issue of *Cahiers alsaciens d'archéologie, d'art, et d'histoire,* XIX, 1975–1976, 77–90. I subsequently pursued this direction in an expanded publication, "The Meaning and Function of the Isenheim Altarpiece: The Hospital Context Revisited," *Art Bulletin,* LIX, 4, Dec. 1977, 501–17. I am grateful to the late Howard Hibbard, then editor of the *Art Bulletin,* for his sympathetic criticism. I would like to thank the current editor for permission to reprint portions of the article, which, with revisions, forms the basis of the present chapter; it, in turn, has had the benefit of astute commentary by two medical historians who served anonymously as readers for Princeton University Press.

10. A. Leflaire, *L'Hôtel-Dieu de Beaune et les hospitalières,* Paris, 1959, 16.

11. V. Advielle, *Histoire de l'ordre hospitalier de Saint-Antoine de Viennois et de ses commanderies et prieurés,* Paris-Aix, 1883; Abbé Dassy, *L'Abbaye de Saint-Antoine en Dauphiné,* Grenoble, 1844; L'Abbé Luc Maillet-Guy, *La Commanderie de Saint-Antoine de Vienne en Dauphiné,* Vienne, 1925.

12. *Liber Religionis Sancti Antonii Viennensis Sacrae Reformationis,* Archives

Départementales de l'Isère, Grenoble, X.H.4. Sections of these reforms, redated from 1477 to 1478, in A. Mischlewski, "Die Auftraggeber des Isenheimer Altares," *Cahiers alsaciens*, XIX, 1975–76, 15–26, and idem., *Grundzüge*, 1976, 319–23, have been reprinted in period French translation in Henry Chaumartin, *Le Mal des ardents et le feu Saint-Antoine*, Paris, 1946, 99ff.; Abbé Dassy, *L'Abbaye de Saint-Antoine*, 1844, 181ff.; A. Falco, *Antonianae Historiae Compendium*, Lyon, 1534. A French eighteenth-century translation of this manuscript can be found in the Bibliothèque Municipale, Grenoble, U. 4391.

13. P. Heitz and W. L. Schreiber, *Pestblätter des XV Jahrhunderts*, Strassburg, 1901, 9f.; Emile Mâle, *Religious Art in France: The Late Middle Ages. A Study of Medieval Iconography and Its Sources* (1908), ed. H. Bober, trans. M. Mathews, Princeton, N.J., 1986, 179f. Sebastian's role as *depulsor pestilitatis* appears to hinge on his having survived a first attempt to kill him with arrows; the unleashing of arrows by a deity as an infliction upon mankind, in turn, constitutes a thematic motif in the Bible and in ancient epic (Job 6: 4; Iliad 1, 46.).

14. Marie-Madeleine Antony-Schmitt, *Le Culte de Saint-Sébastien en Alsace*, Strasbourg-Colmar, 1977, 36, singles out especially the years 1473, 1474, 1494, and 1509 from the time frame that concerns us.

15. Ibid., 63–64, ". . . *ab ipsa peste epidemiae et ab omni tribulatione corporis et animae liberemur*."

16. H. Chaumartin, *Le Mal des ardents*, 1946, 88. "*Toutes les personnes atteintes du Feu Sacré, de quelque contrée du monde qu'elles viennent, elles y sont reçues et si elles sont estropiées y sont nourries et sustentées avec grande charité toute leur vie.*" ("All persons stricken with the Holy Fire, from whatever region they come, are received there and, if they are disabled, they are fed and supported with great charity for the rest of their lives.") Ernest Wickersheimer, "*Ignis Sacer*—The History of a Name," *CIBA Symposium*, VIII, 4 Oct. 1960, 160–69; Veit Harold Bauer, *Das Antonius-Feuer in Kunst und Medizin*, Historische Schriftenreihe Sandoz AG 2, Basel, 1973.

17. Louis du Broc de Segange, *Les Saints patrons des corporations et protecteurs*, I, Paris, 1887, 49–56; C. D. Cuttler, "The Temptation of St. Anthony in Art," Ph.D. diss., New York University, 1952, 13.

18. Added insurance against illness through the pairing of saints is common both in writings of the time and in visual representation. Saint Roch is the other popular example. Ieronimo Brunswig, *Liber pestilentialis de venenis epidimie*, Strasburg, 1500, II, Cap. V rect., invokes Saint Sebastian with Saint Roch, "that they should beg to God for us that He will shield us from this gruesome and terrifying illness."

19. See J. M. Charcot and P. Richer, "Les Syphilitiques dans l'art," *Nouvelle Iconographie de la Salpêtrière*, I, 1888, 258–60; idem, *Les Difformes et les malades dans l'art*, Paris, 1889, 79ff.; H. Meige, "La Lèpre dans l'art," *Nouvelle Iconographie de la Salpêtrière*, X, 1897, 454–58; G. Thibierge, "Sur le prétendu lépreux du polyptique de Grünewald au musée de Colmar," *Les Annales de dermatologie*, IV, 1920, 164–70; E. Wickersheimer, "Mathias Grünewald et le feu Saint-Antoine," 1er *Congrès de l'Histoire de l'art de guérir*, Anvers, 1920, 3–11; H. Fleurent, *L'Art et la médicine au musée de Colmar*, Colmar, 1928.

20. Ibid., 101. "Le lendemain le malade doit être admené à la crotte dudit hopital (chapelle souterraine), et visité pour savoir si la maladie est du mal infernal; et s'il en est."

21. H. Brabant, *Médecins, malades et maladies de la renaissance*, Brussels, 1966, 89ff.; Anon., *From Ergot to "Ernutin": An Historical Sketch*, London, Burroughs Wellcome & Co., 1908, II, 37ff. In 1597 a tract was published by the University of Marburg attributing the cause of this disease to spurred rye. This was confirmed in 1630 by the Duc de Sully's physician in France. Ergot is a form of the fungus Claviceps Purpurea, which grows, especially in rye, after a damp season and a bad harvest.

22. H. Chaumartin, *Le Mal des ardents*, 1946, 24; Appendix 1. Sigeberti Gamblacensis Chronica, 1098: "Annus pestilens, maxime in occidentali parte Lotharingiae; ubi multi, sacro igni interiora consumente computrescentes, exesis membris instar carbonum nigrescentibus, aut miserabiliter moriuntur, aut manibus et pedibus putrefactis truncati, miserabiliori vitae reservantur, multi vero nervorum contractione distorti tormentantur."

This disease was known variously as Feu d'Antoine, Ignis Sacer, Ignis Infernalis, and Erysipelas. Medical histories, consistent with the above description, generally divide the symptoms of ergot poisoning into two forms, the gangrenous and the convulsive (*From Ergot to "Ernutin,"* 1908, 41ff.).

23. The reform doctrines of 1478 contain a section on regulations for the attire of these patients. One of the requirements is "a cowl, according to the long-held custom," which might explain the red hood draped around the head and shoulders of this figure (Chaumartin, *Le Mal des ardents*, 99).

24. H. Fleurent, *L'Art et la médicine au musée de Colmar*, 1928, 16; C. Tollet, *De l'assistance publique et des hôpitaux jusqu'au* XIX siècle, Paris, 1889, 45. Evidence for this is seen, for instance, in Nicolas Rolin's dedication of the Hôtel-Dieu, in which he says, "I herewith found . . . a hospital for poor sick people." (A. Leflaire, *L'Hôtel-Dieu de Beaune*, 1959, 16).

25. W. Kühn, "Grünewalds Isenheimer Altar als Darstellung mittelalterlicher Heilkräuter," *Kosmos*, XLIV, 1948, 327–33. According to Kühn, of the twenty identifiable plants in this seemingly naturalistic still life, fourteen have been "planted" there by the artist because of their frequent use in the treatment of Saint Anthony's Fire. See also L. Behling, *Die Pflanze in der mittelalterlichen Tafelmalerei*, Cologne, 1967, 141–47.

26. See W. L. Schreiber, "Die Kräuterbücher des XV. und XVI. Jahrhunderts," in *Hortus Sanitatis/Deutsch*, Mainz, 1485, facsimile ed., Munich, 1924; *The Illustrated Bartsch; Herbals, 1484–1500*, XC, ed. F. J. Anderson, New York, 1983.

27. Thus Hieronymus Bock prescribes "Eisenkraut mit Essig zerstossen unnd auff das Wildfeur gelegt/ stillet und leschet den Brandt" (Strassburg, 1577; facsimile ed., Munich, 1964, 77v.). ("Verbena crushed with vinegar and placed upon the *Wildfire* soothes and extinguishes the burning.") See also Karl Sudhoff, "Eine Antoniter-Urkunde aus Memmingen vom Jahre 1503 und ein therapeutischer Traktat über das Sankt Antonius-Feuer," *Archiv für Geschichte der Medizin*, VI, 1913, 270–80. Ernest Wickersheimer, "Recepte pour le mal monseigneur Saint Anthoine," *Sudhoffs Archiv*, XXXVIII, 2, 1954, 164–74.

28. See above, note 9. J. K. Huysmans's early essay on the Isenheim Altarpiece in *Trois Primitifs*, Paris, 1905, 36ff., directly relates some of the imagery to the hospital context. W. K. Zülch, *Der historische Grünewald*, Munich, 1938, 214, implies, in his discussion of the *Temptation of Saint Anthony* panel, that it had particular meaning for the patients. The use of the altarpiece in a healing program is suggested but neither substantiated nor examined in E. Ruhmer's catalogue in *Grünewald*, New York, 1958, 119.

29. A. Hayum, *Art Bulletin*, 1977, 504–5. It is obvious that I am not speaking here of the many physical conditions also existing in the Renaissance—from gout to hemorrhoids and headaches—that could be self-reparative, chronic, or curable, whatever the case may be.

30. A. Leflaire, *L'Hôtel-Dieu de Beaune*, 1959, 16: "Je fonde et dote irrevocablement dans la ville de Beaune, un hôpital pour les pauvres malades, avec une chapelle en l'honneur de Dieu."

31. H. Chaumartin, *Le Mal des ardents*, 1946, 100. "Qu'ung chacun malade soit tenu de dire pour chaque heure canonique: qui sont douze Paternôtres et autant d'Ave Maria: et dans l'église s'il est possible."

32. Ibid., 101. "Le lendemain (le malade) . . . doit être receup et conduit devant les Frères pour le saint vinage et devant les reliques, selon l'usage."

33. A. Leflaire, *L'Hôtel-Dieu de Beaune.*, 1959, 18.

34. A. Châtelet, "Unité ou diversité du thème du retable d'Issenheim?" *Cahiers alsaciens*, XIX, 1975–76, 61–68, emphasizes the fact that in all surviving ground plans (Colmar, Archives Départementales du Haut-Rhin, H 10 1 a,b,c; Lyon, Archives du Rhone, 49H699), the choir appears as a discrete section of the church. He suggests that although the altarpiece could have been viewed through the central opening leading from nave to choir, patients may have been effectively excluded from the choir. But by the time the altarpiece was commissioned, the separation between laymen and friars was probably less rigid than Châtelet suggests. (See M. B. Hall, "The Ponte in Sta. Maria Novella: The Problem of the Rood Screen in Italy," *Journal of the Warburg and Courtauld Institutes*, XXXVII, 1974, 157–73.) The existing ground plans of the Isenheim monastery show a diagonal passageway leading into the south side of the choir from points within the monastery complex.

35. In discussing food allotments, the reforms of the Antonite order specify that "on the six yearly holidays when the patients take communion (receive the holy Eucharist), [they should get] a jug of good wine that is pure and unadulterated" (Dassy, L'Abbaye de Saint-Antoine, 1844, 188f.).

36. In an essay on the Isenheim Altarpiece by J.K Huysmans (trans. Robert Baldick in *Grünewald*, New York, 1958, 10–25), the writer already drew attention to the apparently pitiable aspect of this demon. "Was Grünewald's intention to depict a demon in its most despicable form? I think not. On careful examination the figure in question is seen to be a decomposing, suffering human being."

37. "Ubi eras ihesu boni, ubi eras? Quare non affuisti ut sanares vulnera mea?" See also C. Cuttler, "Some Grünewald Sources," *Art Quarterly*, XIX, 1956, 101ff., 115. Actually there is an interesting change of emphasis in the quotation on the *cartello* compared to the original passage in Athanasius. In the Greek text,

Anthony's questions are formulated in a more generalized vein. He does not specifically name Jesus but asks why God had not appeared earlier to remove his pangs or troubles (*odunai*) rather than *ut sanares vulnera mea* (in order to heal my wounds), a citation from the *Legenda Aurea* that seems more pointedly relevant to a clinical context.

38. A. Martin, "Das Antoniusfeuer und seine Behandlung in der deutschen Schweiz und im benachbarten Elsass," *Schweizerische medizinische Wochenschrift*, 1922, 106. W. Kühn, "Gestalt und antike Vorbilder des Antonius Eremita," *Psyche*, II, 1, 1948, 71–96.

39. W. Kühn, *Kosmos*, 1948, 327–33. See above p. 31 and note 32.

40. Hans von Gersdorff, *Feldtbuch der Wundtartzney*, Strassburg, 1517, section XX, "Von der abschneydung" ("Concerning Amputation"). Framing the top of Gersdorff's illustration is the couplet "Arm/bein abschniden hat sein kunst/ Vertriben Sanct Anthonien brunst." ("To cut off an arm or leg requires its art/ in order to expel Saint Anthony's ardor.")

41. K. Sudhoff, *Archiv für Geschichte der Medizin*, VI, 1913, 270–80; H. Fleurent, "L'Art et la médicine à Colmar," *Revue d'Alsace*, LXXV, 1928, 7.

42. H. Chaumartin, *Le Mal des Ardents*, 1946, 92: "*Vidimus ambustos artus atque ossa perenni Exemplo, ad postes sacri pendentia templi.*" ("We saw scorched limbs as well as bones suspended, as an enduring example, on the doorposts of the holy sanctuaries.") One of the stipulations of the reform doctrine of 1478 (ibid., 100), also suggests this reverential attitude toward the dismembered body: "Item: que les uns et les autres portent leurs robes ou habits de manière que la copure de leurs membres puisse apparaître; afin que par là le peuple soit induit à plus grande dévotion et compassion et révérence envers Sainct-Anthoyne." ("Item: let these and the others wear their garments or habits in such a way that the cut-off of their limbs be apparent, so that, through this, people may be induced to greater devotion and compassion and reverence for Saint Anthony.")

43. K. Bauch, "Aus Grünewalds Frühzeit," *Pantheon*, XXVII, 1969, 93. The predella was in fact described as a two-part panel in the eighteenth century when the altarpiece was still in situ: H. A. Schmid, *Die Gemälde*, 1911, 350.

44. As startling a display of the body of Christ as this proposed treatment of the predella would produce, it is important to realize that Christ's right arm in the main Crucifixion section was routinely cut off from his body any time these panels were opened. This, in turn, reminds us of the even more fundamental "severing" of the body—the fraction of the Host during the Mass. Indeed, a teaching missal for priests published in 1523, but first sponsored by Pope Leo X (Albertum Castellanum, Missale. Fratrum Praedicatorum, Venetia, 1523, 14 verso), shows diagrams of the Host as a circle with the crucified Christ inscribed in it. Illustrating a text that instructs the priest on how to break the wafer, they show the Host first halved along the vertical axis, thus down the center of the crucifix, then quartered with another crucified Christ split at the diameter.

Also relevant here are the known devotions to single portions of the body of Christ. Saint Bernard apparently initiated a prayer to the single limbs of Christ, and in the fifteenth century Thomas à Kempis's *Orationes ad membra Christi*

consist of fourteen prayers to the different limbs of Christ. See Sixten Ringbom, *Icon to Narrative*, Acta Academiae Aboensis, Ser. A., Humanora, 31, nr. 2, 1965, 48–49.

45. For the conventions of depicting Anthony and his attributes (staff or crutch, book, bell, and pig), see *In Symbolicam S. Antonii magni Imaginem commentatio Theophili Raynaudi*, Gandavi, 1659; Henry Chaumartin, "Le Compagnon de Saint Antoine," *Aesculape*, Sept. 1930, 1–24; idem, "L'Image de Saint-Antoine le Grand, *Bulletin de la société française d'histoire de la médecine*, XXVI, nos. 9–12, 1932, 333–85, 413–41.

46. A. S. Pease, "Medical Allusions in the Works of St. Jerome," *Harvard Studies in Classical Philology*, XXV, 1914, 73–86.

47. John Shearman, *Raphael's Cartoons in the Collection of Her Majesty the Queen and the Tapestries for the Sistine Chapel*, London, 1972, 77f.; Kathleen Weil-Garris Posner, *Leonardo and Central Italian Art: 1515–1550*, New York, 1974, 45–47; Gerhard Fichtner, "Christus als Arzt. Ursprünge und Wirkungen eines Motives," *Frühmittelalterliche Studien*, XVI, 1982, 1–18.

48. Rudolph Arbesmann, O.S.A., "The Concept of 'Christus Medicus' in St. Augustine," *Traditio*, X, 1954, 1–28.

49. The most specific Old Testament reference to the mark of the Tau is in Ezekiel 9. In the context of a vision of the destruction of Jerusalem, one man, a scribe, is commanded by God to write the letter Tau on the foreheads of a righteous few; this distinguishing mark will allow them to be spared from extermination. Christian exegetes also identified the mark of the blood taken from the Paschal Lamb and placed on the doorways of the houses of the Israelites in Exodus 12:13, 23, and the bronze serpent raised by Moses in Numbers 21:6–9, with the apotropaic and/or curative powers of the Tau cross. Franz Joseph Dölger, "Ein Türsegen mit der 'Blut Christi'-Formel und eine 'Blut Christi'-Litanei," *Antike und Christentum*, V, 1936, 248–54; Hugo Rahner, S.J., "Antenna crucis: Das mystische Tau," *Zeitschrift für Katholische Theologie*, 75, 1953, 385–410. See also the sensitive discussion of this subject in John V. Fleming, *From Bonaventure to Bellini*, Princeton, N.J., 1982, 112–20.

50. E. Wickersheimer, "Le Signe Tau, faits et hypothèses," *Strasbourg médical*, LXXXVIII, 1928, 241–48; C. D. Cuttler, *The Temptation of St. Anthony in Art*, Ph.D. diss., New York University, 1952, 13.

51. H. L. Schreiber, *Handbuch der Holz- und Metallschnitte des* XV Jahrhunderts, II, Leipzig, 1926–1930, 73–74, no. 931. Possibly from Alsace, ca. 1500, this print is discussed and reproduced in E. Wickersheimer, *Strasbourg médical*, 1928, 343, fig. 6.

52. See, for instance, H. Feurstein, *Matthias Grünewald*, Bonn, 1930, 87, in connection with Saint Bridget's *Sermo Angelico*.

53. S. Kayser, in an important article, "Grünewald's Christianity," *Review of Religion*, V, 1, 1940, 3–35, also recognizes a river in the background and brings up the theme of baptism; W. Rugamer, "Der Isenheimer Altar Matthias Grünewalds im Lichte der Liturgie und der kirchlichen Reformbewegung," *Theologische Quartalschrift*, CXX, 1939, 371–82, points to the river in the background as a reminder of the Jordan.

It should be mentioned that in the left wing of Roger van der Weyden's Braque triptych a half-length figure of John the Baptist is set against the depiction of a river in the distant background, where John appears once again in a minuscule baptism of Christ (M. Davies, *Rogier van der Weyden*, New York, 1972, fig. 52). Thus Roger articulates even more precisely that the river is a personal attribute of John the Baptist and that it refers to the larger theme of the sacrament of baptism.

54. *Selected Easter Sermons of St. Augustine*, ed. P. T. Weller, St. Louis, 1959, 45; *The Missal of Robert of Jumièges* (ed. H. A. Wilson, London, 1896, 100ff.) contains an *Ordo ad Baptisandum Infirmum* of 1008–1025.

55. S. Mayer, *Paracelsus und die Balneologie seiner Zeit*, Bad Kissingen, 1931, 6.

56. J. F. Heyfelder, *Die Heilquellen des Grossherzogthums Baden, des Elsass, und das Wasgau*, Stuttgart, 1841; L. Pfleger, "Culte des eaux et sources sacrées en Alsace," *Revue d'Alsace*, XCII, 1958, 57–78. Pfleger brings out the fact that certain natural sources of water were considered holy and that many were actually consecrated to Saint John the Baptist.

57. M.J.L. Beitz, *Description historique, chymique et médicinale des eaux minérales de Sultzbach en Haute Alsace*, Colmar, 1789, 32.

58. A. Kehl, *Grünewald Forschungen*, Aschaffenburg, 1964, 11, 35f.; doc. nos. 2, 10, 17, 18.

59. A woodcut from southern Germany, reproduced in *Grünewald—Der Isenheimer Altar*, Stuttgart, 1973, 221, depicts the same four saints as in the *Crucifixion* state of the Isenheim Altarpiece. W. L. Schreiber, *Holzschnitte . . . des fünfzehnten Jahrhunderts in der Königliche graphischen Sammlung zu München*, I, Strassbourg, 1912, 22, no. 5. The catalogue entry discusses the four saints in relation to disease and healing, associating the two Johns with epilepsy and Anthony and Sebastian with the plague. Thus, in the Isenheim Altarpiece, not only Sebastian and Anthony but also the two Johns could be part of this overall meaning.

60. Dr. H. Blum, "Grünewald, les deux volets fixes du Retable d'Issenheim," *L'Information d'histoire de l'art*, XVII, 5, Nov.–Dec. 1972, 199–207, puts forth an interesting explanation for the discrepancy in scale between the two saints. He says that if Anthony is the physician, Sebastian could represent the archetypal patient, and that in medieval manuscripts the doctor is sometimes shown in larger scale than the patient.

Grünewald's panel of Saint Cyriac, now in Frankfurt, depicts a healer and his patient within one space (Fig. 63). Cyriac performs an exorcism on the possessed Artemia, daughter of Diocletian. This panel shows a female patient, certainly much younger than Cyriac and in a kneeling posture. But beyond all these reasons for representing her in smaller scale, she seems shrunken or contracted in a manner that one might compare with the structural discrepancy of the two Isenheim saints.

61. F. Rademacher, *Die deutschen Gläser des Mittelalters*, Berlin, 1963, 73–74.

62. Henricus Cornelius Agrippa ab Nettesheym, *De Occulta Philosophia*, 1533, facsim. ed., K. A. Nowotny, Graz, Austria, 1967, 107–8, Bk. 1, Chap. 24. This text circulated in manuscript form by 1510, although it did not receive its first

printing until 1533. H. C. Agrippa von Nettesheim, *The Philosophy of Natural Magic*, ed. L. W. de Laurence, Chicago, 1913, 219, 221: "The writing of the Hebrews is, of all, the most sacred in the figures of the characters, points of vowels, and tops of accents; or consisting in matter, form, and spirit. . . . If there is any language whose words have a natural signification, it is manifest that this is the Hebrew." See also S. Seligmann, *Der böse Blick und Verwandtes*, II, Berlin, 1910, 338.

63. The mezuzah encases a tightly rolled scroll on which are written the first two paragraphs of that monotheistic proclamation central to Judaism, the *Shma Yisroel*. Shin is the first letter of *Shma* as well as of *Schaddai*, the Hebrew word meaning Almighty, also at times abbreviated on the mezuzah. See L. B. Philip, *The Ghent Altarpiece and the Art of Jan van Eyck*, Princeton, 1971, 149, figs. 161–63.

64. Ibid.; S. Seligman, *Der böse Blick*, II, 1910, 338.

65. Ibid., I, 57. Aside from the scholarly and theological commitment to Hebrew that kept it alive in the monastic context, fascination with the occult in the first quarter of the sixteenth century provoked its renewed study. In 1510, for instance, the entire parliament of Dôle, not far from Isenheim, came to hear H. C. Agrippa von Nettesheim's commentary on the Kabbalistic writings of Reuchlin (L. Durey, *La Médecine occulte*, Paris, 1900, 30).

66. G. Ritz, *Der Rosenkranz*, Munich, 1963, 5. See also the recent study on this particular feature in the Isenheim Altarpiece, Karen Barbara Roberts, *The Influence of the Rosary Devotion on Grünewald's Isenheim Altarpiece*, Ph.D. diss., State University of New York at Binghamton, 1985.

67. Ritz, ibid., 6.

68. Ibid., 65ff.

69. E.A.W. Budge, *Amulets and Talismans*, New Hyde Park, N.Y., 1961, xiv; Camillus Leonardus, *Speculum Lapidum*, Pisaro, 1502, trans. *The Mirror of Stones*, London, 1750, 83: "Their Virtue (red coral) is to stop every flux of Blood. Being carried about one, or wherever it be in a House or Ship, it drives away Ghosts, Hobgoblins, Illusions, Dreams, Lightings, Winds, and Tempests. I have it from a creditable Person . . . it will prevent Infants, just born, from falling into Epilepsy. Let it be put in the mouth of the Child before it has tasted anything, half a scruple of the Powder of Red Coral, and let it be swallowed; for it is a wonderful Preserver."

70. For instance, *Hortus Sanitatis* (ed. Strassburg, 1497 and 1517 under *De Lapidibus*), cap. ii, "*Agathes valet ad morsum scorpionis alligatum vel illinitum cum aqua statim tollit dolorem.*" (Agate is effective against the bite of a scorpion; either affixed to it or smeared on with water, it immediately takes away the pain"); cap. xviii, "*Aurum ist calide nature. lepram acscabiem curat.*" ("Gold is of a warm nature. It heals leprosy and scabies.") See G. F. Kunz, *The Curious Lore of Precious Stones*, Philadelphia, 1913, 33; A. Pazzini, *Le Pietre preziose nella storia della medicina e nella legenda*, Rome, 1939, 49ff.

71. H. C. Agrippa von Nettesheim, *The Philosophy of Natural Magic*, 1913, 146.

72. Grünewald's painting of *Saints Erasmus and Maurice* (Munich, Alte Pinakothek; see L. Behling, *Matthias Grünewald*, Königstein im Taunus, 1969,

figs. 81–83) demonstrates the greatest expertise in the description of gems. An interpretation of this panel might do well to take into account the myriad jewels represented.

73. A. Underwood, "Apollo and Terpsichore: Music and the Healing Art," *Bulletin of the History of Medicine*, v, Sept.–Oct. 1947, 639–73.

74. C. D. Heline, *Healing and Regeneration through Music*, Santa Barbara, Calif., 1943, 18.

75. Johannes Tinctoris, *Complexus effectuum musices*, a treatise written after 1475 and dedicated to Beatrice of Aragon; of twenty effects or conditions of music, the fourteenth is *Musica aegrotos sanat*. R. Hammerstein, *Die Musik der Engel*, Munich, 1962, 138ff.

76. A. Carapetyan, "Music and Medicine in the Renaissance," *Music and Medicine*, ed. D. Schullian and M. Schoen, New York, 1948, 121f.

77. J. Schumacher, "Musik as Heilfaktor bei den Pythagoreen im Licht ihrer naturphilosophischen Anschauungen," *Musik in der Medizin*, ed. H. R. Teirich, Stuttgart, 1958, 1–16. In discussing the nature of love, Plato's *Symposium* includes a speech by the physician Eryximachus, also equating the salutary effects of music and medicine in creating balance out of discord, as was kindly pointed out to me by Laura Slatkin.

78. M. Agricola, *Musica Instrumentalis Deudsch*, Magdeburg, 1528.

79. L. Spitzer, *Classical and Christian Ideas of World Harmony*, Baltimore, 1963, 37.

80. *The Hermetic and Alchemical Writings of Paracelsus the Great*, ed. A. E. Waite, Vol. II, New Hyde Park, N.Y., 1967, 333. In "A Book Concerning Long Life," from which the quote is taken, Paracelsus also says, "For if the force of gold is so great that it preserves the body and renders it free from all sickness, nor allows it to be corrupted, how much more itself, and that without any infection?" See also T. S. Sozunskey, *Medical Symbolism*, Philadelphia, 1891, 156; H. C. Bolton, *The Follies of Science at the Court of Rudolph II*, Milwaukee, 1904, 117.

81. F. Birren, *The Story of Color*, Westport, Conn., 1941, 184f; G. S. White, *The Story of the Human Aura*, Los Angeles, 1928.

82. Although Grünewald remains an enigmatic personality, references to the occult sciences do appear in his other works. Drawings of a kneeling king with angels and of Saint Dorothy contain representations of the astrolabe, that basic instrument of astrological studies (see Figs. 44 and 45). In the Stuppach *Virgin and Child* (Fig. 65), the Christ child's bracelet, the rosary in a bowl, and the strange lighting effects, along with the appearance of an actual rainbow, combine to suggest a magical interpretation for this picture. Bernard Saran, in a highly original study that deserves more attention (*Matthias Grünewald, Mensch und Weltbild*, Munich, 1972), emphasizes this aspect of Grünewald's life and art. Saran brings to bear contemporary texts about alchemy, including facets of the enterprise such as prospecting, mining, metallurgy, and mineralogy, to shed light on documents such as the artist's inventory, with its possibly relevant items, among them a compass, a scale, and precious pigments. It is perhaps telling, as Saran also mentions, that Rudolf II, who tried to purchase the altarpiece

for his collection in 1598, was himself immersed in every aspect of the occult (H. C. Bolton, *The Follies of Science at the Court of Rudolph II*, passim).

83. G. F. Kunz, *The Curious Lore of Precious Stones*, 1913, 7, 11, 214.

84. The common ground between alchemy and apothecary practice has been discussed in L. S. Dixon, "Bosch's *St. Anthony Triptych*—An Apothecary's Apotheosis," *Art Journal*, 44, 2, 1984, 119–31. It is, of course, important to realize that here lies also the solid foundation of the science of chemistry (note the transliterated Arabic that is the name alchemy), as its principal experimental procedure, distillation, further suggests. At the same time, M. Bergman, *Hieronymus Bosch and Alchemy—A Study on the St. Anthony Triptych*, Stockholm Studies in the History of Art, 31, Stockholm, 1979, rightly touches on the way in which alchemical processes were perceived to be harmonious with and analogous to the Christian mysteries. Indeed, the impact of the writings of Agrippa and Paracelsus resides largely in their philosophical and spiritual content. For the intellectual context of certain of these themes, see the account of the diffusion of Neoplatonism in thinkers such as Agrippa and Paracelsus in D. P. Walker, *Spiritual and Demonic Magic*, London, 1958; Notre Dame, Ind., 1975. That Grünewald shows himself, according to my analysis, to be such a synthetic and syncretic thinker—treating the essences, not just the trappings, of the occult sciences and their contiguity with religious belief as well as other branches of medical practice—may also be fueled by the way such concerns in the north extended to and were supported by a broad base in the popular realm.

85. In particular, the small figures kneeling in devotion on either side of the sculptured Saint Anthony (Pl. 1) do not show signs or symptoms of disease, unlike early printed representations of the enthroned saint (Fig. 19), where the attendant figures carry crutches or may have their hands or feet represented turning into flames; instead, as mentioned above, the statuettes hold up offerings of livestock.

86. Émile Benveniste ("La Doctrine médicale des Indo-Européens," *Revue de l'histoire des religions*, 130, 1945, 5–12) discovers a threefold approach to medical treatment that corresponds to the three occupational identities underlying Indo-European culture. From the evidence of ancient texts, Benveniste isolates a medicine of the knife (warriors), of plants (farmers), and of charms (magicians, priests). Here is an interesting parallel to the differing approaches to disease, as I see them, posited in terms of the tripartite structure of the Isenheim Altarpiece.

87. A. Burckhardt, *Geschichte der medizinischen Facultät zu Basel, 1460–1900*, Basel, 1917, II, 16; L. Binet and P. Vallery-Radot, *La Faculté de médecine de Paris*, Paris, 1952, 16; J. Schumacher, *Zur Geschichte der medizinischen Fakultät Freiburg/Br.*, Stuttgart, 1957, 9–16.

88. J. G. Fuller, *The Day of St. Anthony's Fire*, New York, 1968, 96. It would seem that sixteenth-century conventions for recording symptoms were restricted to what could actually be observed by the physician. Visions and hallucinations were of course characterized in the religious context of saints' writings.

89. J. G. Fuller, *The Day of St. Anthony's Fire*, 276.

90. H. C. Agrippa von Nettesheim, *La Philosophie occulte ou la magie* (1510), III, Paris, 1910, 244ff.

91. A recent dissertation, H. C. Collinson, *Three Paintings by Mathis Gothart-Neithart; called Grünewald: The Transcendent Narrative as Devotional Image*, Yale University, 1986, in discussing the early *Last Supper*, the Munich *Mocking of Christ*, and the Karlsruhe *Crucifixion* and *Carrying of the Cross*, also characterizes Grünewald's originality of statement as issuing directly from his response to a given work context.

CHAPTER II

1. By far the most revealing treatment of the German *Flügel- und Schreinaltar* or *Schnitzaltar* to have appeared recently, significant especially for this section of my study, is Michael Baxandall's *The Limewood Sculptors of Renaissance Germany*, New Haven and London, 1980. See especially Chap. 1 and the bibliography. Of general interest also, Walter Grundmann, *Die Sprache des Altars*, Berlin, 1966; Arthur Burkhard, *Seven German Altars*, Munich, 1965–1972.

2. Wilhelm Röhrich, *Geschichte der Reformation im Elsass*, Strassburg, 1830, 30; Bernward Deneke, "Umwelt: Spätmittelalterliche Frömmigkeit," *Albrecht Dürer 1471–1971*, Ausstellung des Germanischen Nationalmuseums, Munich, 1971, 179–80; Jean-Claude Schmitt, "Apostolat mendiant et société: une confrérie dominicaine à la veille de la Réforme," *Annales Économies Sociétés Civilisations*, I, Jan./Feb. 1971; Bernd Moeller, "Religious Life in Germany on the Eve of the Reformation," *Pre-Reformation Germany*, ed. Gerald Strauss, New York, 1972, 13–42.

3. Bernd Moeller, "Piety in Germany around 1500," *The Reformation in Mediaeval Perspective*, ed. S. E. Ozment, Chicago, 1971, 50–75; Bernward B. Deneke, *Albrecht Dürer*, 1971, 179–80. Equally important in this period is the revived interest in preaching (see Chap. III). As for the development of printing in the late fifteenth century, we should keep in mind that it was the Bible as well as other religious texts that constituted about fifty percent of the works published. François Ritter, *Histoire de l'imprimerie alsacienne aux XV & XVI siècles*, Strasbourg and Paris, 1955, 467; Rudolf Wackernagel, "Mitteilungen über Raymundus Peraudi und kirchliche Zustände seiner Zeit in Basel," *Basler Zeitschrift für Geschichte und Altertumskunde*, II, 1903, 171–273.

4. Hans Rott, *Quellen und Forschungen zur südwestdeutschen und schweizerischen Kunstgeschichte im 15. und 16. Jahrhundert*, III, Q.1, Stuttgart, 1933–1938, 358–59. This document appears along with an English translation in M. Baxandall, *Limewood Sculptors*, 1980, 64–66. The altarpiece itself, by Hans Bongart, still stands in the Kaysersberg parish church.

5. The document prescribes the components of the altarpiece in terms of an agreement based on the artist's presentation drawing. This type of drawing, often referred to in contracts as a *Visierung*, appears to have been a standard part of workshop practice. Several surviving examples are reproduced in Hans Huth,

Künstler und Werkstatt der Spätgotik (Augsburg, 1925), Darmstadt, 1967, figs. 18–35. There is an example by Veit Stoss, now in the University Museum, Cracow, in M. Baxandall, *Limewood Sculptors*, 1980, fig. 41.

6. In adding the painted predella with the *Lamentation* next to the empty tomb, Grünewald depicts literally the sepulchral function expressed in the German name for this section of the altarpiece: *Sarg*; this nomenclature in turn reminds us of the inextricable association between grave and altar in the Catholic liturgy.

7. That such a carved superstructure was part of the original complex at Isenheim is confirmed also by a few surviving fragments housed in the museum in Colmar. (See, most recently, a handsome publication by the Musée d'Unterlinden, *Le Retable d'Issenheim avant Grünewald*, Colmar, 1987, with relevant essays by Christian Heck.) The 1794 description by the commissaries of the district also clearly states (repr. in H. A. Schmid, Die Gemalde, 1911, 345): "Rien de plus élégant dans le goût gothique. Les ornemens d'Architecture qui décorent cet Autel et qui consistent en bois doré, imitent tellement la fonte du Métal, qu'il semble y voir toute la légéreté dont il est susceptible. Quoique un peu endommagé par l'enlevement des Peintures et Figures en relief, on est surpris qu'un Ouvrage aussi fini et aussi délicat ait pû resister aux injures de plusieurs Siècles et se Conserver dans l'état de perfection ou il est encore aujourd'hui." ([There is] "nothing more elegant in the Gothic taste. The architectural embellishments that adorn this altar, and that consist of gilded wood, so much resemble cast metal that one seems to see in it all the buoyancy of which it [metalwork] is capable. Although somewhat damaged by the removal of the paintings and the sculpture, it is surprising that a work so finely finished and so delicate was able to withstand the abuse of several centuries and find itself in such a perfect state of preservation even today.") Especially impressive must have been the effect of continuity from painting to carving or, to put it another way, of ambiguity in determining the boundaries between mediums, in that passages of the painted section, such as the foliate ornament on the gold tabernacle in the middle state, rivaled the carved finials of the actual wooden frame.

8. Judging from the surviving ground plans of the original monastery church at Isenheim, where the main altar is clearly designated, Grünewald's altarpiece would have conformed to the placement as I describe it for the Kefermarkt Altarpiece.

9. Carl C. Christensen, "Patterns of Iconoclasm in the Early Reformation: Strasbourg and Basel," *The Image and the Word*, ed. Joseph Gutmann, Missoula, Mont., 1977, 107–48. See also the same author's *Art and the Reformation in Germany*, Athens, Ohio, 1979, especially Chap. v; M. Baxandall, *Limewood Sculptors*, 1980, Chap. III, part 3.

10. W. R. Jones, "Art and Christian Piety: Iconoclasm in Mediaeval Europe," *The Image and the Word*, ed. J. Gutmann, Missoula, Mont., 1977, 75–105. See also M. Baxandall, *Limewood Sculptors*, 1980, Chap. III, part 1.

11. Quoted from the translation by Howard Kaminsky, *A History of the Hussite Revolution*, Berkeley, 1967, 261–62.

12. *Symbols in Transformation: Iconographic Themes at the Time of the Refor-*

mation, Princeton University Art Museum, Princeton, N.J., 1969: Erwin Panofsky, "Comments on Art and Reformation," 9–14; Craig Harbison, "Introduction to the Exhibition," 15–34.

13. Indeed, with an inscription on his own copy of this print, now in the collections at the Veste, Coburg, Dürer expressed his disapproval of this cultic worship: "This spectre has risen against the Holy Scripture in Regensburg and is permitted by the Bishop because it is useful for now. God help us that we do not dishonor the worthy Mother of Christ in this way but (honor) her in His name, Amen." See *From a Mighty Fortress: Prints, Drawings, and Books in the Age of Luther 1483–1546*, Detroit Institute of Arts, 1983, 323, no. 184.

14. Quoted from the translation by Miriam Usher Chrisman, *Strasbourg and the Reform*, New Haven and London, 1967, 148.

15. This important document, which appears at the end of a bound manuscript of the *Divinae Institutiones* of Lactantius that came from the Isenheim monastery library, seems to have gone unnoticed until now, although it is listed as follows in the *Catalogue général des manuscrits* (des Bibliothèques de France), LVI, *Colmar*, Paris, 1969, 47, fol. 182 (addition du XVI siècle): "Sequitur modus ornandi ecclesiam divi Anthonii per anni circulum." ("What follows is the mode of adorning the church of the divine Anthony throughout the cycle of the year.") I am indebted to Christian Wilsdorf of the Archives Départementales du Haut-Rhin for arranging to have the document transcribed for me and to Philippe Richard, former conservator at the Archives, for providing me with his masterfully rendered transcription of the original French handwriting.

16. "Item, a la Purification Notre-Dame, l'on faict la benediction / des chandelles, et puis l'on faict la procession par / l'église, en pourtant la Croix, la bandière et deulx / torches allumées.

"Item, à notre dédicasse qui est Quasimodo la veille / l'on apporte le chief et les deulx mains à l'église / et la croix pour donner à baiser."

17. "Item, le dimenche Palmarium l'on orne ung / ferdeaulx de palme, . . . Et puis l'on faict la benediction / des palmes, l'on faict la procession par l'église / et par dessus le cymetière, et l'on pourte la / croix et deulx tourche. Et l'on romp les / portes d'enffer, eodem die secundum ritum Remarum.

"Item, a la St Anthoine après Noël, l'on chante Tierce /, . . . Puis après /, l'on faict la procession en portant le chief / de Monseigneur St Anthoine ensemble des deulx mains / et prent-on aussi des clouchettes."

18. "Item, a l'Ascension l'on prendt une belle chasuble / de bleue damas. Et apres le disner l'on / chante None en la cour et puis l'on monte / le St Esprit au Ciel."

19. "Item, la veille de la Feste-Dieu, l'on faict de grant / courroye de fleurs que l'on mect alentour des / quatre bastons a pourter le ciel dessus le sacrement /, et de deulx bandières, et de quatre tourches, et / a la croix."

"Item, aussi, l'on mect / les cierges, environ quinze ou quatorze, sur le gros / chandelier qui est au mytan du cuer. Et / quant l'on veult encommencer la messe de la / mynuict on les allumes."

20. Quoted in Henry Chaumartin, *Le Mal des Ardents*, 1946, 138: "En cette même année où nous écrivons et qui est l'an du Seigneur 1530, nous apportons

témoignage que beaucoup souffrant de cette terrible maladie guérirent complètement par l'imploration de ce saint patron (Antoine) et par les mérites du saint vinage ou l'on avait trempé les reliques du corps saint qu'on appliquait localement à l'endroit de la maladie."

21. Desiderius Erasmus, *The Praise of Folly*, ed. and trans. Clarence H. Miller, New Haven, 1979, 63.

22. Migne, P. L. LXXVII, cols. 1027–28, 1128–30; W. R. Jones, *The Image and the Word*, 1977, 75–105.

23. M. Baxandall, *Limewood Sculptors*, 1980, 186f.

24. The execution of the wings of carved altarpieces in low relief is evident in countless examples (Veit Stoss, High Altarpiece, Saint Mary's, Cracow, 1472–1489; Tilman Riemenschneider, Altar of the Holy Blood, Sankt Jakobskirche, Rothenburg, 1501–1505; Martin Kriechbaum, Altarpiece, Saint Wolfgang, Kefermarkt, 1490–1498) and is specifically called for in surviving documents such as the aforementioned 1518 contract for the altarpiece at Kaysersberg: "also the two *Flügel* or wings, in each wing four stories taken from the Passion, in good measure, *carved flatly (flach geschnitten)* most skillfully." In Riemenschneider's contract of 1501 for the Altarpiece of the Holy Blood: "and on the *Flügel* on the right to *carve a relief* scene of Palm Sunday, . . . the figures of this scene to project about three fingers deep; and on the *Flügel* on the left he shall *carve also in relief (auch flach schneiden)*" (documents with English translations in M. Baxandall, *Limewood Sculptors*, 1980, 64–66, 174–76).

25. How Grünewald came to be chosen for this commission and how, as a painter, he could attain such prominence, given a type of monument that had traditionally emphasized carving, are questions that need to be posed, at least in light of the longstanding regulation of artists' rights and their use of materials, handed down through a guild system that had been especially powerful in many German cities a century earlier. If one thinks of the Italian scene, by the time of the Isenheim Altarpiece, one finds a growing separation of mediums, accompanied by attempts to define their nature in theoretical terms and to assess their relative status and merits. In the north these issues were considered in more practical terms. The carved, retable altarpiece, to which the format of the Isenheim Altarpiece corresponds, traditionally brought together diverse craftsmen: sculptors, painters, joiners, and so forth. Here it was the guilds that addressed the problem of what constituted a practitioner of one medium as opposed to another, and considered the boundaries and associations between one medium and another, with the goal of protecting interests and insuring work to eligible craftsmen.

Outside the jurisdiction of a major city, and as a religious order, the Isenheim monastery was possibly exempt from the guilds' prescriptions, which had become marked by competitive and protectionist impulses at this time of slackening requests for altarpieces in such cities as Strasbourg. Yet there is also evidence suggesting an increased license granted to painters in the guilds and a heightened status attached to painters' contributions to the production of an altarpiece, which may have some relevance to our discussion of the Isenheim Altarpiece. A document from the Strasbourg painters' guild, contemporary with

the Isenheim Altarpiece, for example, revises the approach to the execution of a masterpiece. Where relying on preexisting models had been the practice, now free handling, based on an artist's original conception, was advocated. In other documents an appreciation of the virtuosity needed to create effects with paint, in only two dimensions, is revealed through use of the term *flach malen* to distinguish positively between relief polychromy and painting as we know it. Finally, there was also the prestige attached to the costly materials of painters such as precious pigments and gold leaf. All of these might have been contributing factors in the high monetary evaluation of a case like Hans Baldung Grien's painted altarpiece in the Freiburg im Breisgau Cathedral—contemporary with the Isenheim Altarpiece—for which payment records survive.

See H. Huth, *Künstler und Werkstatt*, 1967. Max Hasse, "Lübecker Maler und Bildschnitzer um 1500," *Niederdeutsche Beiträge zur Kunstgeschichte*, III, 1964, 285–318; idem, "Maler, Bildschnitzer und Vergolder in den Zünften des späten Mittelalters," *Jahrbuch der Hamburger Kunstsammlungen*, 21, 1976, 31–42; Thomas A. Brady, Jr., "The Social Place of a German Renaissance Artist: Hans Baldung Grien (1484/85–1545) at Strasbourg," *Central European History*, VIII, 4, Dec. 1975, 295–315; M. Baxandall, *Limewood Sculptors*, 1980, 102–22.

26. Baldung's altarpiece is still in situ and is signed: Joannes Baldung cog. Grien Gamundianus Deo et virtute auspicibus faciebat. The artist moved from Strasbourg to Freiburg im Breisgau with his family and his workshop in 1512 to take on this commission. The altarpiece was completed in 1516, according to an inscription on the back. Fritz Baumgarten, *Der Freiburger Hochaltar*, Strassburg, 1904; Arthur Burkhard, "The Freiburg Altar of Hans Baldung," *Seven German Altars*, Munich, 1970.

27. The four-part sequence of scenes from the life of Mary seems especially to reflect the four-part division of the middle state of the Isenheim Altarpiece. In both cases the *Annunciation* is the first at the left. Unlike the conventional placement of figures in Annunciation scenes, Baldung's angel enters from the right side, which is a distinguishing feature of Grünewald's example. Also the sharp contrasts in modalities of light moving from one section to another—a night scene, a daylight setting, an architectural interior illuminated by a shaft of light that enters through a window, figures giving off their own illumination— are surely inspired by Grünewald's unique treatment of varieties of light in the middle state of the Isenheim Altarpiece, to be characterized below.

28. The influence of the Isenheim Altarpiece on Baldung's work of ca. 1513– 1516 is also affirmed in the catalogue *Hans Baldung Grien: Prints and Drawings*, ed. James H. Marrow and Alan Shestack, National Gallery of Art, Washington, D.C; Yale University Art Gallery, New Haven, 1981. See especially Alan Shestack, "An Introduction to Hans Baldung Grien," 3–18, and cat. nos. 44–54.

29. Francis Clark, S.J., *Eucharistic Sacrifice and the Reformation*, Westminster, Md., and London, 1960; Carl C. Christensen, *Art and the Reformation in Germany*, Athens, Ohio, 1979, 18f.

30. See Elizabeth Eisenstein, *The Printing Press as an Agent of Change*, 2 vols., Cambridge, London, and New York, 1979.

31. H. A. Schmid, *Die Gemälde*, 1911, 88. Isenheim was apparently at the in-

tersection of two major routes leading to Flanders, the one starting in the Rhône Valley, the other in northern Italy. *Catalogue général des manuscrits*, LVI, *Colmar*, Introduction, XXVI–XXVII.

32. Werner Weisbach, *Die Basler Buchillustration des XV. Jahrhunderts*, Strassburg, 1896, 5; Rudolf Wackernagel, *Geschichte der Stadt Basel*, II, 2, Basel, 1916; III, 1924, 126–85.

33. Léon de Laborde, *Débuts de l'imprimerie à Strasbourg*, Paris, 1840, 82f; Charles Schmidt, *Histoire littéraire de l'Alsace*, 2 vols., Paris, 1879; E. Henry, "Strasbourg et la naissance de l'imprimerie," *La Vie en Alsace*, 1931, 249–57; *La Bibliothèque humaniste de Sélestat*, Colmar, 1983; *Beatus Rhenanus*, Exposition à la Bibliothèque humaniste de Sélestat, 2 May–31 Dec. 1985; L'Abbé L. Dacheux, *Les plus anciens écrits de Geiler de Kaysersberg*, Colmar, 1882; E. Jane Dempsey Douglass, *Justification in Late Mediaeval Preaching, A Study of John Geiler of Keiserberg*, Leiden, 1966.

34. C. Schmidt, *Histoire littéraire*, I, 1879, Intro., XVII–XVIII; Jacob Wimpfeling, *Germania*, ed. and trans. Ernst Martin, Strassburg, 1885; E.K.J.H. Voss, "Introductory Remarks, Jacob Wympfflinger's *Tutschland*," *Transactions of the Wisconsin Academy of Sciences, Arts, and Letters*, XV, part 2, 1907, 826–28. Wimpfeling's 1502 treatise argues for the German origin of the region, a theory subsequently contradicted by Thomas Murner, in his *Germania Nova*, who posits instead the French roots of Alsace. See catalogue *Humanisme et réforme à Strasbourg*, 5 May–10 June 1973, especially part 3, "Le Triomphe de l'humanisme," 24–36; Miriam Usher Chrisman, *Strasbourg and the Reform*, 1967, especially 50–65; and the same author's *Lay Culture, Learned Culture—Books and Social Change in Strasbourg, 1480–1599*, New Haven and London, 1982, 82f; Andrée Hayum, "Dürer's Portrait of Erasmus and the *Ars Typographorum*," *Renaissance Quarterly*, XXXVIII, 4, Winter 1985, 650–87. A letter of Erasmus dated 21 Sept. 1514, from Basel, published at the end of *De duplici copia verborum, ac rerum*, Basel, 1519, thanks the members of this literary society for their exceptionally warm welcome of him in Strasbourg the month before.

35. Donations in the course of the fifteenth century seem to have marked a turning point in the wealth of the library at Isenheim. Francis Rapp, "La Bibliothèque de Jean Bertonelli, Précepteur d'Issenheim et de Strasbourg," *Refugium Animae Bibliotheca: Festschrift für Albert Kolb*, Wiesbaden, 1969, 334–44. Bertonelli was preceptor from 1436 to 1459. During the preceptorship of Jean d'Orliac, 1460–1490, Jean Brochard, chaplin of the Antonites in Basel, also gave books and manuscripts to Isenheim, identifiable by inscriptions that include his name and that of d'Orliac. Surviving manuscripts from the Antonite monastery at Isenheim, now in the Bibliothèque de la Ville in Colmar, are listed in *Catalogue général des manuscrits*, LVI.

36. C. Christensen, *Art and the Reformation in Germany*, 1979, 18; E. Eisenstein, *The Printing Press as an Agent of Change*, 1979, 319f.

37. See my comments on the heightened concern with lettering and the distinctions and varieties among alphabets and typefaces in relation to printing, in *Renaissance Quarterly*, 1985, 650–87.

38. Stephan Beissel, S.J., "Die bildliche Darstellung der Verkündigung

Maria," *Schnütgens Zeitschrift für christliche Kunst*, IV, 1891, 191–96; 207–14; Yrjö Hirn, *The Sacred Shrine*, Boston, 1957, 114; Barbara Lane, *The Altar and the Altarpiece*, New York, 1984, 47f.; Lotte Brand Philip, *The Ghent Altarpiece*, Princeton, N.J., 1971, 69. Though not part of the biblical account of the Annunciation, the dove finds its way into paintings of the scene based on a relocation, as it were, of the biblical simile—the Holy Spirit "like a dove"—which appears at the baptism of Christ, a theme particulary significant for the Isenheim Altarpiece; there it is also buttressed by the motif of the angel entering from the right side, with the emphasis of this orientation on the role of the divine agent. (Don Denny, *The Annunciation from the Right*, New York and London, 1977, 1, 118–20.) The apparitional effect of the Isenheim dove may also be linked, however, to a dramatic tradition: the Annunciation play in the church, with a mechanism used to raise and lower a sculptured dove. (Karl Young, *The Drama of the Mediaeval Church*, 11, Oxford, 1933, 246.) It is perhaps also in this light that we should understand the reference to a "releasing of the Holy Ghost" in the Isenheim document, note 18 above.

39. I am indebted for this observation to William M. Voelkle.

40. Moshe Barasch, *Light and Color in the Italian Renaissance Theory of Art*, New York, 1978, 166–70; Fulvio Pellegrino Morato, *Del Significato de colori*, Venice, 1535; Antonii Thylesii, *De Coloribus*, Basel, 1537 (in Lazari Bayfii, *Annotationes*), 316, 317.

41. Donald L. Ehresmann, "The Brazen Serpent, a Reformation Motif in the Works of Lucas Cranach the Elder and his Workshop," *Marsyas*, XIII, 1966–1967, 32–47; Craig Harbison, *The Last Judgment in Sixteenth Century Northern Europe*, New York and London, 1976, 94–102.

42. Oskar Thulin, *Cranach-Altäre der Reformation*, Berlin, 1955.

43. Erwin Panofsky, *The Life and Art of Albrecht Dürer*, Princeton, N.J. (1943), repr. 1971, 231–35; Donald Kuspit, "Melanchthon and Dürer: the Search for the Simple Style," *Journal of Mediaeval and Renaissance Studies*, III, 1973, 177–202; idem, "Dürer and the Lutheran Image," *Art in America*, 63, 1975, 56–61; C. Christensen, "Excursus: Dürer's *Four Apostles*—A Reformation Painting," *Art and the Reformation*, 1979, 181–206.

44. Thus, in spite of his recorded revulsion against what he took to be the misguided devotional excess documented by the Ostendorfer print of a pilgrimage to *Schöne Maria* (see above, note 13), Dürer's dedicatory remarks to Willibald Pirckheimer in the *Unterweisung der Messung* constitute a defense of painting against the growing criticism of iconoclasts: "Notwithstanding the fact that at the present time the art of painting is viewed with disdain in certain quarters, and is said to serve idolatry. A Christian will no more be led to superstition by a painting or a portrait than a devout man to commit murder because he carries a weapon by his side. It must be an ignorant man who would worship a painting, a piece of wood, or a block of stone. Therefore, well-made, artistic, and straightforward painting gives pleasure rather than vexation." See facsimile of 1525 edition, Dürer, *Unterweisung der Messung mit dem Zirkel und Richtscheit*, Zurich, 1966; Albrecht Dürer, *The Painter's Manual*, New York, 1977, 37.

45. E. Panofsky, *Albrecht Dürer*, 1971, 233–34; C. Christensen, *Art and the Reformation*, 1979, 181–206.

46. E. Panofsky, ibid.

47. Ibid., 234–35. I am thinking of Panofsky's analysis and elucidation of these features in terms of the association already made in the sixteenth century— first by Dürer's hired calligrapher—of these four figures with the four temperaments.

48. In his letter to the Nuremberg civic authorities Dürer offers the "Apostle" panels as a souvenir or memorial, as has frequently been noted. *Dürer, Schriftlicher Nachlass*, I, ed. Hans Rupprich, Berlin, 1956, 117, no. 59, Nürnberg, before 6 Oct., 1526. But one might also understand Dürer's choice of words in the letter—"Die weil jch for lengst geneigt wer gewest, e[wer] w[eisheit] mit meinem kleinwirdigen gemel zu einer *gedechtnus* zu fereren, . . . Nach dem jch aber diese vergangen zeit ein thafel gemalt vnd darauf mer fleis dan ander gemel gelegt hab, acht jch nyemant wirdiger, die zu einer *gedechtnus* zu behalten, an e[wer] w[eisheit]"—as relevant to my suggestion of how the imagery was meant to function vis-à-vis the viewer. (*The Writings of Albrecht Dürer*, ed. and trans. William Martin Conway, New York, 1958, 135.) ("I have been intending, for a long time past, to show my respect for your Wisdoms by the presentation of some humble picture of mine *as a remembrance*; . . . Now, however, that I have just painted a panel upon which I have bestowed more trouble than on any other painting, I considered none more worthy to keep it *as a reminiscence* than your Wisdoms.) Italics mine.

49. *Manuale Curatorum*, Basel, 1502, under *predicandi prebens modum* ("supplying the manner of preaching: demonstrated by the practice of sermons in Latin as well as in the vernacular").

50. *L'Instruction des curez pour instruire le simple peuple*, Paris, 1506, fol. III. (". . . which, for the edification of laymen as much as for the people of the Church, he wrote in French as well as in Latin.") "Et nous l'avons pour ceste cause fait correctement Imprimer en toutes les deux langues." ("And we have for this reason correctly had it printed in both of these languages.")

51. See "Geilers von Kaysersberg, 'Ars Moriendi' aus dem Jahre 1497," ed. Alexander Hoch, *Strassburger theologische Studien*, IV, 1901, 1–83, for an interesting discussion of this preacher's use of language, a subject more fully treated here in the following chapter.

CHAPTER III

1. See Chap. I, note 51. John the Baptist appears in several trecento *Crucifixion* scenes, such as the fresco in the refectory of the Istituto Ricovero e Educazione (E. Carli, *P.H. Pis. Trecento*, II, 1961, 44, fig. 89), the lunette of the tomb of Michele Morosini in S. Giovanni e Paolo (L. Testi, *Pittura Veneziana*, 1909, 114, no. I, 295, fig. 293), and a fresco in the choir of S. Zeno, Verona (G. Mellini, *Altichiero*, 1965, 81f, fig. 295). Two northern examples seem to relate more closely

to the Isenheim *Crucifixion*, however. One is a fourteenth-century manuscript in the Germanisches Nationalmuseum, Nuremberg. (H. Swarzenski, *Die Lateinischen Illuminierten Handschriften des XIII Jahrhunderts*, Vol. 1, Berlin, 1936, 75, no. 5, 79, fig. 184). Like the image described by Saint Bridget, a sword pierces Mary's heart as she is being held by John the Evangelist at the left side of the cross. John the Baptist, holding a medallion with a representation of the lamb, stands alone to our right. In the same museum is a painting dated 1508 by Hans Schäuffelein, which shows the aged King David at the right side of the cross and John the Baptist at the left. With one hand John points down to the lamb and book on the ground, and with the other up toward Christ on the cross. (E. Lutze & E. Wiegand, *Die Gemälde des 13. bis 16. Jahrhunderts* [Kataloge des Germanischen Nationalmuseums zu Nürnberg], Leipzig, 1937, 160, fig. 210.)

2. *The Gospel According to John I–XII*, ed. and trans. Raymond E. Brown, S.S., The Anchor Bible, XXIX, Garden City, N.Y., 1966, 150–56; Rudolf Schnackenburg, *The Gospel According to St. John*, trans. Kevin Smyth, 1, New York, 1968, 417. Stephen S. Kayser, "Grünewald's Christianity," *Review of Religion*, V, 1, 1940, 3–35, brings up Saint Augustine's interpretation of the fourth gospel, which juxtaposes the decapitated John the Baptist and the crucified Christ as one way of envisaging the decreasing and increasing marked by the quotation from the Gospel of Saint John. Saint Augustine, *Eighty-three Different Questions*, trans. David L. Mosher, *The Fathers of the Church*, LXX, Washington, D.C., 1982, 104.

3. For a discussion of these foods see *The Book of the Prophet Isaiah*, ed. Rev. J. Skinner, D.D., Cambridge, Mass., 1963, 60–61. R. E. McNally, "The Evangelists in the Hiberno-Latin Tradition," *Festschrift Bernhard Bischoff*, Stuttgart, 1971, 111f., discusses paradisiacal foodstuffs—traditionally: oil, honey, wine, milk—as does Carl Nordenfalk, "The Diatessaron Miniatures Once More," *Art Bulletin*, LV, 4, Dec. 1973, 532–46. In these early medieval manuscripts the four foods form a structural system with the symbols of the four evangelists, the four rivers of Paradise, etc.

4. Also 1 Corinthians 3:1–3: "Brothers, I myself was unable to speak to you as people of the Spirit: I treated you as sensual men, still infants in Christ. What I fed you with was milk, not solid food, for you were not ready for it; and indeed, you are still not ready for it since you are unspiritual."

Sometimes English-language Bibles translate the Latin *ut* that separates the two clauses of this passage from Isaiah as "that," in the sense of "He will eat curds and honey 'in order that' he may learn to refuse evil and choose the good." Saint Paul's formulations, quoted here, militate against such a translation and instead show that emphasis should be placed on the temporal aspect, which defines the conjunction used in the Greek version, *prine*, meaning until or before, and is the preferred rendering in this context of the Hebrew prefix *le*, as in "until the time that." I would like to thank Byron Shafer for discussing the Hebrew passage with me.

5. In the Old Testament the idea of eternal peace is expressed in Micah 4:4: "Nation will not lift sword against nation, there will be no more training for war. Each man will sit under his vine and his fig tree, with no one to trouble him." See also 1 Maccabees 14:11. The Gospels invoke the fig tree as a sign for

the messianic realm, as in Luke 21:29: "And then he told them a parable, 'Think of the fig tree and indeed every tree. As soon as you see them bud, you know the summer is now near. So with you when you see these things happening: know that the kingdom of God is near.' "

6. George Ferguson, *Signs and Symbols of Christian Art*, New York, 1966, 31. This association, as given in Genesis 3:7, is also pictured by Michelangelo in the Sistine ceiling *Expulsion*: "Then the eyes of both of them were opened and they realized they were naked. So they sewed fig-leaves together to make themselves loin-cloths."

The fig branch in the the middle state of the altarpiece lies directly underneath the crucified Christ in the closed view, a structural connection deriving from the Legend of the True Cross, where the wood of the cross is traced back in miraculous lineage to a branch of the tree of knowledge planted on Adam's grave.

7. Saint Augustine, *The Fathers of the Church*, LXX, 1982, 103–8.

8. Mark 16:16. In Luke 3:16–17: ". . . so John declared before them all, 'I baptise you with water, but someone is coming, someone who is more powerful than I am, and I am not fit to undo the strap of his sandals; he will baptise you with the Holy Spirit and fire. His winnowing-fan is in his hand to clear his threshing-floor and to gather the wheat into his barn; but the chaff he will burn in a fire that will never go out.' "

9. Karl von Amira, *Die Dresdener Bilderhandschrift des Sachsenspiegels*, I, parts 1 and 2, Leipzig, 1902; "Die Handgebärden in den Bilderhandschriften des Sachsenspiegels," *Abhandlungen der philosophisch-philologischen Klasse der Königlichen Bayerischen Akademie der Wissenschaften*, XXIII, Munich, 1905, 163–263; M. Letts, "The Sachsenspiegel and Its Illustrators," *The Law Quarterly Review*, XLIX, no. 196, Oct. 1933, 555–74; R. Schmidt-Wiegand, "Gebärdensprache im mittelalterlichen Recht," *Frühmittelalterliche Studien*, XVI, 1982, 363–79.

10. Ibid. See also R. Schmidt-Wiegand, "Gebärden," *Handwörterbuch zur deutschen Rechtsgeschichte*, I, Berlin, 1971, 1411–19.

11. Craig Harbison, *The Last Judgment in Sixteenth Century Northern Europe*, New York and London, 1976, 24–26, for two traditions of depicting the Deësis. The Byzantine tradition, which filtered into German art, shows John the Baptist and Mary on either side of Christ. Originating in the West, the other tradition has John the Evangelist as the counterpart to Mary. Gary M. Radke, "A Note on the Iconographical Significance of St. John the Baptist in the Ghent Altarpiece," *Marsyas*, XVIII, 1975–1976, 1–6, points to the Baptist's prominence in Van Eyck's altarpiece, where he is paired with the Evangelist in grisaille on the closed state and seated to the left of Christ on the inside. Also discussing the two traditions for Deësis representations, Radke specifies that the inclusion of John the Baptist signals the theme of the *Last Judgment*.

12. Interestingly, this association of Saints Anthony and Sebastian with the realms of hell and paradise is also made structurally in Roger van der Weyden's *Last Judgment* triptych at Beaune; the two narrow panels depicting paradise and hell at the extremities of the open state fold over to reveal the grisaille Sebastian and Anthony on their obverse sides when the panels are closed.

13. Charles Minott brings up this possibility in his sensitive discussion of the

Mérode Altarpiece ("The Theme of the Mérode Altarpiece," *Art Bulletin*, LI, 3, Sept. 1969, 267–71): "But in addition, the format of the whole triptych bears a portent of the Last Judgment—the future Advent. On the side of the Saved appear the donors in the garden; on that of the Damned is all of the diabolical imagery in St. Joseph's carpentry shop. In the center appears Christ bearing his chief sign, the cross."

14. On the subject of Bosch's millenarianism and the theme of the Last Judgment, see C. Harbison, *The Last Judgment*, 1976, 69–82.

15. Chap. I, p. 32. Amy Johnson pointed out to me the parallel and perhaps even underlying example in antiquity of Apollo, a deity whose power is also expressed in terms of the binary opposites of dispensing and healing of disease. The association of identities of physician and judge pertinent to the case of Saint Anthony seems to derive from a broad and deep historical tradition. Émile Benveniste's study ("La Doctrine médicale des Indo-Européens," *Revue de l'histoire des religions*, 130, 1945, 5–12) of the etymology of the word for treating disease medically, i.e., *medicus*, etc., finds the Indo-European root to contain the overlapping meanings: to judge, to govern, and to cure.

16. I would like to thank Natalie Zemon Davis for informing me of this tradition, especially in terms of the presentation of a chicken or rooster, and Keith Moxey for providing the reference to the representation of such a scene from the workshop of Pieter Bruegel the Younger (G. Marlier, *Pierre Brueghel le Jeune*, Brussels, 1969, 435–40). Among the figures who pay homage to the enthroned Anthony in an aforementioned mid-fifteenth-century print (see fig. 19), is a knight in armor who offers a rooster to the saint.

17. The two statuettes that offer livestock may also partake of the Last Judgment thematic. The figure holding the small pig (also the animal attribute of Saint Anthony) wears a headdress, gazes out into the viewer's space, and is situated at the saint's left side—characteristics that suggest the worldly domain— whereas the figure holding the rooster, to Anthony's (heraldic) right side, is bareheaded, with curly long hair. His head and eyes are turned upward toward the saint in a more idealized, spiritual mode. Here it is worth recalling that medieval exegesis sometimes saw Cain and Abel as models for the damned and the blessed at the Last Judgment—an interpretation based on the respective rejection and acceptance by God of their agricultural offerings to him. See Robert Deshman, "Anglo-Saxon Art after Alfred," *Art Bulletin*, LVI, 2, June 1974, 176–200.

18. Dr. Alfred Martin, "Das Antoniusfeuer und seine Behandlung in der deutschen Schweiz und im benachbarten Elsass," *Schweitzerische Medizinische Wochenschrift*, 1922, 1–6; L. Pfleger, "St. Anton der Einsiedler und das Antoniusfeuer," *Elsassland*, 14, 1934, 5–9. Geyler von Keysersberg makes this association in his sermon on the Ship of Fools.

Relevant to the discussion of demons may be a recent attempt, which appeared after my book was in production (Ruth Mellinkoff, *The Devil at Isenheim*, Berkeley and Los Angeles, 1988), to identify the peacock-crested, music-making angel under the gold tabernacle as Lucifer.

19. Jules Corblet, *Histoire du sacrement de baptême*, Vol. I, 1881, 158.

20. In Matthew 3:16–4:1: "As soon as Jesus was baptised he came up from

the water, and suddenly the heavens opened and he saw the Spirit of God descending like a dove and coming down on him. And a voice spoke from heaven, 'This is my son, the Beloved; my favour rests on him.'

"Then Jesus was led by the Spirit out into the wilderness to be tempted by the devil." Also Mark 1:9–13.

21. Franz Jos. Dölger, *Der Exorzismus im altchristlichen Taufritual*, Studien zur Geschichte und Kultur des Altertums, III, Paderborn, 1909, 158; Hugh M. Riley, *Christian Initiation*, Studies in Christian Antiquity, XVII, Washington, D.C., 1974, 191.

22. H. M. Riley, ibid., 22, 84; Henry Ansgar Kelly, *The Devil at Baptism*, Ithaca, N.Y., and London, 1985.

23. Leonel L. Mitchell, *Baptismal Anointing*, Alcuin Club Collections, XLVIII, London, 1966, 2, mentions the priest's command "Let all the spirits depart from thee," which accompanies the anointing with the oil of exorcism. H. M. Riley, *Christian Initiation*, 1974, 199–202, discusses Chrysostom's simile of the oil as armor for the candidate's protection against the attack of adverse forces.

24. For this observation I am indebted to the focus provided by a conversation with William M. Voelkle about the representation of texts in this altarpiece.

The manuscript held by Cyriac contains a pastoral formula for exorcism in clearly decipherable Roman lettering. Thus, while John the Baptist's manuscript in the Isenheim Altarpiece is illegible, it may be significant in this regard that the incription next to him is also made up of Roman majuscules. (Interestingly, an exorcism of the waters forms the textual accompaniment to the Gothic illuminated manuscript mentioned above [see note 1], where John the Baptist stands alone on one side of a crucified Christ.)

Furthermore, an idiosyncratic detail in John the Baptist's pointing gesture in the altarpiece may be relevant to this discussion. Not only is the saint's index finger outstretched but his thumb is flexed diagonally downward instead of the more usual securing of the three furled fingers into a fist by means of the thumb. Now the isolation of the thumb plays a part both in the prescribed gestures of the priest during the baptismal rite and in the gesture of Grünewald's exorcising Saint Cyriac. The priest employs the thumb to trace the sign of the cross on the forehead and chest of the candidate, as well as to apply saliva to the mouth, ears, and eyes—procedures that sensitize the catechumen to the Word of God and against evil spirits. Saint Cyriac keeps hold of the possessed Artemesia with a fringed ribbon (maniple?) like the one extending from the sleeve of his garment, which is used to circle around the back of her neck. Gathering the ends like reins with his right hand at her throat, he presses his thumb of the same hand against her chin for leverage and support. I would like to thank Bart Collopy for discussing with me these gestures and their possible meaning.

25. Helmi Gasser, *Das Gewand in der Formensprache Grünewalds*, Bern, 1962, 77. In discussing Saint Cyriac's brooch, Gasser mentions that such objects would be filled with aromatic herbs meant to dispel the offensive odors of Satan, but the author does not explore the implications for the Isenheim Altarpiece of this association of the brooch with exorcism. The pine cone or pineapple is also an

attribute of the ancient physician Aesculapius, and it was used by the Babylonians and the Assyrians to restore health and combat witchcraft (T. S. Sozunskey, *Medical Symbolism*, Philadelphia, 1891, III, 116). Deborah Markow, "Hans Holbein's Steelyard Portraits, Reconsidered," *Wallraf-Richartz-Jahrbuch*, XL, 1978, 39–47, also brings up a tradition of apotropaic power—that of warding off the devil as well as diseases—attached to the fig leaf. As she points out, this is the type of foliage appearing behind Saint Cyriac; and the fig branch is a motif whose importance in the Isenheim Altarpiece is indicated by its central position in the middle stage.

26. Friedrich Hubert, *Die Strassburger liturgischen Ordnungen im Zeitalter der Reformation*, LVII, Göttingen, 1900, 25–43, reproduces these. The example of 1513 includes exorcism; in the revised versions of 1525–1530, the exorcistic elements have been removed. See J.D.C. Fischer, *Christian Initiation—The Reform Period*, Alcuin Club Collection, XLVII, London, 1970, 23. Exorcism is almost totally excised as well from Luther's second *Taufbüchlein* of 1526. See also a fascinating account of the effect of the prohibition against exorcism in its theatrical manifestations in late sixteenth-century England in Stephen Greenblatt, "Shakespeare and the Exorcists," *Shakespeare and the Question of Theory*, ed. P. Parker and G. Hartman, New York and London, 1985, 163–87.

27. Or see Matthew 8:28–34, 9:32–34, 17:14–21, Mark 1:21–27, 5:1–17, 7:27–30, 9:14–28; Luke 4:33–37, 8:26–39, 9:37–43.

28. After the Transfiguration, Matthew 17:14–21: "Then the disciples came privately to Jesus. 'Why were we unable to cast it out?' they asked. He answered, 'Because you have little faith.' " Or again in Mark 9:29, Christ responds to the same question: "This is the kind [of demon] that can only be driven out by prayer."

29. Matthew 10:1: "He summoned his twelve disciples, and gave them authority over unclean spirits with power to cast them out and to cure all kinds of diseases and sickness." Mark 16:17–18: "These are the signs that will be associated with believers: in my name they will cast out devils."

30. In the middle state, for instance, apart from the music-making angels, the inscription in Mary's book on the *Annunciation* panel, mentioned earlier, evokes sound through its presentation of Isaiah's prophecy, "Ecce virgo concipiet et parium filium et vocabitur nomen eius Emmanuel." After including the subsequent sentence from Isaiah's text, "Butyrum et mel . . . ," the "Ecce virgo . . . " is repeated on the right-hand page of the Madonna's open book (Fig. 55). Just such repetition occurs in liturgical books—missals or breviaries, with their responsaries and refrains—rather than in the Bible itself. For example, in the missal (ed. Latin and English, Westminster, Md., 1962), the lesson on Ember Wednesday during Advent contains the lines from Isaiah 7:10–15: "Ecce, virgo concipiet et pariet filium, et vocabitur nomen eius Emmanuel. Butyrum et mel comedet, ut sciat reprobare malum, et eligere bonum." The liturgy proceeds through the Gradual, Gospel, Offertory, and the Secret. Then, at Communion, the line "Ecce, Virgo concipiet et pariet filium: et vocabitur nomen ejus Emmanuel" follows by itself. I am suggesting that Grünewald's text shows this sequence by means of an ellipsis. Through the Gothic lettering of the inscription and the Gothic vocabulary of the architectural setting, we enter the realm of

ecclesiastic ritual and ceremony. Thus, by its page layout, Isaiah's prophecy is transposed to the chanted exchange of the liturgy, an auditory address that also characterizes the reiterative and incantatory prayers linked to the rosary held by the Christ child in the central panel (Fig. 28). See Chap. I, 44f.

Also relevant here is the fact that several scholars have responded to the way Mary turns her head in this panel, causing her ear to face the angel Annunciate. They relate this picturing of the *Annunciation* to the Augustinian notion of the *conceptio per aurum*. Stephan Beissel, S.J., "Die bildliche Darstellung der Verkündigung Maria," *Schnütgens Zeitschrift für christliche Kunst*, IV, 1891, 191–96; 207–14; Stephen S. Kayser, *The Review of Religion*, 1940, 3–35. Among the many explanations of the miraculous incarnation of Christ, Augustine used the evidence of Mary's receptivity to the Word of God—her belief in God's promise—to posit a conception caused by the active penetration of the Spirit of God into her ear. See Yrjö Hirn, *The Sacred Shrine*, Boston, 1957, 296f.

31. Henry Chaumartin, "L'Image de Saint-Antoine le Grand," *Bulletin de la Société Française d'histoire de la Médecine*, XXVI, 11 and 12, part 2, 413–41; Theophili Raynaudi, *In Symbolicam S. Antonii magni Imaginem*, Gandari, 1659, 52f. Whether Anthony's bell also bears out what appears to emerge from the scant documentation about the monastery at Isenheim—that the institution gave priority to auditory phenomena—is uncertain. But the late sixteenth-century account of liturgical décor for the calendar year, mentioned earlier, does require a variety of bells to be used in the services. (See Chap. II, 58–60. This document mentions "clouchettes," "la grosse clouche," and "la tarenelle que sert de clouche.") Significant also is the privilege accorded by Pope Boniface IX to the Antonite order of ringing bells and singing at their offices, even during periods otherwise subject to the prohibition of sound. (Paul Stintzi, *Les Antonites d'Issenheim*, Mulouse, 1972, 7.)

32. Jehan de Gerson, *L'Instruction des curez pour instruire le simple peuple*, Paris, 1506, a ii 48, "The substance of baptism is simple, elemental water, the form, these words: I baptize you. . . ." Nicolas de Blony, *Tractatus sacerdotalis de Sacramentis deque divinis officiis et eorum ad ministrationibus*, Strassburg, 1499, ends with the statement "Baptismus est ablutio corporis exterius facta sub forma verborum prescripta." ("Baptism is the cleansing of the body, performed externally, under the prescribed formula of spoken words.")

33. Jehan de Gerson, ibid., "*Est ablutio corporis exterior facta ex aqua sub hac forma verborum. Ego Baptiso te In nomine patris et filii et spiritus sancti. Amen.*" ("It is the external washing of the body performed through water in accordance with this formula of spoken words: I baptize you in the name of the Father and the Son and the Holy Ghost. Amen.")

34. Johannes Geffcken, *Der Bildercatechismus der fünfzehnten Jahrhunderts*, Leipzig, 1855, 16–17, contains this passage from Guido da Monte Rocherii, *Manipulus Curatorum*: "Catechism is the same as instruction because in catechism the one to be baptized is taught about faith and the value of faith. Whence the priest says to the one about to be baptized: 'What do you seek?' And he replies (if he is grown up), 'Faith.' And if it is a child, his godparents reply in his person. Then the priest says: 'What will faith bring to you?' And they answer: 'Life eternal.'"

35. As at the end of the Gospel of Saint Mark 16:15–20: "And he said to them, 'Go out to the whole world; proclaim the Good News to all creation. He who believes and is baptized will be saved; he who does not believe will be condemned. These are the signs that will be associated with believers: in my name they will cast out devils; they will have the gift of tongues; . . . they will lay their hands on the sick, who will recover.'

"And so the Lord Jesus, after he had spoken to them, was taken up into heaven; there at the right hand of God he took his place, while they, going out, preached everywhere, the Lord working with them and confirming the word by the signs that accompanied it." Also Mark 1:39 and 2:3.

36. Rudolf Wackernagel, "Mitteilungen über Raymundus Peraudi und kirchliche Zustände seiner Zeit in Basel," *Basler Zeitschrift für Geschichte und Altertumskunde*, II, 1903, 171–273; E.J.D. Douglas, *Justification in Late Mediaeval Preaching, A Study of Geiler of Keisersberg*, Leiden, 1966, 2f.; Miriam Usher Chrisman, *Lay Culture, Learned Culture. Books and Social Change in Strasbourg, 1480–1599*, New Haven and London, 1982, 82–90.

37. Dorothea Roth, "Die mittelalterliche Predigttheorie und das Manuale Curatorum des Johann Ulrich Surgant," *Basler Beiträge zur Geschichtswissenschaft*, 58, 1956, 4–198. Guido da Monte Rocherii *Manipulus Curatorum* was published in Cologne, Paris, Rome, Strasbourg, and Geneva between ca. 1470 and 1500. Surgant's *Manuale Curatorum* was first published in Basel in 1503 and 1504 and subsequently in Augsburg, Strasbourg, and Mainz. Both Augustine's treatise and that of Aquinas appeared in Strasbourg in 1466 and 1479 respectively.

38. Doctor Keisersbergs Postill (1522 ed.), part V. "Des alles vormols nye gedocht noch gepredigt ist worden."

39. *Sermones Johannis geileri Keiserspergii De Arbore humana*, Strassburg, 1519, folio XXXVI.

40. Johañ Gayler von Kaysersberg, *Das Schiff der penitentz*, Augsburg, 1514, folio LXXXVII, p. iiii.

41. *Das Buch Granatapfel*, Augsburg, 1510, hiiii verso, "Von dem volkomen menschen."

42. *Navicula Penitentie*, Freiburg, 1510, folio v, "Von den Siben Schwerten."

43. See Chap. I, 29, Chap. II, 79.

44. *Das Buch Granatapfel*, Strassburg, 1511, folio A iii verso, "Von dem anhebenden menschen."

45. Jean-Claude Schmitt, " 'Gestus'–'Gesticulatio,' Contribution à l'étude du vocabulaire latin médiéval des gestes," *La Lexicographie du latin médiéval et ses rapports avec les recherches actuelles sur la civilisation du Moyen-Age*, Oct. 1978, C.N.R.S., 1981, 377–90. See also the same author's "Introduction and General Bibliography," *History and Anthropology*, I, 1984, 1–28.

46. Rudolf Suntrup, *Die Bedeutung der liturgischen Gebärden und Bewegungen in Lateinischen und deutschen Auslegungen des 9. bis 13. Jahrhunderts*, Munich, 1978; Karl Meyer, "Geistliches Schauspiel und kirchliche Kunst," *Vierteljahrsschrift für Kultur und Litteratur der Renaissance*, I, 1886, 162–86, 356–83, 409–38; Anke Roeder, *Die Gebärde im Drama des Mittelalters*, Munich, 1974. Dorothea Roth, *Basler Beiträge zur Geschichtswissenschaft*, 1956, 180, discusses the combi-

nation of verbal utterance, facial expression, and manual gesture known as *pronuntiatio*, classified in Surgant's preaching manual and derived from rules of rhetoric. In Jacob Wimpfeling's *Germania* (1501), the northern humanist lays out the conditions for educational reform in the north. The importance for him of the performative aspects of rhetorical training in the Latin schools is indicated by the way he classifies rhetoric with other types of lessons in comportment. See also Walter J. Ong, S.J., *Ramus—Method, and the Decay of Dialogue*, Cambridge, Mass., 1958, 272–75.

47. G. van Rijnberk, *Le langage par signes chez les moines*, Amsterdam, 1953; *Gestes et paroles dans les diverses familles liturgiques* (1978), Conférences Saint-Serge. XXIV^e séminaire d'Études Liturgiques (Paris 28 Juin–1^{er} Juillet 1977), Rome: Centro Liturgico Vincenziano (Biblioteca "Ephemerides Liturgicae"– Subsidia, 14); Jean-Claude Schmitt, "Between text and image: the prayer gestures of Saint Dominic," *History and Anthropology*, I, 1984, 127–62; Creighton E. Gilbert, "A Sign about Signing in a Fresco by Fra Angelico," *Tribute to Lotte Brand Philip*, New York, 1985, 64–70.

48. Thomas Ohm, *Die Gebetsgebärden der Völker und das Christentum*, Leiden, 1948, 267, 271–72.

49. Explaining the parable of the sower in Luke 8:11–15, "This, then, is what the parable means: the seed is the word of God. Those on the edge of the path are people who have heard it, and then the devil comes and carries away the word from their hearts in case they should believe and be saved. Those on the rock are people who, when they first hear it, welcome the word with joy. But these have no root; they believe for a while, and in time of trial they give up. As for the part that fell into thorns, this is people who have heard, but as they go on their way they are choked by the worries and riches and pleasures of life and do not reach maturity. As for the part in the rich soil, this is people with a noble and generous heart who have heard the word and take it to themselves and yield a harvest through their perseverance." In John 12:47, Jesus declares, "If anyone hears my words and does not keep them faithfully, it is not I who shall condemn them." Isaiah's prophecy is incorporated by the Gospels, as in Matthew 13:15, "For the heart of this nation has grown coarse, their ears are dull of hearing, and they have shut their eyes, for fear they should see with their eyes, hear with their ears, understand with their heart, and be converted and be healed by me."

50. See Chapter I, 39.

51. Jean Daniélou, *The Bible and the Liturgy*, Notre Dame, Ind., 1956, 78f.

52. Romans 6:3. Also Colossians 2:12: "You have been buried with him, when you were baptised; and by baptism, too, you have been raised up with him through your belief in the power of God who raised him from the dead."

53. To be associated with Mary is the enclosing wall that forms the *hortus conclusus*, the mountain towering in back of the seated Madonna and echoing her overall shape, the rose next to her, and the church building behind it. See Y. Hirn, *The Sacred Shrine*, 1957, Chap. 21, 462. Moreover, as Lotte Brand Philip points out (*The Ghent Altarpiece*, Princeton, N.J., 1971, 219, note 421), the fact that some of the furnishings, such as the cradle and the chamber pot, would

more appropriately belong to an interior environment speaks for the symbolic rather than the naturalistic character of the scene.

54. See Georg Scheja, *The Isenheim Altarpiece*, New York, 1969, 43f., for an account of the principal interpretations of this section of the altarpiece. Significant specialized studies are Josef Bernhart, "Die Symbolik im Menschwerdungsbild des Isenheimer Altares," *Kunstchronik und Kunstmarkt*, XXXI, Apr. 1920, 531–33; Egid Beitz, *Grünewalds Isenheimer Menschwerdungsbild und seine Quellen*, Cologne, 1924; Herbert von Einem, "Die 'Menschwerdung Christi' des Isenheimer Altares," *Kunstgeschichtliche Studien für Hans Kauffman*, Berlin, 1956, 152–71. Generally the small blond crowned figure in the tabernacle is identified as Mary, although a few scholars have seen here the Queen of Sheba standing in Solomon's temple (Erwin Poeschel, "Zur Deutung von Grünewalds Weihnachtsbild," *Zeitschrift für Kunstgeschichte*, XIII, 1950, 92–104). Sometimes the one figure is perceived to be a vision of the other. Scheja, for example, credits the seated Madonna with a visionary experience of the tiny Madonna in the tabernacle, although the reverse has also been suggested.

55. The music-making angel next to the tub in the Isenheim Altarpiece may illuminate a tradition derived from the writings of Tertullian and Origen that involves the presence of an angel at baptism, both as a figure for the Holy Spirit and an agent for purifying the baptismal waters. (J. Daniélou, *The Bible and the Liturgy*, 1956, 212.) Grünewald depicts viscous-looking drops extending from the middle rim around the small glass pitcher in the same section of the Isenheim Altarpiece. Given that the pitcher is aligned with the tub and contains a clear liquid with a slightly golden cast, this detail is suggestive of the chrism, the consecrated oil used in the baptismal rite.

Peter Strieder ("Coffre, baquet et sarcophage dans la première ouverture du retable d'Issenheim," *Actes de la Table Ronde: Grünewald et son oeuvre*, Strasbourg and Colmar, 1974, 49–59) speculates, in connection with the tub, on the possible use of baths among the healing procedures at the Isenheim monastery, but he overlooks the sacramental implication of the representation of the tub. Indeed, in what he claims to be the only other contemporary example of a Nativity of Christ (as opposed to other birthing scenes, principally the *Birth of the Virgin*) that shows a wooden tub—a panel of Jörg Stocker's altarpiece in the Augsburg Cathedral—Strieder ignores the sacramental reference that clearly obtains from the placement of the tub just below a tabletop on which rest a loaf of bread and a chalice. For the conjunction of the tub or bathing motif with the Madonna and Child, Marie Tanner ("Concordia in Piero della Francesca's *Baptism of Christ*," *Art Quarterly*, XXXV, 1, 1972, 1–20) discusses the significance of the original feast of the Epiphany, which celebrated both the birth and the baptism of Christ.

56. J. J. Dietrich, "La Dépouille du couvent des Antonites d'Issenheim," *Revue d'Alsace*, Nouvelle Série, Deuxième Année, II, 1873, 70–78, refers to an inventory of 1628 from a *procès-verbal*: "Plus derrière le maître autel, un bassin de cuivre rouge étamé, servant pour les fonts baptimaux, estimé à 1 livre 10 sous."

57. Among other possible connotations for John the Baptist's bare feet in the *Crucifixion* scene, one is also reminded here of the liturgical practice of removing

the shoes at the time of the Adoration of the Cross on Good Friday. See Hélène Lubienska de Lenval, *La Liturgie du geste*, Casterman, Tournai, Paris, 1956, 43.

58. Ludwig Eisenhofer and Joseph Lechner, *The Liturgy of the Roman Rite*, trans. A. J. Peeler and E. F. Peeler, New York, 1961, Chap. VIII, 177–219; O. B. Hardison, Jr., "Christus Victor," *Christian Rite and Christian Drama in the Middle Ages*, Baltimore, 1965, 139–77.

59. O. B. Hardison, Jr., ibid., especially 157f.

60. Marsilio Ficino, *Commentary on Plato's Symposium on Love*, trans. Sears Jayne, Dallas, Texas, 1985, 85–86. In Speech V, Chap. 2, under the heading "How love is pictured, and with what parts of the soul beauty is recognized and love is generated": "Sight is located in the highest part of the body, just as fire is located in the highest region of the world, and by its nature perceives light, which is characteristic of fire. Hearing, following sight in the same way that pure air follows fire, takes in sounds. . . . From these things it can be apparent to anyone that of those six powers of the soul, three pertain more to the body and to mattter (touch, taste, and smell) whereas the other three (reason, sight, and hearing) pertain to the spirit." See Ernst H. Gombrich, *Symbolic Images*, London and New York, 1972, 44; Michael J. B. Allen, *The Platonism of Marsilio Ficino*, Berkeley, Los Angeles, and London, 1984, 54–57. The ultimate source for this hierarchy of the senses lies in Plato's *Timaeus* (ed. and trans. John Warrington, London, 1965, 46–47). In his theoretical writings, Leonardo da Vinci also incorporates these ideas. Ranking the senses—seeing, hearing, touch, taste, and smell—Leonardo concludes, "That sense functions most swiftly which is nearest to the organ of perception; this is the eye, the chief and leader of the others." (*The Notebooks of Leonardo da Vinci*, ed. and trans. Edward MacCurdy, I, New York, 1939, 200.)

61. Guido da Monte Rocherii, *Manipulus Curatorum.*, specifies that the candidate must have his ears opened to hear the word of God and the articles of faith. Saliva is placed on the mouth to prepare and ready him to respond and speak of faith. At the same time, the candidate must have his ears closed to the suggestions of the devil and his mouth closed to keep from speaking ill. See Arthur McCormack, *Christian Initiation*, 50, Twentieth Century Encyclopedia of Catholicism, New York, 1969, 50.

62. H. Lubienska de Lenval, *La Liturgie du Geste*, 1956, 30.

63. See Chap. I, 50–51.

64. *Selected Writings of Martin Luther, 1517–1520*, ed. Theodore G. Tappert Philadelphia, 1967; see especially "The Babylonian Captivity of the Church," 363–478.

65. Ibid., especially 410f. for Luther's views.

66. L. B. Philip, *The Ghent Altarpiece*, 1971, 219–20.

CHAPTER IV

1. Wolfgang von Goethe, *Dichtung und Wahrheit*, eds. J. Vogel and J. Zeitler, part II, book 8, Leipzig, 1903, 233: ". . . feeling of solemnity. . . more resem-

bled the feeling with which one enters a church, as the adornments of so many a temple, the objects of so much adoration, seemed here to be set up only for the sacred purpose of art."

2. My characterization relates to the one in Walter Benjamin, "The Work of Art in the Age of Mechanical Reproduction," *Illuminations*, New York, 1968, 219–53.

3. Claude Champion, *Le Musée d'Unterlinden à Colmar*, Paris, 1924, 20. On June 20, 1849, the municipal council decided that the newly formed "Société Schongauer" would place the collections from archives and library in the Unterlinden cloister. See André Waltz, "Comment fut créé le Musée des Unterlinden," *Bulletin de la Société Schongauer à Colmar, 1923–33*, 47–55. The museum was opened to the public on April 3, 1853.

4. H. A. Schmid, *Kunstsammlungen, Kunstwissenschaft und Kunstunterricht*, Basel, 1935, 46.

5. H. A. Schmid, *Die Gemälde und Zeichnungen von Matthias Grünewald*, Strassburg, 1911.

6. H. A. Schmid, "Jacob Burckhardt," *Gesammelte Kunsthistorische Schriften*, Leipzig, Strassburg, and Zurich, 1933, 274–87. In the same volume see the speech on the occasion of Schmid's seventieth birthday by W. Ueberwasser, Xf. Also H. Wölfflin, *Autobiographie, Tagebücher und Briefe*, ed. J. Gantner, Basel and Stuttgart, 1982, xiv. Schmid and Wölfflin were in Italy together in December 1886.

7. *Jacob Burckhardt und Heinrich Wölfflin: Briefwechsel und andere Dokumente ihrer Begegnung 1882–1897*, ed. J. Gantner, Basel, 1948, 10. A letter from Burckhardt to Wölfflin, dated 3 October 1892 (ibid., 73–74), addresses itself to Wölfflin's inquiries about possible successorship at the university. Burckhardt responds, "What I write to you here holds true as well for Dr. Alfred Schmid, whom I also value highly; if it actually came to something of the kind, he, too, would surely be glad to accept a permanent appointment here and would likewise have his supporters." Wölfflin was appointed to the chair in 1893. Schmid took over in 1901 and remained until 1904, when he went to Prague. He returned to Basel as Ordinarius in 1919, at which time he also became curator of the Öffentliche Kunstsammlung.

8. See above, notes 4 and 6.

9. H. A. Schmid, *Die Werke Hans Holbeins in Basel*, Basel, 1930; idem, *Hans Holbein der Jüngere*, 2 vols., Basel, 1945–1948.

10. H. A. Schmid, "Matthias Grünewald," *Gesammelte Schriften*, 1933, 49–97.

11. Ibid., 49. "Since this artist is still practically unknown even today, since he worked in the vicinity of Basel, and since the greatest of his surviving works can still be seen in nearby Colmar, a characterization of this important man would surely be in order."

12. Ibid., 62.

13. W. Füssli, *Zürich und die wichtigsten Städte am Rhein*, Zürich, 1842, 364, mentions Grünewald as the artist of the Colmar altarpiece. A newspaper article signed "B." (sometimes attributed therefore to Burckhardt), "Mitteilungen aus Basel," *Kunstblatt*, no. 36, 2 May 1844, 151–52, reports on the panels by Grüne-

wald and the fact that they would soon be placed in the Dominican cloister in Colmar and thus be easier to see. F. Kugler, *Handbuch der Kunstgeschichte*, Stuttgart, 1848, 799. E. Förster, *Geschichte der deutschen Kunst*, II, Leipzig, 1853, 319–22, calls Grünewald "*ausgezeichneten Meister*" ("excellent master") and discusses some of his works, but ascribes the Isenheim Altarpiece to Baldung.

14. H. A. Schmid, *Gesammelte Schriften*, 1933, 97. "Today there is even a general stirring toward a celebration of color, a direction in painting that is closely related to our melancholy outsider from the age of the Reformation."

15. See the speech by Schmid, "Böcklin und Jakob Burckhardt," *Jahres-Bericht 1927, Oeffentliche Kunst Sammlung*, Basel, N.F. XXIV, 1928, 23–39. See also H. Wölfflin, "Arnold Böcklin," *Kleine Schriften*, Basel, 1946, 109–18. Wölfflin was also the speaker at the memorial service for Böcklin in January 1901 (ibid., 253).

16. J. Meier-Graefe, *Der Fall Böcklin und die Lehre von den Einheiten*, Munich, 1905. See also K. Moffett, *Meier-Graefe as Art Critic*, Munich, 1973.

17. H. von Tschudi, "Arnold Böcklin" and "Die Werke Arnold Böcklins in der Nationalgalerie zu Berlin," *Gesammelte Schriften zur neueren Kunst*, Munich, 1912, 119–27, 134–62. The latter essay appeared in the catalogue accompanying an exhibition of 1901; the former was an article written immediately after Böcklin's death in early 1901.

18. R. Andrée, *Arnold Böcklin*, Basel, 1977, 31. See also the exhibition catalogue, "Arnold Böcklin 1827–1901," Basel, 1977. Schmid visited Böcklin for the first time in 1891 in Zurich and again in 1894 and 1900 (which he considered the most important time). The scholar published articles, a catalogue of works, and a monograph that came out in several editions. H. A. Schmid, *Arnold Böcklin sein Leben und sein Schaffen*, Munich, 1901; idem, *Arnold Böcklin*, Munich, 1922.

19. R. Schick, *Tagebuch-Aufzeichnungen aus den Jahren 1866; 1868; 1869 über Arnold Böcklin*, Berlin, 1901, 146. R. Andrée, *Arnold Böcklin*, 1977, 32, speaks of Böcklin going to Colmar in 1890 "to resee" the Grünewalds. "Arnold Böcklin 1827–1901," 20, mentions Böcklin going to Colmar in 1892 to study Grünewald for the last time.

20. R. Schick, *Tagebuch*, 1901, 146, 281.

21. H. A. Schmid, *Gesammelte Schriften*, 1933, 49, 97. The author argues for the relevance of characterizing Grünewald for his readers, "all the more so, because in many respects he is a very related phenomenon to our great fellow citizen Arnold Böcklin." See also Schmid's review of Meier-Graefe's *Der Fall Böcklin*: "Meier-Graefe contra Böcklin," *Die Kunst für Alle*, XX, 1904–1905, 432–36. See above, note 14. Also illuminating in this regard are the comments of the painter Hans Thoma, "Einiges über Farbenmaterial und Maltechnik," *Süddeutsche Monatshefte*, 2 Jahrg., no. 10, Oct. 1905, 341–51. Having seen the Isenheim Altarpiece for the first time in the days when he was working on an essay concerning color and painting techniques for artists, Thoma speaks of nearly abandoning his project, as Grünewald's handling of color transcended and defied any possible prescriptions or theoretical formulation.

22. For example, F. Baumgarten, "Matthias Grünewald als Meister der Isenheimer Altargemälde und seine Vorbildlichkeit für Arnold Böcklin," *Das Kunstgewerbe im Elsass-Lothringen*, V, 1904–1905, 1–10, 36–48, 151–57. This critic ex-

plains that he associated the Isenheim Altarpiece with Böcklin without at first being aware of an actual connection. Then he says of Böcklin, "And this new prophet of colorism was in a certain sense a pupil of Grünewald's and explicitly acknowledged this tutorship."

23. H. A. Schmid, *Arnold Böcklin*, 1901, 40f.

24. H. A. Schmid, *Arnold Böcklin*, 1922, 19; "Arnold Böcklin," 1977, 20.

25. R. Schick, *Tagebuch*, 1901, 281, speaks of the impression of the Isenheim Altarpiece on Böcklin and continues, "Burckhardt recognized the impact of this picture but thought it dated from a time in German art when anything was allowed." H. A. Schmid, *Arnold Böcklin*, 1901, 41, speaks of the conflict and of Burckhardt, "He had pleaded with Böcklin in favor of the more moderate conception of form of the High Renaissance." H. A. Schmid, *Arnold Böcklin*, 1922, 33, says of Böcklin, "It is no coincidence that precisely in relation to Grünewald the opposition to Burckhardt became evident for the first time."

The sense of conflicting interests between Grünewald, on the one hand, and a classical tradition, on the other, was later reiterated by Wölfflin, especially in his growing concern over defining Dürer's position. Dürer, the one artist on whom Wölfflin bestows the honor of full monographic treatment, came to represent to the former student of Burckhardt the potential for all that was rational and intellectual in the German character. With his Italian grounding and inclinations toward theory, Dürer embraced a sort of world that Wölfflin felt to be clearly at odds with the one posited in Grünewald's pictures. In the preface to the first edition of his monograph on Dürer (1905), Wölfflin does not mention Grünewald. He does attempt to set straight the notion of Dürer as the most German of German masters by emphasizing his attraction to Italy and the impact of Italian art on him. In Wölfflin's preparatory notes of 1904 for a lecture on German art, he begins to pit the two artists against each other: "He [Grünewald] must have seemed ghastly to Dürer: Dürer's entire life's work was called into question by such an art" (H. Wölfflin, *Autobiographie, Briefe*, 1982, 206). For the fifth edition of his monograph on Dürer (1925), Wölfflin amends his preface to comment somewhat bitterly on the way in which Grünewald had by then robbed Dürer of the center stage in contemporary critical reevaluation. Explaining this fact, he adds, "We demand living color. Not the rational but the irrational. Not the structured but a free rhythm. Not the fabricated but that which seemingly evolved by chance."

26. W. Worringer, *Abstraktion und Einfühlung*, Munich, 1908.

27. W. Worringer, *Formprobleme der Gotik*, Munich, 1910.

28. Ibid., 78, "Grünewalds Gotik gebärdet sich als malerische Pathetik." By the sixth edition of 1919, the number of illustrations accompanying Worringer's essay was doubled and includes Grünewald's *Crucifixion* from the Isenheim Altarpiece.

29. See an illuminating article, kindly brought to my attention by Angelica Rudenstine: P. Paret, "The Tschudi Affair," *Journal of Modern History*, LIII, 4, 1981, 589–618. A controversy among artists and critics also ensued, with C. Vinnen, *Ein Protest deutscher Künstler*, Jena, 1911, taking the chauvinist position with respect to the purchase and critical backing of contemporary art and *Im Kampf*

um die Kunst—Die Antwort auf den "Protest deutscher Künstler," Munich, 1911, reacting with a more progressive, international attitude.

30. Worringer's preface to the 4th and 5th editions of *Formprobleme* refers to the war "which has already kept the author nearly three years at the front," and he signs off with "On field service, February 1918." (Wilhelm Worringer, *Form in Gothic*, trans. Herbert Read, London, 1924.)

31. P. Selz, *German Expressionist Painting*, Berkeley, 1957, 17; idem, "Max Beckmann," New York, Museum of Modern Art, n.d. 26 (based on a 1948 interview with the artist).

32. F. Marc, "Die neue Malerei"; "Die konstruktiven Ideen der neuen Malerei," *Pan*, 2 Jahrg., 1911–1912, 468–71, 527–31.

33. W. Kandinsky, *Über das Geistige in der Kunst*, Munich, 1912. In the annals of publishing, it is of interest that Worringer's books, Kandinsky's *On the Spiritual in Art*, and the above-mentioned collected manifestos, *Im Kampf um die Kunst*, were all released by the estimable Piper Verlag.

34. J. Meier-Graefe, *Die Entwicklungsgeschichte der modernen Kunst: Ein Beitrag zur modernen Ästhetik*, 3 vols., Stuttgart, 1904. See K. Moffet, *Meier-Graefe as Art Critic*, 47f.

35. P. Selz, *German Expressionist Painting*, 1957, 17, lays the foundation for any full consideration of the importance of the Isenheim Altarpiece to the Expressionist painters.

36. P. Selz, ibid., 286; told to Selz in an interview with Beckmann. See also M. Q. Beckmann, *Mein Leben mit Max Beckmann*, Munich, 1983, 149.

37. E. Nolde, *Jahre der Kämpfe (1902–1914)*, Flensburg, 1957, 178f., 237. Other works in this nationalistic genealogy are Goethe's *Faust* and Nietzsche's *Thus Spake Zarathustra*.

38. R. M. Rilke, *Briefe an seinen Verleger 1906–26*, Leipzig, 1934, 68, letter to Anton Kippenberg. I am grateful to Thomas Greene for calling my attention to Rilke's interest in the Isenheim Altarpiece and to Angelica Rudenstine and Ted Ziolkowski for their assistance in tracking down the references.

39. Elias Canetti, *Die Fackel im Ohr (Lebensgeschichte 1921–31)*, Munich and Vienna, 1980, 259–62. Canetti recalls that after spending a day viewing the altarpiece in Colmar, he longed for invisibility so that he might remain in the museum all night.

40. G. Scholem, *Walter Benjamin—Die Geschichte einer Freundschaft*, Frankfurt, 1975, 51. I would like to thank Svetlana Alpers for first mentioning Scholem's account to me.

41. H. A. Schmid, *Die Gemälde*, Part I, Strassburg, 1907 (Portfolio of 69 Collotypes). Max Friedländer coordinated another such volume of plates published in Munich, 1908.

42. See notes 37 and 38. According to Scholem, these reproductions of the Isenheim Altarpiece hung in Benjamin's study. Canetti characterizes his search for living quarters in Vienna as bound up with the goal of accommodating as many reproductions of details of the altarpiece as possible. He concludes this passage entitled "The View of Steinhof," from the autobiographical notes (see note 39), *The Torch in My Ear*, trans. Joachim Neugroschel, New York, 1962, 233,

"I spent six years in this room; and it was here, as soon as the reproductions of Grünewald hung around me, that I wrote *Auto-Da-Fé*."

43. F. Baumgarten, *Das Kunstgewerbe im Elsass-Lothringen*, V, 1904–1905, 1–10.

44. Another aspect of the cresting interest in the Isenheim Altarpiece about 1905 is the evidence of factions openly hostile to Grünewald. See Max Liebermann's letter of 23 August 1905 to Wilhelm von Bode in *Künstlerbriefe über Kunst*, ed. H. Uhde-Bernays, Dresden, 1926, 648f.

45. *Le Mois littéraire et pittoresque*, no. 63, March 1904, 282–300. *Trois Primitifs* was published by A. Messein, Paris, 1905. A new critical edition (Paris, 1988) of Huysmans's essay on the Isenheim Altarpiece was sent to me by its editors, P. Brunel, A. Guyaux, and C. Heck, after my book went into production.

46. Huysmans's essay on the Isenheim Altarpiece, as well as his account of this picture, punctuate sight-seeing trips: in 1888, at the invitation of his friend, the novelist Arij Prins, then living in Hamburg, Huysmans journeyed to Germany. He saw Grünewald's *Crucifixion*, at the time in the Kassel Museum. See Robert Baldick, *The Life of J. K. Huysmans*, Oxford, 1955, 144. (See also Pierre Cogny, "Repères chronologiques," *L'Herne*, 47, 1985, 18–24. This excellent volume devoted to Huysmans, edited by Pierre Brunel and André Guyaux, was brought to my attention by Antoine Compagnon.)

That Grünewald's standing was in no way secure up to this point is revealed by the fact that this *Crucifixion* had apparently been offered during the 1880s to the Kaiser-Friedrich-Museum, Berlin, and to the Germanisches Nationalmuseum, Nuremberg, both of which turned it down. See P. Selz, *German Expressionist Painting*, 1957, 16. The painter Hans Thoma seems to have been the catalyst in getting the picture to the Kassel Museum and was himself director of the Staatliche Kunsthalle in Karlsruhe when the picture entered that collection in 1899. (*Tout l'oeuvre peint de Grünewald*, ed. P. Vaisse and P. Bianconi, Paris, 1974, 96–97.)

It is interesting to note that a German book review of 1895 relates to a German translation of Huysmans's description of this painting and displays no awareness of Schmid's 1894 publication. (O. J. Bierbaum and J. Meier-Graefe, *Pan*, I Jahrg., no. 2, 1895, 94–96.)

47. These views are expressed in the novel itself, for which see the Garnier-Flammarion edition, 1978, 35–37. Relevant also are Huysmans's comments in a nearly contemporary letter: J. K. Huysmans, *Lettres inédites à Jules Destrée*, Geneva, 1967, 174. On 12 December 1890 he discusses the work of Roger van der Weyden, Metsys, and Grünewald as comprising "absolute realism laced with rays of the spirit, exactly what materialist naturalism didn't understand—and it has collapsed because of this, despite all the services it has rendered."

48. An essay on Félicien Rops and a comparison of Gustave Moreau's work with that of Puvis de Chavannes was published in 1889 in the collection called *Certains* (Oeuvres complètes, X, Paris, 1928–1934). On the general subject of Huysmans and the visual arts, see Annette Theresa Weissenstein, *The Influence of the Visual Arts in the Work of J. K. Huysmans*, Ph.D. diss., Columbia University, 1981. See also some relevant essays in the recent publication *Huysmans, Une*

esthétique de la décadence, Actes du colloque de Bâle, Mulhouse et Colmar, Nov. 1984, Paris, 1987.

49. J. K. Huysmans, "Le Salon Officiel de 1881," *L'art moderne*, Oeuvres complètes, VI, Paris, 1928–1934, 214: "Here it is the nightmare carried over into art. Blend into a macabre setting somnambulant figures having a vague kinship with those of Gustave Moreau, transformed by terror, and maybe you will have some idea of the bizarre talent of this singular artist."

50. J. K. Huysmans, *À rebours*, Garnier-Flammarion, 1978, Chap. V, 109f. Interestingly, these characteristics of Moreau's work are explained by Huysmans in terms of a particularly modernist sensibility: "Without provable ancestors he remained, in contemporary art, a unique figure . . . his hieratic and sinister allegories made yet more poignant by the restless apperceptions of a nervous system altogether modern in its morbid sensitiveness." J. K. Huysmans, *Against the Grain*, trans. P. G. Lloyd (?), London, 1946, 58–63, repr. in ed. Linda Nochlin, *Impressionism and Post-Impressionism 1874–1904*, Englewood Cliffs, N.J., 1966, 201f.

51. Jean Moréas, "Un manifeste littéraire—le symbolisme," *Le Figaro*, Paris, 18 Sept. 1886, as trans. in Robert Delevoy, *Symbolists and Symbolism*, New York, 1978, 71. In reference to the contemporary debate in the newspapers, see also Paul Adam, "Le Symbolisme," *La Vogue*, II, no. 12, 4–11, Oct. 1886, 397–401.

52. An unsigned column, "Un peintre symboliste," *L'Art Moderne*, no. 17, 24 Apr. 1887, 129–31, entertains the question of Symbolist style in the plastic arts. Émile Verhaeren, the Belgian writer to whom it is attributed, seems actually to have preceded Huysmans in French-speaking Europe in his consideration of Grünewald; see Christian Heck, "Grünewald et le culte des Primitifs septentrionaux chez Huysmans," *Une esthétique de la décadence*, 1987, 271–284. In "Le Peintre Matthias Grünewald, d'Aschaffenburg," *La Société Nouvelle*, II, no. 10, Dec. 1894, 661–79, Verhaeren mentions that eight years earlier (1886), upon having seen the Cassel Grünewalds, he had published notes in *L'Art Moderne* that were subsequently reprinted in the Parisian *La Vogue*. He comments that it was Huysmans, however, who made a larger public aware of Grünewald—and well before the publication of the essay on the Isenheim Altarpiece; in that essay Huysmans does refer (p. 13) to "une intéressante étude" by Verhaeren, almost certainly the more extensive 1894 publication and not the earlier one. The critic most responsible for creating a notion of Symbolist style in painting by centering on Van Gogh and Gauguin was G.-Albert Aurier in publications around the time of Huysmans's *Là Bas*: "Les Isolés: Vincent van Gogh," *Mercure de France*, I, Jan. 1890, 24–29; "Le Symbolisme en peinture: Paul Gauguin," *Mercure de France*, II, Mar. 1891, 155–65; "Les Symbolistes," *Revue encyclopédique*, 1892, 474–86.

53. First published in J. M. Charcot and P. Richer, "Les Syphilitiques dans l'art," *Nouvelle Iconographie de la Salpêtrière*, I, 1888, 258–60; idem, *Les Difformes et les malades dans l'art*, Paris, 1889, 80–81; see also reprint edition of this book, Amsterdam, 1972. The book is divided into sections according to the visible symptoms of pathological conditions, i.e., dwarfs, lepers, syphilitics, and so forth. Buttressing Charcot's careful observation was the collecting of visual rec-

ords; this involved not only works of art of the past but a newly formed pho-
tographic archive. Charcot also relied on his own skill as a draftsman.

54. J. K. Huysmans, *Là Bas*; see especially Chap. 19. Durtal witnesses such
bodily states when he attends a black mass.

55. Ibid., Chap. IX. Surely the most eloquent summation of Charcot's con-
tributions occurs in Freud's writing. Having studied with Charcot at the Sal-
pêtrière in the winter of 1885–1886, he translated several of Charcot's lectures into
German, with a preface explaining the work. The *Weiner medizinische Wochen-
schrift*, 43(37), 9 Sept. 1893, 1513–20, contains an obituary written by Freud hon-
oring the French physician.

56. This controversy is explicitly rendered in Chap. IX of *Là Bas*, where these
diseases are summarized from the following point of view, (J. K. Huysmans,
Down There, trans. Keene Wallis, Evanston and New York, 1972, 141–42): "Only
the church can answer. Science cannot. . . . Science goes all to pieces on the
question of this inexplicable, stupefying malady, which, consequently, is subject
to the most diversified interpretations. . . . Mystery is everywhere and reason
cannot see its way."

57. This philosophical crisis is similarly expressed by G.-Albert Aurier in his
"Les Symbolistes," 1892: "With the infatuation for positivist science, with the
enthusiasms that it had aroused since its baptism, the aesthetic that was born of
it now suffers the pangs of death, sounds its death rattle, and dies. In vain, the
art that is exclusively materialist, experimental, and spontaneous fights against
the attacks of a new art that is visionary and mystical."

58. J. K. Huysmans, *Down There*, 1972, 9–10.

59. *Journal de l'Abbé Mugnier, 1879–1939*, Paris, 1985, 134. They went in mid-
September. Huysmans refers to W. H. James Weale's catalogue for this exhibi-
tion in his essay on Frankfurt, published with the Grünewald essay as *Trois Pri-
mitifs*.

60. I owe my first awareness of the importance of this exhibition to com-
ments made by Francis Haskell in a lecture at the Collège de France in the spring
of 1985.

61. H. Fierens-Gevaert, "L'Exposition des primitifs flamands à Bruges," *La
Revue de l'art ancien et moderne*, 12, 1902, 105–16, 173–82, 435–44; Octave Uzanne,
"The Exhibition of Primitive Art at Bruges," *The Connoisseur*, IV, Sept.–Dec.
1902, 172–80.

62. Fierens-Gevaert, for example, characterizes the Ghent Altarpiece, which
was to have been reconstructed for display in this exhibition as a work "in which
art and faith so intimately interpenetrate."

63. Octave Maus, "Les Primitifs flamands," *L'Art moderne*, 13 July 1902, 233–
35.

64. Émile Mâle, *L'Art religieux du XII siècle en France*, Paris, 1898; idem, "La
Légende dorée et l'art du Moyen Age," *La Revue de L'Art Ancien et Moderne*, V,
1899, 187–96; idem, "Le Renouvellement de l'art par les 'Mystères' à la fin du
Moyen Age," *Gazette des Beaux-Arts*, 31, Feb., Mar., Apr., May 1904, 89–106,
215–30, 283–301, 379–94.

65. J. K. Huysmans, "Bouquins," *L'Écho de Paris*, 26 Apr. 1899, 1; repr. with
notes by André Guyaux in *L'Herne*, 47, 1985, 345–48. Huysmans even faults Mâle

for not going far enough in his discussion of symbolic significance because the scholar does not attach more than decorative value to the vegetal and floral motifs of the cathedral sculpture. But generally Huysmans praises him: "The reading of these church buildings has thus gone a step further with him. . . . [He] envisages not only the material body of churches but also their soul"—a distinction that anticipates the one Mâle himself makes in his review of Rodin's book on the French cathedrals when he compares Rodin's evocative characterizations to the more strict, archaeological approach of Viollet-le-Duc (*Gazette des Beaux-Arts*, ser. 4, 11, 1914, 372–78). Interestingly, it is also around the turn of the century that Proust becomes involved in translating some of Ruskin's works and in 1900 publishes several articles on Ruskin. See *Gazette des Beaux-Arts* 23 and 24, nos. 86 and 87, 310–18, 135–46; *Mercure de France*, 34, no. 124, 56–88. Proust focuses on the way Ruskin's Christianity shapes his aesthetic. Discussing "La Bible d'Amiens," Proust also emphasizes the notion of the cathedral as a Bible requiring explication. In one footnote (p. 56), he, too, refers to Mâle's book on thirteenth-century Christian art: an "unadulterated masterpiece and the last word on French iconography that I shall be citing very often in the course of this study."

66. The subtitle for Mâle's 1898 book is "Étude sur l'iconographie du Moyen Age et sur ses sources d'inspiration." In his 1904 publication (see note 64) he poses the problem in terms of how to explain the sudden transformation and elaboration of Christian iconography, along with the amplifying of emotional content in the art of the late Middle Ages. The proliferation of the practice of mystery plays remains the backbone of his explanation, along with the broad-based cultural infiltration of texts such as the *Biblia Pauperum*, Saint Bonaventure's *Meditations on the Life of Christ*, and the *Speculum humanae salvationis*.

67. See Pierre Cogny, "Repères chronologiques," *L'Herne*, 47, 18–24. Huysmans's first of several retreats at the Trappe d'Igny took place a year after the publication of *Là Bas*. Somewhat later he went to the Norman abbey of Saint-Wandrille, then to a Benedictine monastery at Solesmes. He wrote prefaces to Rémy de Gourmont's *Latin mystique* in 1892 and to the *Petit Catéchisme liturgique* of the Abbots Dutilliet and Vigourel in 1895. His own *La Cathédrale* was published in 1898 and *Saint Lydwine de Schiedam* in 1901. In 1904, the year in which he wrote the essay on the Isenheim Altarpiece, Huysmans also completed a preface to a new edition of *À Rebours*. For this twenty-year commemoration of the novel's first printing, the writer charts his development, which he envisages primarily in terms of his intensifying Catholicism. Another 1904 preface by Huysmans, to an edition of Paul Verlaine's *Poésies religieuses*, locates in this poet's Catholic writing a dynamic voice within contemporary society comparable to that of François Villon in the Middle Ages.

68. Interestingly, certain of the reviews of the 1902 Bruges exhibition do address themselves to a discrepancy between the magnificent craftsmanship everywhere evident in these pictures and the reticence, by and large, of documentary information about their artists, especially when compared to the situation in Italian Renaissance art. (O. Uzanne, *The Connoisseur*, 172–80.)

69. It might be appropriate to see this sensitivity on the part of Huysmans also in terms of a line of passionate if isolated voices in a France of the salon

exhibition, the museum, and the deracination of art through wartime plunder, eloquent on behalf of the need to restore works to their original contexts. Etienne Delécluze records the response of his teacher, Jacques-Louis David, to the creation of the Musée Napoleon (*Louis David, son école et son temps*, Paris, 1855, 209; trans. in Lorenz Eitner, ed., *Neoclassicsm and Romanticism 1750–1850*, II, Englewood Cliffs, N.J., 1970, 9): "The site of a work of art, the distance one must travel to see it contribute singularly to our notion of its worth. This is particularly true of the paintings which one hung in churches. They will lose much of their beauty and effect when they are no longer seen in the places for which they were made." Ironically, even Alexandre Lenoir's approach to installing the Musée des monuments français, which was made up of works of art confiscated from French churches during the revolution, was partly guided by the same attitude.

70. See Thierry Lescuyer, "Huysmans et Zola: Lourdes en question," *L'Herne*, 47, 324–32.

71. Originally published as a pamphlet by the Bibliothèque Diabolique, the essay is reprinted in *Les Démoniaques dans l'art*, édition Macula, Paris, 1984.

72. J. K. Huysmans, *Oeuvres Complètes*, II, 1928–1934, 325; 340: "Qu'est-ce que cet être énigmatique, cette androgyne implacable et jolie, si étonnamment de sang-froid quand elle provoque?" . . . "La Vierge relève surtout du domaine de la liturgie et de la mystique."

73. Ibid., 356: "les deux antipodes de l'âme . . . les deux extrêmes de la peinture, le ciel et l'enfer de l'art."

74. Ibid., 356. "After being uprooted from the monastery of Flémalle, it was sold and brought to the banks of the Main, where it continues its grievous internship in the hands of the Jews."

75. John McManners, *Church and State in France 1870–1914*, London, 1972, 118, speaks of France's generation-long "moral cataclysm" created by the Dreyfus Affair. See the *Journal de l'Abbé Mugnier 1879–1939*. The abbot's journals are interspersed with references to Dreyfus. On 5 June 1899 he talks about having dined with Huysmans (114): "Finally we chatted vividly about the Affair. Huysmans is anti-Dreyfus, anti-Semitic. For him this campaign is 'the oppression of the old society; it is a war against religion.' "

76. Relatedly, Huysmans came to perceive conversion as the ultimate sign of religious commitment. In his preface to the volume of Verlaine's religious poetry (see above, note 67), Huysmans emphasizes that the poet was a convert to Catholicism and that the greatest talents among Catholics were frequently to be found among this group. On church and state in this period in France, see J. McManners, *Church and State in France*, 1972, xxi–xxii, 140–48.

77. *Le Matin*, 30 July 1919. On the front page an article mentions the date of Feb. 1917 for the removal of the altarpiece to Munich. *L'Opinion*, 21 Aug. 1920, 211–13, says it left Colmar in Oct. 1917.

78. *Kunstchronik und Kunstmarkt*, 54 Jahrg. N.F. xxx, no. 34, June 1919, 715–16, makes note of a lecture held in front of the Isenheim panels in the Alte Pinakothek, reporting on restoration and transportation. O. Hagen, *Matthias Grünewald*, Munich, 1919, introduces a folio of new reproductions, photographs taken while the altarpiece was in Munich.

79. *Rainer Maria Rilke und Marie von Thurn und Taxis-Briefwechsel*, II, Zurich, 1951, 542, no. 283, letter of 30 Mar. 1918. "Dass der Isenheimer-Altar (Grünewald) aus Colmar hier ist, wissen Sie wohl?"

80. Katharina Kippenberg, *Rainer Maria Rilke, Ein Beitrag*, Zurich, 1948, 261; *Rainer Maria Rilke–Katharina Kippenberg, Briefwechsel*, Wiesbaden, 1954, 300, letter from Leipzig, 1 Aug. 1918; 365, letter to Rilke in Soglio, 8 Dec. 1919.

81. Thomas Mann, *Diaries*, 104–5, 8 Dec. 1918; 113, 22 Dec. 1918: "On the whole these paintings are among the strongest that ever came before my eyes."

82. Kurt Gerstenberg, review of A. L Mayer, *Matthias Grünewald*, Munich, 1919, in *Monatshefte für Kunstwissenschaft*, Jahrg. 12, no. 12, 1919, 350–51, gives a brief overview of the publications of this time.

83. *L'Opinion*, 21 Aug. 1920, no. 34, 211–13, talks about the time in Munich, "where processions of admirers filed by daily to study . . . their Grünewald." *L'Illustration*, 19 Apr. 1919, 418, relates the report of a correspondant who had been in Munich, where the altarpiece "daily receives the visit of hundreds of curious people."

84. The critic Wilhelm Hausenstein (*Der Isenheimer Altar*, Munich, 1919, 108–11) best evokes the content of this magnetic attraction to Grünewald's paintings during their time in the Munich museum and in the context of an immediately postwar sensibility. I am grateful to O. K. Werckmeister for mentioning Hausenstein's book to me.

85. Hans Tietze, "Grünewalds Isenheimer Altar im Lichte neuer Würdigungen," *Die Bildenden Künste*, III Jahrg., 1920, 19–26.

86. See, for example, A. Marguillier, "Le Retable d'Isenheim au Musée de Colmar," *Les arts*, no. 176, 1919, 9–14; Louis Réau, "Une Restitution qui s'impose," *L'Illustration*, 19 Apr. 1919, 418.

87. *Münchner Neuster Nachrichten*, 72 Jahrg., no. 391, 27/28 Sept. 1919, parallels returning the altarpiece to France to an amputation of the German body politic. See also H. Tietze, *Die Bildenden Künste*, 1920, 19–26. Louis Réau, *Mathias Grünewald et le retable de Colmar*, Nancy, Paris, and Strasbourg, 1920, 142, speaks of the panels having been taken to Munich *"on the pretext* of protecting them from French cannons," and that "the Colmar altarpiece wasn't *returned from captivity* until the 29th of September 1919, more than two months after the signing of the peace treaty." André Hallays, "Le Retour des Grünewald à Colmar," *L'Illustration*, 1 Nov. 1919, 363–64: "Remaining faithful to their traditions, the Munich restorers did not fail to try out their *savage cleaning procedures* on one of the Schoengauers" (italics mine).

88. Louis Réau, "Le Retable d'Isenheim de Mathias Grünewald," *Revue de L'Art*, 30, no. 15, July 1911, Part 1, 225–36.

89. L. Réau, *Mathias Grünewald et le retable de Colmar*, 1920, 337–38.

90. Ruth Kaufmann, "Picasso's *Crucifixion* of 1930," *The Burlington Magazine*, Sept. 1969, 553–61; John Golding, "Picasso and Surrealism," *Picasso—1881/ 1973*, London, 1973, 84; William S. Rubin, *Dada and Surrealist Art*, New York, 1968, 292–94; ed. W. S. Rubin, *Pablo Picasso, A Retrospective*, New York, Museum of Modern Art, 1980, 277, 300–2, 306.

91. Christian Zervos, *Pablo Picasso—Oeuvres 1932–1937*, Vol. 8, nos. 22–25, figs. 49–56.

92. *Minotaure*, no. 1 (Numéro Spécial), June 1933, 30–32. Brassai, *Conversations avec Picasso*, Paris, 1964, 36, records an exchange with Picasso on the relation of these drawings to the Isenheim *Crucifixion* The conversation took place when Brassai went to Picasso's studio to photograph them for *Minotaure*.

93. C. Zervos, *Matthias Grünewald—Le retable d'Issenheim*, Éditions *Cahiers d'Art*, Paris, 1936. James Thrall Soby, *Modern Art and the New Past*, Norman, Okla., 1957, 11, says that "for a long time some magnificent photographs" of the Isenheim paintings could be seen by artists in the window of a bookshop (Bulloz) near Les Deux Magots in Paris, and that it was either these or comparable reproductions that were published in 1936 by the aforementioned *Cahiers d'Art* series.

94. With reference to any of the more recent discussions of Picasso's *Crucifixion* drawings, Zervos's Isenheim portfolio seems to have escaped notice. The inscription at the head of his introduction reads: "à Picasso, à Paul Éluard."

95. Excerpts of Éluard's Barcelona speech in a special issue of *Cahiers d'Art*, 10ᶜ 1935, 165–68.

96. C. Zervos, *Pablo Picasso*, Vol. 8, no. 273, pl. 127. The portrait, in lead pencil, is dated 8 Jan. 1936. The drawing "Le Crayon qui parle" (Herbert Read, *Surrealism*, London, 1936, fig. 82) is dated 11 March 1936. Lydia Gasman, *Mystery, Magic, and Love in Picasso, 1925–1938*, Ph.D. diss., Columbia University, 1981, Vol. 3, 1074, refers to Roland Penrose's identification of Picasso's written words on the left side of the sheet as nicknames for M. Zervos, Mme. Zervos, M. Éluard, Mme. Éluard, respectively. This drawing passed on to the collection of Roland Penrose, as Marie-Laure Bernadac, curator at the Musée Picasso, Paris, kindly informs me.

97. Stefan Zweig, "Unvergessliches Erlebnis—Ein Tag bei Albert Schweitzer," *Begegnungen mit Menschen, Büchern, Städten*, Berlin, 1956, 113–22.

98. At the opening of this account, dated Dec. 1932, Zweig indicates that he had also seen the Isenheim Altarpiece twenty years earlier.

99. Erwin Panofsky, "Zum Problem der Beschreibung und Inhaltsdeutung von Werken der bildenden Kunst," to the Kieler Ortsgruppe der Kantgesellschaft is included in ed. Hariolf Oberer and Egon Verheyen, *Erwin Panofsky: Aufsätze zu Grundfragen der Kunstwissenschaft*, Berlin, 1980, 85–97.

100. E. Panofsky, "Zum Problem . . . ," *Logos*, 21, 1932, 103–19.

101. In particular, I am referring to the first portion of Chap. 1, named "Introductory," in the collection *Studies in Iconology*, originally published by Oxford University Press in 1939 and reissued in a Harper Torchbook edition in 1962.

102. Erwin Panofsky: *Aufsätze und Grundfragen*, 1980, 86.

103. Geoffrey Skelton, *Paul Hindemith, the Man Behind the Music*, London, 1975, especially Chap. v, "Music to Sing and Play"; ed. Dieter Rexroth, *Erprobungen und Erfahrungen zu Paul Hindemiths Schaffen in den zwanziger Jahren*, Mainz, 1978.

104. Paul Hindemith, *Mathis der Maler*, libretto, B. Schott Söhne, Mainz; Associated Music Publishers Inc., New York, 1935, 1967. See Elaine Padmore, "Hindemith and Grünewald," *The Music Review*, Vol. 33, no. 3, August 1972,

190–93, for a sensitive characterization, particularly of the thematic contents of Hindemith's opera.

105. Harold C. Schonberg, "Hindemith and Matthias the Painter," *American Music Lover*, 8, 1941–1942, 163–168.

106. *"Vom belebenden Geiste eines der grössten Künstler, die wir je besassen."* The first full-scale performance of *Mathis der Maler* took place at the Zürich opera house on 28 May 1938. Hindemith's program notes for that performance are reprinted on the jacket cover of the complete recording (Angel SZCX-2869) under the baton of Rafael Kubelik.

107. Berta Geissmar, " 'Der Fall Hindemith'—Deutsche Musikpolitik 1934," *Musica*, 1–2, 1948, 40–46. This title, in turn, refers to an article by Wilhelm Furtwängler (25 Nov. 1934, *Deutsche Allgemeine Zeitung*), in which the conductor came to Hindemith's defense.

108. Roger Sessions, "Hindemith's *Mathis der Maler*," *Modern Music*, XII, no. 1, Nov.–Dec. 1934, 13–16. On the occasion of the first New York presentation, by Otto Klemperer, of these symphonic excerpts, Sessions gives an account of the Berlin performance the previous season.

109. W. K. Zülch, *Der historische Grünewald—Mathis Gothardt-Neithardt*, Munich, 1938.

110. See, for instance: W. K. Zülch, " 'Die Grünewaldlegende,' Kritische Beiträge zur Grünewaldforschung von W. Rolfs (Leipzig, 1923)," *Der Kunstwanderer*, 4/5, 1922–1923, 429–30; idem, "Wahrheit über Grünewald," ibid., 1925; idem, "Das Dunkel um Grünewald," ibid., 17; idem, "Eine Grünewaldurkunde. Mathis Gothardt-Neithardt, 27/28 Aug. 1528," *Jahrbuch der öffentlichen Kunstsammlung Basel*, N.F. 24, 1927, 40–62; idem, "Das Selbstbildnis Grünewalds mit M.N.," *Pantheon*, 3, 1929, 222.

111. Arthur Burkhard, *Mathias Grünewald. Personality and Accomplishment*, Cambridge, Mass., 1936. A year later an important study was published in England of the Munich *Saints Erasmus and Maurizius* by Edgar Wind, "Studies in Allegorical Portraiture. 2. Albrecht von Brandenburg as St. Erasmus," *Journal of the Warburg Institute*, I, 1937, 142–62.

112. Guido Schoenberger, *The Drawings of Mathis Gothart Nithart, called Grünewald*, New York, 1948. By this time, Stephen Kayser's sensitive and sensible exploration of the religious meaning of the altarpiece had appeared: "Grünewald's Christianity," *The Review of Religion*, 5, no. 1, Nov. 1940, 3–35. The entry into an American museum collection in 1953 of the first (and only) painting by Grünewald (*The Small Crucifixion*, National Gallery of Art, Washington, D.C.) could be seen as culminating this phase of the post-war critical appraisal of Grünewald.

113. The charcoal drawing is inscribed: H. Matisse/D. Grunewald 49. John Elderfield, *The Drawings of Henri Matisse*, New York, 1984, 238, 280, no. 143. Alfred H. Barr, Jr., *Matisse—His Art and His Public*, New York, 1951, 285, suggests that the preparatory drawings for the chapel also show that Matisse was studying Grünewald's crucified Christ.

114. E. C. Goosen, *Ellsworth Kelly*, New York, 1973, 16. This reference was first pointed out to me by Angelica Rudenstine.

115. Philip Melanchthon, *Elementorum rethorices libri duo*, 1531. The passage appears in the last section of the treatise under the heading *De tribus generibus dicendi*: "In picturis facile deprehendi hae differentiae possunt. Durerus enim pingebat omnia grandiora, et frequentissimis lineis variata. Lucae picturae graciles sunt, quae et si blandae sunt, tamen quantum distent a Dureri operibus, collatio ostendit. Matthias quasi mediocritatem servabat." ("In pictures, these differences can easily be detected. Dürer, indeed, painted all things in a grander manner and varied with multitudinous lines. The paintings of Lucas are in the simple style, although they are charming; however, comparison shows how different they are from the works of Dürer. Matthias kept to, as it were, a moderate course.")

INDEX

References to illustrations are in italics.

PRINCETON ESSAYS ON THE ARTS

DATE DUE
REMINDER

NOV 10 2004	
APR 19 2005	
APR 19 2006	
MAR – 5 2013	

Please do not remove
this date due slip.